SHOOT
Sexy

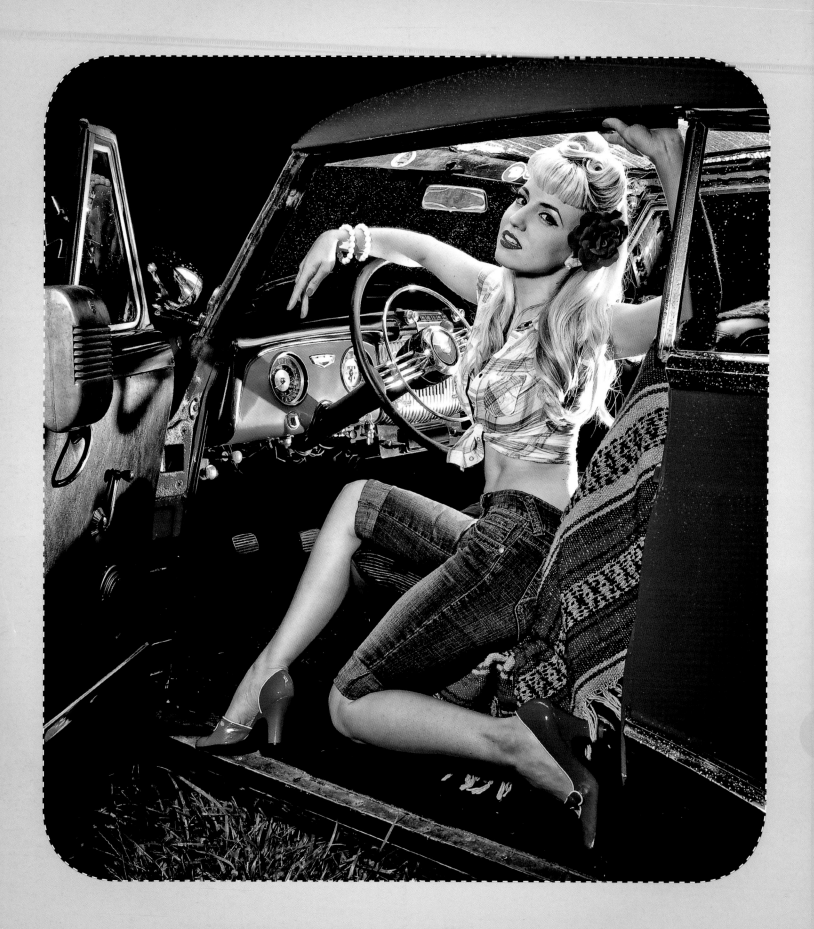

SHOOT Sexy

❂ *Pinup* PHOTOGRAPHY *in the* DIGITAL AGE ❂

by RYAN ARMBRUST

ELSEVIER

AMSTERDAM • BOSTON • HEIDELBERG • LONDON
NEW YORK • OXFORD • PARIS • SAN DIEGO
SAN FRANCISCO • SINGAPORE • SYDNEY • TOKYO

Focal Press is an imprint of Elsevier

Focal
Press

Focal Press is an imprint of Elsevier Inc.
225 Wyman Street, Waltham
MA 02451, USA
Copyright © 2012 The Ilex Press Ltd.
All rights reserved

This book was conceived, designed,
and produced by
Ilex Press Limited, 210 High Street,
Lewes, BN7 2NS, UK

PUBLISHER: Alastair Campbell
ASSOCIATE PUBLISHER: Adam Juniper
MANAGING EDITOR: Natalia Price-Cabrera
EDITOR: Tara Gallagher
SPECIALIST EDITOR: Frank Gallaugher
CREATIVE DIRECTOR: James Hollywell
SENIOR DESIGNER: Kate Haynes
DESIGNER: JC Lanaway
COLOR ORIGINATION: Ivy Press Reprographics

Library of Congress Control Number:
A catalog record for this book is available
from the Library of Congress.

ISBN: 978-0-240-82108-5
For information on all Focal Press publications
visit our website at:
www.focalpress.com
Printed and bound in China
10 9 8 7 6 5 4 3 2 1

Contents

ever in a million years would I have guessed that I would be shooting photos of girls in their underwear for a living! Out of all the different types of photography, I think I have chosen one of the most fun to shoot. It sure beats shooting weddings!

People always ask me how I got started with boudoir and pinup girl photography. I think it is actually the number one question asked at our studio. I've been a huge fan of everything retro for many years. I always liked the old TV shows from the 1950s, the cars and culture from that time period just looked like a great deal of fun. I was getting a little bit bored with shooting commercial photography and was looking for something a bit more creative to have a little fun with. I was thumbing through a book of pinup girl paintings and thought, this would be fun! I decided to round up a few of my female friends and try my hand at shooting pinup girl photography. The photos were really bad. We had fun shooting them, but they were not that great. I didn't know how to pose the girls, I wasn't that great at lighting the female form… basically, it was a mess. Since it was a lot of fun to do, I decided I would figure it out. I shot more pinups and after a little bit of practice I was ready to post a few to my main photography blog. As I started to post the shots, something happened that I had not planned for. Strangers started emailing me to ask about booking a pinup shoot. Wow, I guess I need a game plan!

After a few more shoots and a bunch of inquiries, I started a second photography studio, Boudoir Louisville. Now I had a name, but that was about it. My studio at the time was mainly a meeting area for new commercial clients with a small shooting studio attached. I started filling it with tons of retro and vintage props. In no time, I had out grown my studio. It looked more like an antique store than a photo studio. It was time to move. I also needed to hire someone to help me keep up with all of the new business my pinups had generated. I hired an assistant right off the bat. Her name is Britt. She takes care of bookings as well as our hair and makeup. During the shoot, she poses the girls and provides comedic relief. Boudoir Louisville was growing.

Over a two-and-a-half year period, we have grown from our small 600-sq-ft studio to a 4500-sq-ft space in Louisville, Kentucky. We have also just snapped photos of our 500th girl!

We received a bunch of emails from other photographers all over the world. They all wanted tips on starting their own pinup and boudoir business as well as how to shoot this stuff. Last year we decided to offer workshops at our studio for photographers who wanted to learn our tricks of the trade. We have had folks fly in from all over the country to learn pinup and boudoir from us. It's always fun to check in on folks that have attended our workshops to see how they have grown their businesses. During the first year of shooting studio pinups, I developed a very straightforward lighting system that is 100% repeatable every time. Since you don't have to worry about the technical aspect of the shoot, you can concentrate on your interaction with your client.

As you read through this book, keep in mind that I'm a bit of a goof-ball! I like to have fun with what I do for a living. What we do is not rocket science, but it does make a huge difference in the lives of our clients. We often receive emails and letters from past clients thanking us for the experience. It's always fun when the husband of past clients contacts us to thank us as well! Girls book photo shoots as a gift for their special someone, but leave feeling empowered. Clients get a huge ego boost when they shoot with us.

There are many reasons that people book with us. We are close to a military base. One of the coolest things we do is shoot pinups that clients send overseas to their men fighting for our country. If you think back, this is the exact way that pinups became so popular. It feels great to keep this art form alive.

If you have ever wanted to shoot pinup photography, you will love this book. We show you everything. We walk you through setting up your first on-location pinup shoot. How to find the perfect location, how to select your model, wardrobe, etc… After the game plan has been established, we get technical! We show you exactly how we lit the shot. We also talk about shopping for the perfect props as well as how to set up your very own pinup studio space.

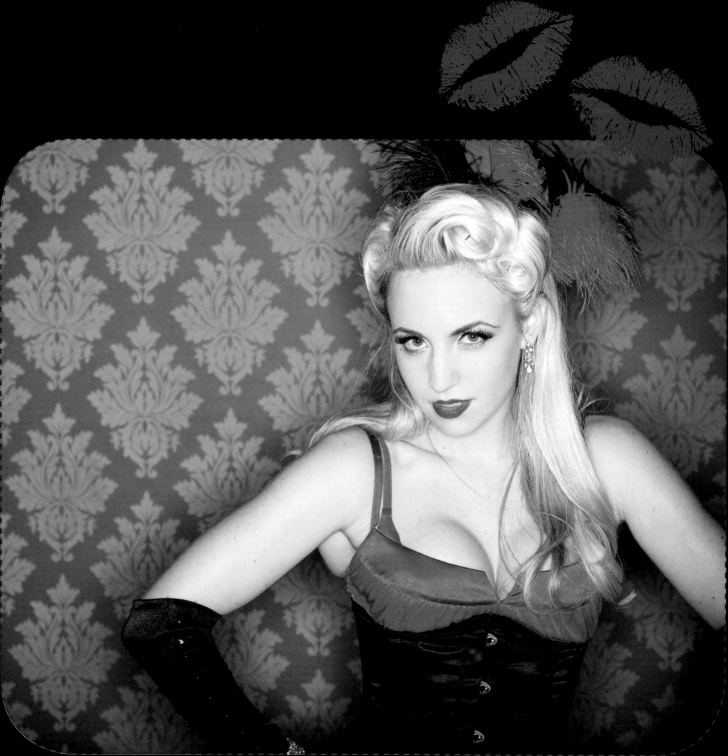

STUDIO SHOOT

Pinups in the studio

Setting up your studio

THE GREAT NEWS about shooting retro pinup photography in the studio is that the setup can be quite simple. When I started shooting pinup photography, my style was dictated by the lack of light in my small studio. This was compounded by the mistake I made of painting the entire shooting area dark gray. I had assumed that by painting the entire area a dark color, I would get rid of any stray light, but basically all I did was create a very uninviting space for the models to enter—not the best way to start a shoot!

When I moved studio, I went for the opposite effect and found an open and airy space with lots of light. I also painted the whole place flat white, which makes it a very pleasant place to shoot, and models feel at ease and comfortable—something you should never underestimate, as a relaxed model will give you better photographs every time.

I have found that using a "high key" style of photography works well for shooting pinup: you might recognize this style from high-end ad campaigns, fashion shots, portraits, and so on, as it has been the standard for some time. In order to shoot high-key images you will need a large white floor and background to shoot your pinup girl against. You can use a

BELOW I admit, this setup does look a bit "shabby," but it works well: the magic happens when you start lighting the set.

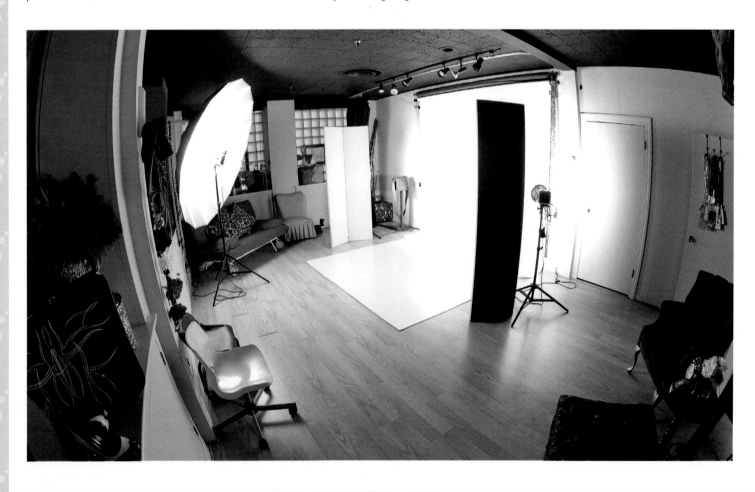

white painted wall, fabric, or something similar, but I personally prefer to use a nine-foot wide roll of white seamless background paper because I don't have to worry about any wrinkles (unlike a fabric background). Paper is also easy to buy and replace—you can purchase a roll of seamless white paper at most photo supply stores.

After you have your roll of paper, you will need some way to hold it off the ground. I use a chain-driven, wall-mounted system that allows me to raise and lower the paper with ease, with two additional slots that can hold other colors of background paper. Alternatively, if you don't want your background support fixed permanently to the wall, you can opt for one of the many portable background stand systems that are available.

The downside to using white seamless is that after just a few photos the paper starts to get dirty and torn as your models walk on it. Since most pinup girls will be wearing high heels, this tends to happen even quicker. I have found that the easiest way to combat this is to use a few sheets of plain white tile board on the floor. This can be purchased at any major home improvement store and is used to cover the walls in bathrooms, I believe. They are sold in 8 foot x 4 foot sheets and I always use two of them, giving me an 8' x 8' "floor"— plenty of room for a pinup girl or two to move around.

BELOW LEFT *A wall-mounted chain system is a quick and easy way to change paper backgrounds.*

BELOW *White tile board from the hardware store makes the perfect floor for your high-key photo setup.*

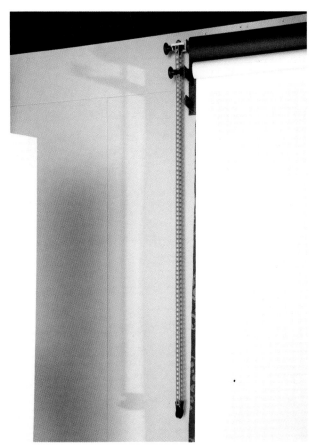

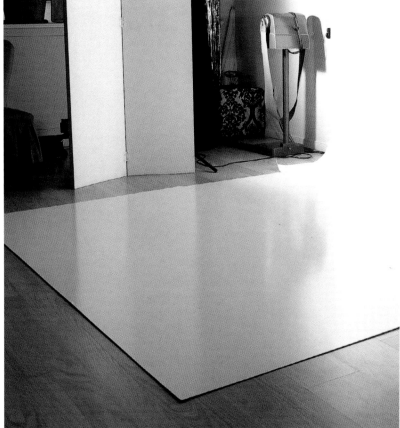

Props

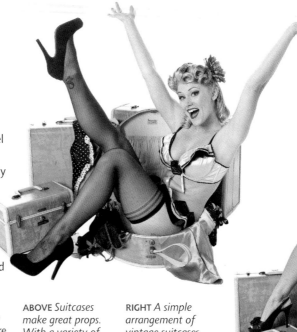

Looking back at all the great pinup artists from yesteryear, a common theme emerges quickly: the girls are all "doing something." You never see a model standing or laying around—they are always busy. It can be something as simple as enjoying an ice cream cone, or as crazy as trying the "latest" exercise craze, and this is where props really make the difference. For an inexperienced pinup girl, props also help to give them direction in the shoot.

In my opinion, props can make or break a pinup photograph. There are lots of photographers trying their hand at the pinup style, but using new or reproduction items as props can really make your shots stand out. Some of my favorite props have come from flea markets or antique stores, and I do so much antique shopping that my studio looks more like an antique store than a photo studio! Give your local antique malls a visit and I'm sure you'll find something that will work well. One word of advice, though: don't overdo it, as having too many props in a single shot will just look like you're photographing a kleptomaniac!

If you're starting out, then one of the most versatile props you can own would have to be a great set of vintage luggage. I started off with a single large suitcase, but over the past few years have put together an entire matching set, which means I can shoot a "travel" type pinup in the studio (or on location), simply by having the model stand or sit with the cases, or position the pinup girl in one of the pieces of luggage, or use the clothes she brought with her to the shoot to make it look as if her suitcase has exploded. In each case, the same prop can be used.

Small, handheld props are also very inexpensive and easy to find, and I have many "faux food" items in our studio— everything from fake cupcakes to fake milkshakes—as well as great items such as old telephones, kitchen mixers, books, and vintage cameras. Vintage books are always a great prop, with lots of potential for humor. I use an old sex-ed book that was written in 1930, for example, and just open it to a random page and tell the model to start reading: the information in the book is so wacky that she is guaranteed to make a funny expression!

ABOVE *Suitcases make great props. With a variety of sizes, there will always be one that fits your pinup girl's "bottom."*

RIGHT *A simple arrangement of vintage suitcases makes for the perfect prop.*

RIGHT *Props can be as simple as an ice cream cone or as fancy as a retro jiggle machine!*

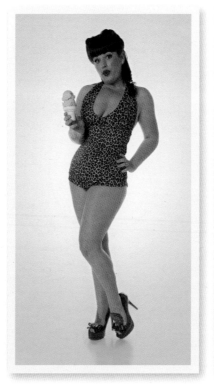

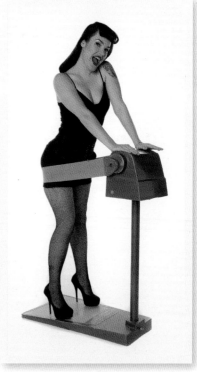

Vintage furniture is another must-have item for any pinup studio. I have a number of retro chairs that allow different poses, but when buying antique furniture, always make sure it's solid—there's nothing worse than a pinup girl lying on the floor of your studio because an old chair collapsed! It would make for an amusing photograph, but a not-so-amusing insurance claim.

When talking about pinup props, it is difficult not to mention the classic Coca-Cola coolers, and the Coca-Cola pinups have a following of their own. The old picnic-chest style of cooler makes a fantastic prop as they are sturdy enough for the model to sit on or to pop a foot onto, but you can also have your model sitting on the ground and lounging against it.

Sometimes I will bring larger props into the studio, and for a few months had an old motorcycle—talk about a great prop. Vintage scooters and bicycles are also great fun, so see what you, your friends, or your family have that could be used as a prop for your pinup photographs.

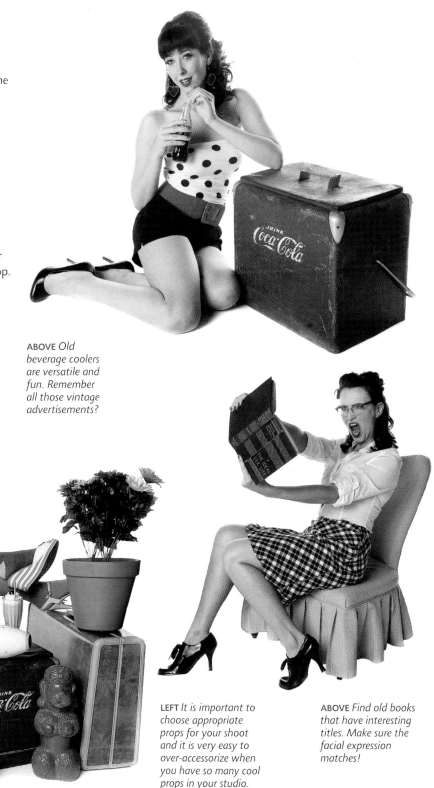

ABOVE *Old beverage coolers are versatile and fun. Remember all those vintage advertisements?*

LEFT *It is important to choose appropriate props for your shoot and it is very easy to over-accessorize when you have so many cool props in your studio.*

ABOVE *Find old books that have interesting titles. Make sure the facial expression matches!*

Wardrobe

THE WARDROBE YOU CHOOSE for your pinup photos is every bit as important as choosing the right prop— if you have a great vintage prop, but style your pinup model in modern clothing, you'll ruin the whole shoot. This isn't easy though. I've tried shopping for my wife and there are way too many sizes and options out there, so I'm not about to try that at the studio where we have a whole heap of different shaped models—it would be impossible to provide something that suits (and fits) them all! They are also far more likely to pose well if they are in a favorite outfit that makes them feel good, so at our studio we simply ask our clients/models to bring their own wardrobe.

However, before a shoot, I always give my clients suggestions of what to bring. One of the staples of pinup wardrobe has to be the simple black bra and panty set. Combine that with a garter belt and some stockings and you have a very versatile outfit that fits the retro vibe you are going for. This simple outfit can then be accessorized in a bunch of different ways, or just left "as is" for a very sexy pinup photo. If a girl comes into the studio with a black bra and panty set, garter belt, and stockings under a great summer dress then I will start by photographing her in the dress, then have her remove the dress and shoot again. After that, I might accessorize with an old vintage apron, which results in three totally different looks, all based on the same outfit.

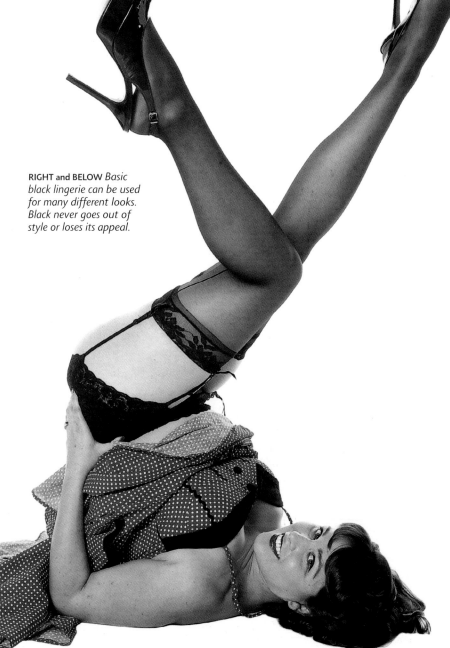

RIGHT and BELOW *Basic black lingerie can be used for many different looks. Black never goes out of style or loses its appeal.*

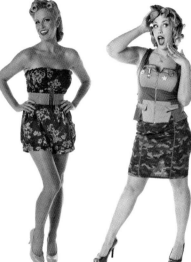

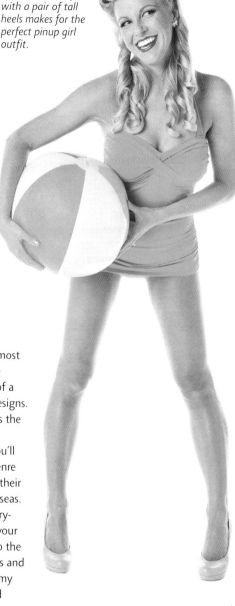

LEFT *A simple pair of jeans rolled up with a pair of tall heels makes for the perfect pinup girl outfit.*

ABOVE *Without vintage hair and makeup, this dress looks too modern to shoot.*

ABOVE *Pinup hair and makeup turn this up-to-date dress into a vintage look.*

ABOVE *Military outfits have always been a staple of the pinup culture.*

The simple summer dress works for many different styles of pinup photography, and the great news is that this type of dress can be found in almost every major department store. Classic styles never really go away, and with the right hair, makeup, and a few vintage accessories, you've got the perfect retro outfit. Even a dress that doesn't look overly vintage can be made to look so with the right additions, and it's amazing how much difference proper hair and makeup can make when shooting classic pinups.

Another popular pinup outfit is the simple undershirt tank top, combined with denim jeans or capri pants. This outfit was typically worn by girls hanging out in hot rod garages watching their boyfriends work on cars, and it's also a very popular outfit for "rockabilly" type pinups.

When talking about pinup girl wardrobe, I can't forget to mention the classic bathing suit. There are so many cute shooting ideas to be had when you are shooting swimsuit pinups; just tossing your model a beach ball or adding a pair of vintage sunglasses can create a great pinup photo, making it one of my favorite outfits. Be sure that the swimsuit you use is not too wacky though—most retro bathing suits were solid colors, or had a very subtle pattern (sure, they also used leopard print, but that isn't very subtle). The cut is equally important. Halter style tops were very popular, as were

high-waisted bottoms, although most retro style bathing suits also came down farther on the leg in more of a modest cut than contemporary designs. Another commonly seen style was the ruffled one-piece.

If you've done your research, you'll know that the entire pinup girl genre started when girls sent photos to their men while they were serving overseas. This means that military, or military-themed clothing is also great for your pinup photos and pays homage to the pinups of the past. Military jackets and hats can be easily found at any army surplus store, and I've often found them in thrift stores as well.

Every outfit idea mentioned here will be improved with the right pair of shoes. Black or red seem to be the most popular colors and I always suggest at least a three-inch heel—the taller the better, really. Heels do a few things: they make the model's legs look longer and give their behind a bit of a boost, both of which are great for pinup photographs. I'll never shoot a girl with bare feet—never!

ABOVE *Retro bathing suits are great for shoots. Just be sure the cut and style is right.*

Hair & makeup

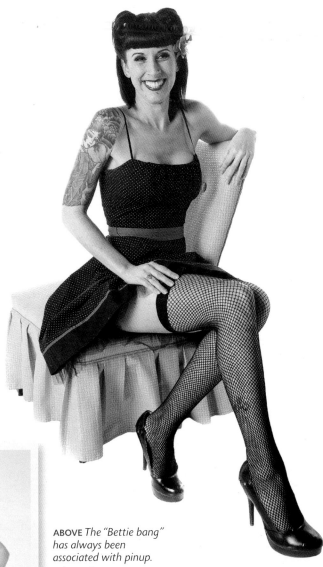

HAIR AND MAKEUP really pull the whole "pinup girl" image together. Without proper pinup hair and makeup, you are just shooting a model portrait, and unless you really know what you're doing my advice is to find a hair and makeup artist who specializes in vintage looks.

One of the most popular pinup girl hairstyles would have to be the "victory roll." Ever laid eyes on a pretty pinup girl with two oversized curls on the top of her head? Those are victory rolls. Wildly popular in the 1940s, and named after a fighter plane maneuver, they could be prepared without any of today's modern styling products. This makes it a fairly quick and easy hairstyle to do, but it does take a lot of practice to get it just right.

"Pin curls" are the staple of pinup girl hair. This style was popular from the 1940s–1960s, and gets its name from all the bobby pins that are used to hold the curls in place. Pin curls can be given to a girl with any length of hair and I tend to use them on just about every girl who walks through the studio door.

BELOW LEFT *Dramatic eye makeup always makes a statement.*

BELOW *The classic pin curl makes for a fun and flirty look.*

ABOVE *The "Bettie bang" has always been associated with pinup.*

I'm sure that if you've bought this book you will know who Bettie Page was, and you're probably familiar with her trademark straight bangs? Everyone associates the "Bettie bangs" with pinup girls, but it does involve cutting the hair and is best left to a professional stylist. If your model doesn't want to commit to this look, try the "rolled bangs" approach instead. This will give the appearance of Bettie bangs, without any cutting of hair: simply roll the bangs under with a curling iron and pin into place.

Every great pinup hairstyle contains a mixture of the three elements mentioned here: the victory roll, pin curls and Bettie bangs. How do you know which styles to incorporate? That is totally dependent upon the type of hair your model has. If she has short hair, go with pin curls only; if she has long straight hair, maybe try pin curls with a side pony tail; medium length hair always looks great in victory rolls. Practice is the key.

Accessories are a great way to dress up any hairstyle. Hair bows and flowers are the most popular for pinup photographs, and both can be handmade without much effort. I keep hair flowers in every color imaginable on hand during shooting, simply because they can add a great pop of color when you need it. Hair flowers are also a great way to fix a fallen hair do if that happens.

Pinup girl makeup tends to be quite natural: red was the only real "bold" color used, and is reserved for the lips. Since pinup girl facial expressions are on the exaggerated side, the makeup should play into this as well. The best way to make the eyes stand out is with a classic "cat eye," but don't forget faux eyelashes as well. These will add lots of glamour to your pinup girl's face, and are fun to wear. They also show up on camera really well.

BELOW *Hair flowers make the perfect hair accessory.*

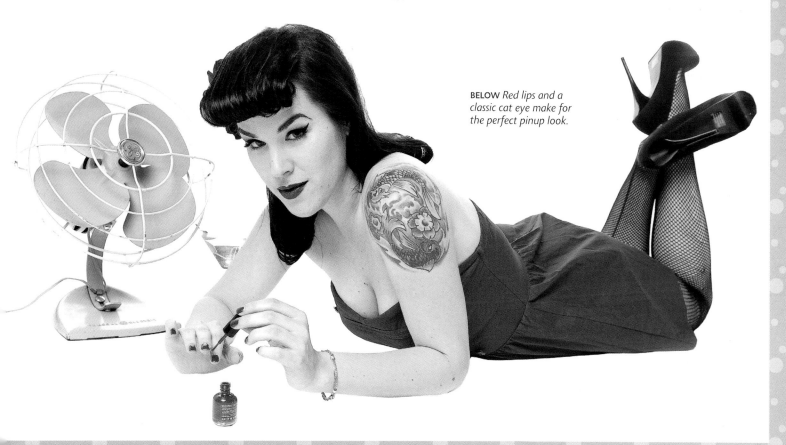

BELOW *Red lips and a classic cat eye make for the perfect pinup look.*

Posing basics

WHEN IT COMES TO POSING your pinup girl, there are a lot of things to think about, but first and foremost you absolutely must consider her body type. Selecting the right pose is key to flattering all shapes and sizes: it is important to hide the areas of your model's body that she feels are not her best, while accentuating the parts she is happy with.

There are huge differences between modern posing conventions—which are often about making your model appear long and lean—and vintage posing, which, by design, is meant to emphasize feminine curves (and it's worth noting that some of the most iconic women in history came from the pinup era). In vintage posing, every part of the body is doing something. For example, toes are always pointed, making the legs look longer; arms are always pulled away from the body, making them look slimmer; the back is always arched as far as possible, which helps to cinch in the waist, pull the hips back, and hide any tummy chunk; and shoulders are pulled back and down. Let's face it, they had better posture back then!

Posture is the first thing you adjust when posing, then you worry about making it look pretty. There is a phrase I use often in the studio: "If it doesn't hurt, you're not doing it right!" This is because pinup posing is about exaggeration, and if your pinup girl is posing right, she'll feel it for the next two days! It's a workout, and the more unnatural a pose feels to her, the better it will look on camera.

When photographing pinups, I shoot from a lower angle. Once you've found the right angle, you'll need to make adjustments depending on your model's body type. Curvier girls don't always look their best from low down, so you'll want to adjust the pose to flatter her. Have her lean in toward the camera a bit and put one knee over the other—this trick works wonders. The legs look nice and long, it brings the bust line closer, and pushes the waistline back to create the perfect hourglass shape. I call this the "pinup leg" pose. With a slimmer, less curvy girl, it may not be necessary to have her lean in toward the camera. The goal with posing is balance: with some women you'll have to give them curves, and on others take curves away by posing them correctly.

There is a lot of psychology that goes into photographing women. If you put your pinup girl in a pose that is unflattering to her, make subtle adjustments to make her look good, and never make negative comments such as "oh, that looks bad." If you put her in an unflattering pose, the worst thing you can do is make her feel bad about herself for your mistake: all women love to feel pretty, and that's a big part of the reason why they're posing like pinups for you in the first place! It's your job to make them feel confident, and have them go home loving something new about their bodies. Women are their own worst critics, but you can completely change her perspective by how well you pose her. When you take a photo that makes her look amazing, flip your camera around and show her—she'll instantly light up!

RIGHT *Do you want your photograph to be sexy and sassy? Or fun and flirty? Facial expressions can change the entire mood of the photograph.*

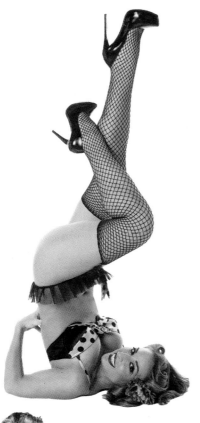

RIGHT *This pose takes a more athletic model to pull off. You can almost FEEL the burn in her abs!*

BELOW *The "Pinup Leg" pose is a favorite go-to pose that everyone can do fairly easily.*

RIGHT *This classic pinup pose works great with vintage bathing suits.*

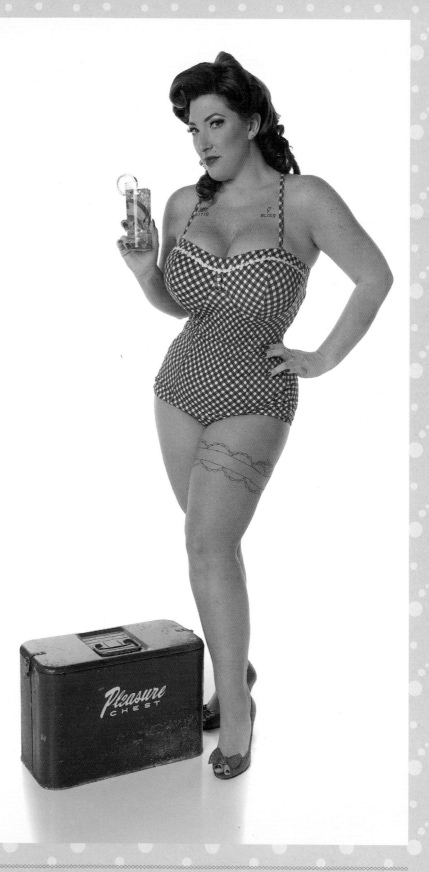

Telling a story

MY FAVORITE PINUP ARTIST is Gil Elvgren. One of the things that Elvgren always made sure he did with his pinup artwork was to tell a story in a single frame. You could look at one of his paintings and figure out an entire storyline, just based on what was included in the image. A lot of the time, humor was used as well—Elvgren was always placing his pinup girls in awkward situations, and a common theme was the dress getting stuck on or in something, exposing the girl's stockings. This is something I also try to do with my pinup photography. Humor is a great way to tell a story, and combining humor with sexiness can make a shot really stand out. The key to telling a story with only one frame is to include the right elements. When it's time to put the shot together, I always start with the model and her outfit, and ask myself what would—or could—this girl be doing while dressed this way? If she's wearing a pretty summer dress, for example, it wouldn't make sense to have her standing in front of a burlesque curtain; she would be more at home having a picnic or cooling off in front of a fan on a hot summer's day. You don't want to complicate the photograph, and a great pinup photo should need no explanation. The viewer should be able to look at your image and instantly figure out what's going on. The same rules apply for the props that will be used in your photo. Would a pinup girl dressed in a vintage bathing suit be ironing clothes or cooking cupcakes? Probably not.

When the clothes and props have been selected, it's time to focus on posing and facial expressions. If you have a pinup girl posing behind a Japanese-themed parasol, you might want to give the illusion that her clothes have fallen off. How would you do that? Simple—it's all in the facial expression. If she's standing with a smile, you would never think that her clothing fell off unexpectedly, but give her a "surprised" look and you instantly think a gust of wind or wardrobe malfunction caused her to be nude suddenly, with only her parasol as cover—cue the exciting photo!

BELOW *Sometimes our props are just too tempting!*

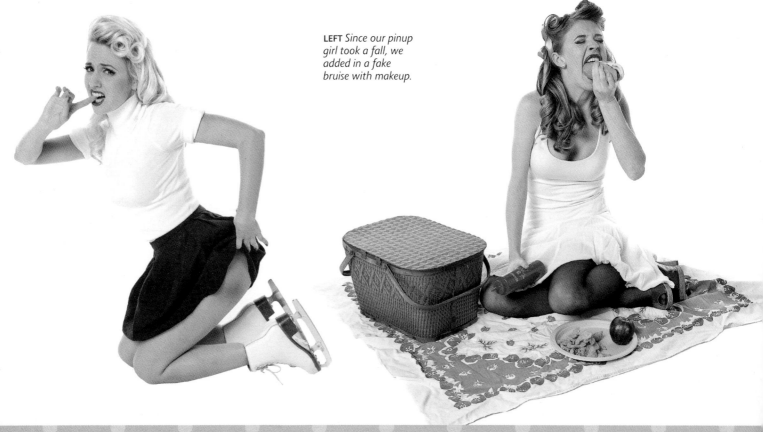

LEFT *Since our pinup girl took a fall, we added in a fake bruise with makeup.*

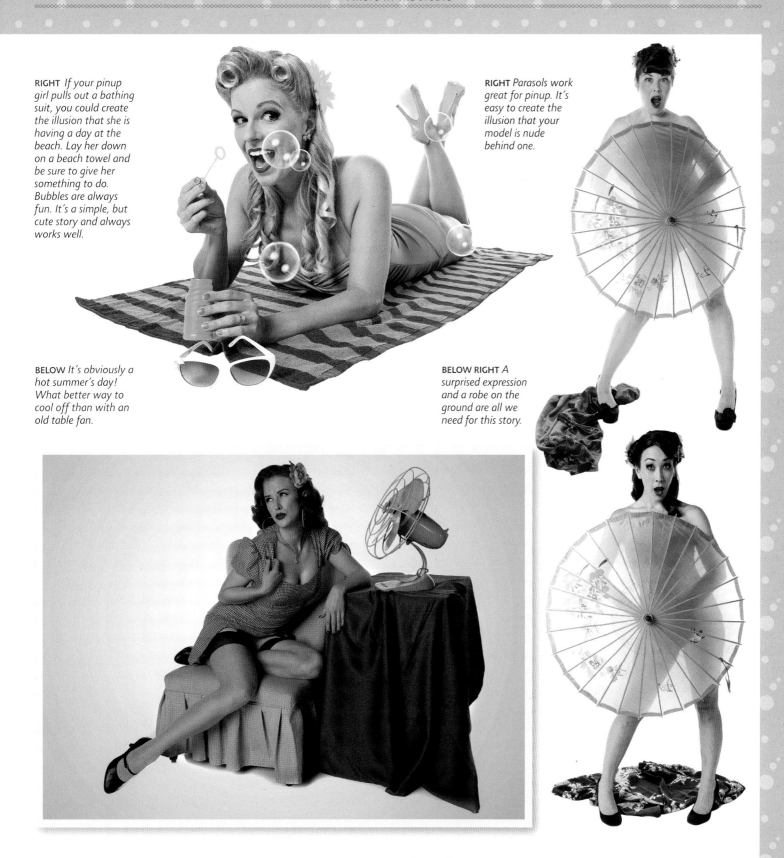

RIGHT *If your pinup girl pulls out a bathing suit, you could create the illusion that she is having a day at the beach. Lay her down on a beach towel and be sure to give her something to do. Bubbles are always fun. It's a simple, but cute story and always works well.*

RIGHT *Parasols work great for pinup. It's easy to create the illusion that your model is nude behind one.*

BELOW *It's obviously a hot summer's day! What better way to cool off than with an old table fan.*

BELOW RIGHT *A surprised expression and a robe on the ground are all we need for this story.*

Studio lighting

IT IS DIFFICULT TO LABEL the style of photography I use when shooting pinups in the studio. I set my studio up to shoot "high key" style portraits, but that's about as far as we go with high-key photography, as it is a style that typically lacks contrast. Since pinup girls are usually wearing bright colors, surrounded by very colorful props, I want to capture a wider range of contrast to convey a happier, more playful mood.

Three light sources are needed to shoot this style of portraiture. Continuous, or "hot," lights are not powerful enough, so I always use studio strobes. Some of my best shots were taken as a model reacted to something that was happening in the studio and with the short recycling time of studio flashes this means I can capture the moment. Another great reason to use studio strobes is ease of use—I have worked with many different brands of studio strobes, but every one of them has used some variation of a slide type switch to adjust power. Studio strobes also have a modeling lamp, which is great for helping you set up your lights, as you know exactly where you are throwing the light.

The goal with my pinup studio lighting setup is to obtain evenly-lit subjects with a pure white background and floor—essentially I want the background to be "blown out" or overexposed, while the subject is exposed correctly. To achieve this I'll light the background separate to the subject, using two studio strobes to light the background and the third strobe to light my subject.

Place the background strobes on stands three to four feet off the ground, and position them either side of your shooting area, making sure the light covers your background evenly. Your main light should then be set up about arm's length away from the camera shooting, either to the left or the right, and I advise using a sturdy lightstand here. This is because many of the light modifiers used in studio photography are bulky and heavy, and a surefire way of ruining a photo shoot is to knock a strobe over onto your model—there's nothing less sexy than an insurance claim.

RIGHT Only the background lights were used for this photo.

FAR RIGHT With only the main light, the background looks dull and gray.

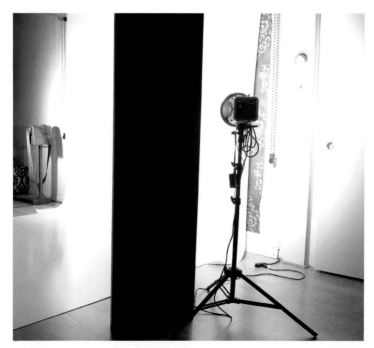

LEFT Lighting the background separately from your subject is important.

ABOVE Alien Bees strobes have a very simple set of controls making them quick and easy to adjust.

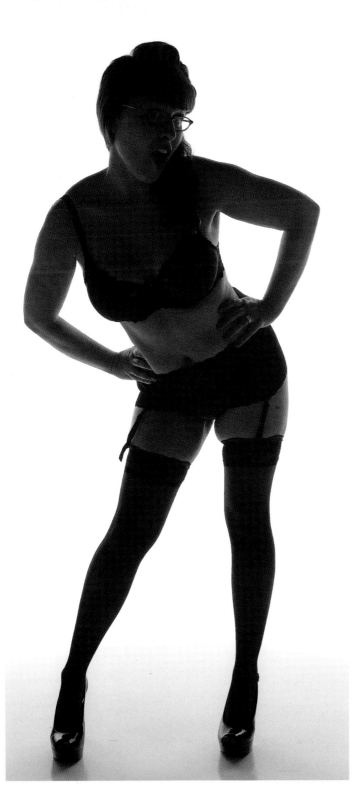
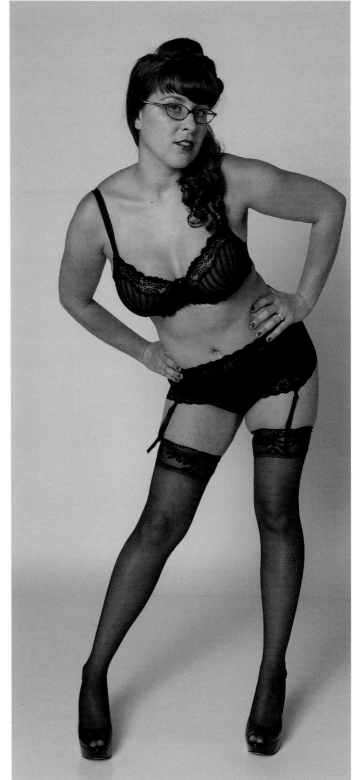

Studio lighting

With your three strobes in place, you need to control the light coming out of them. The background lights should only light the background. If light spills from them onto our subject, you will lose contrast and the model will be washed out. To make sure this doesn't happen, I simply use a pair of ready-made bi-fold closet doors from the hardware store to control my background lights. The built-in hinge makes it easy to adjust the light pattern, so it's guaranteed not to fall on the model.

Move the background lights just behind the bi-fold doors and turn the power on. Using the modeling lights on your strobes to guide you, adjust the background lights and the doors until you have a nice V-shaped shadow on the floor. I've added a bright red line to the accompanying illustration to help you see the shadow on the floor. The tip of the "V" should be about two feet from your background and you should position your pinup girl in the shadow you just created, keeping her about four to five feet away from the background.

The next step is to decide what type of light modifier you want to use on the main strobe. An umbrella, softbox, or parabolic reflector is the most common answer, and each will give you a different type of light. Remember, the bigger your light source, the softer the light. If I'm shooting headshots, I will use a smaller softbox, but for the majority of my full-length pinup work I will use a huge, 84-inch parabolic reflector. This will throw an even light that covers the model completely, as well as lighting any props that might be in the scene with her, without adding dramatic shadows. However, if you want to add a little more drama to your pinups, move your main light further round to the side of your subject: the more off-axis your main light is, the more shadows you will get. Just be careful not to overdo it though.

I recommend setting the strobes so that the exposure on the background is two to three full stops more than the exposure for your subject, which will guarantee a pure white background, and once that's set, the final thing you need to do is trigger your strobes. There are a few ways to do this; you could use a sync cable, with the camera tethered to your lights, or use wireless triggers. This is my preferred solution

BOTTOM LEFT *Bi-fold closet doors work great for blocking your background lights from hitting your main subject.*

BELOW *Your background lights should make a perfect shadow on the floor. This leaves your subject in the dark until you light them.*

as it enables me to move around without worrying about trailing cables. There are numerous different types of wireless trigger on the market today, but they all do basically the same thing—fire your flashes remotely. All wireless triggers consist of two parts: a transmitter that slides into your camera's hot shoe, and a receiver that connects to your studio strobe. Once connected, your strobes will fire every time you press the shutter button.

The lighting setup described is used for about 95% of the pinup style photographs that I shoot in the studio and it has the multiple advantages of being simple to setup, quick to adjust, and it requires no tinkering while you're shooting, which means I can focus entirely on what my model is doing. This will always give you better images in the end.

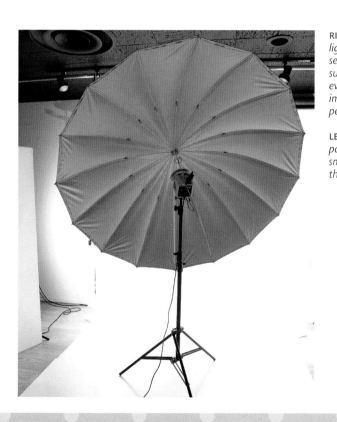

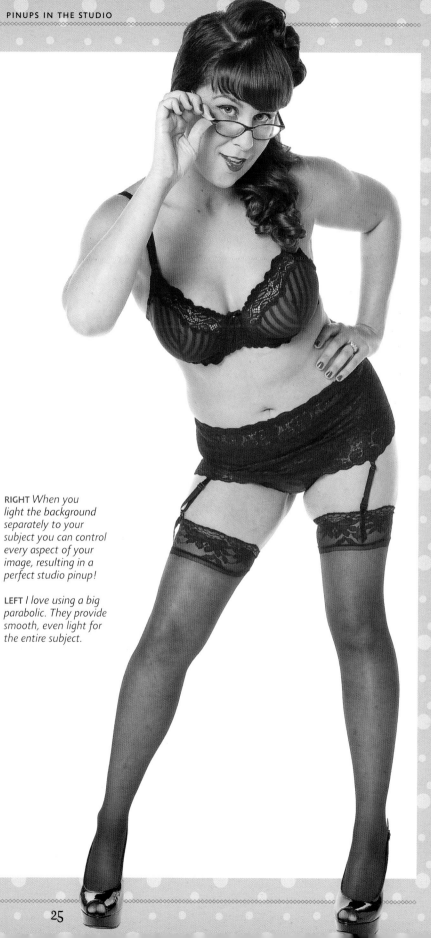

RIGHT *When you light the background separately to your subject you can control every aspect of your image, resulting in a perfect studio pinup!*

LEFT *I love using a big parabolic. They provide smooth, even light for the entire subject.*

Camera settings

WHEN YOU ARE SHOOTING in the studio, you want total control of your camera. The big camera companies may have spent a lot of money developing their cameras' auto modes and fine tuning the metering systems, but you want to make sure that the camera is doing what you want it to do, 100% of the time. Shooting in the studio is all about repeatability: you've already seen how you can maintain repeatable lighting, so now you want to make sure the same applies to your camera. To do this, you will want to shoot in Manual mode, which might seem like a lot of work, but it really isn't—just as the lighting can stay the same for most studio shots, so the same camera settings are used the majority of the time.

First, let's set the aperture. I'm sure you've seen portraits that have tack-sharp focusing on a very small, selected area of the subject, leaving the rest out of focus, but that is not what you want for pinup photos. Instead, you want to maintain a wide depth of field so that your model—as well as any props she may be using—stays in focus and the entire image is tack sharp. I've found that shooting at f/8 gives the best results ("f/8, and everything's great!"), but you don't need to have the aperture set to f/8 all of the time—I might go one stop more (f/5.6) or less (f/11), but f/8 is generally my starting point.

Next comes the shutter speed, which is pretty easy for studio shots: you want to set your shutter speed to the camera's maximum sync speed. This will typically be 1/200–1/250 second. If you set a shutter speed that is faster than this, then the shutter will show up in your photograph and you will see a black bar in your photograph. Shooting at the camera's maximum sync speed also gives you a little range for capturing motion, and will darken any ambient light that might be in your studio. Remember, you want total control over your scene.

The third exposure parameter is the ISO, which determines your camera's sensitivity to light. As a rule, the lower the ISO, the "cleaner" the image, as high ISO settings will start to introduce grainy noise into your shots. If you're using studio strobes, you will have plenty of light, so set the ISO to 200 and forget about it.

Finally, you want to make sure that the color's right. Have you ever taken a shot and noticed a very yellow or blue color cast? This is a result of not having the white balance properly set for the type of lighting in a shot. Studio strobes have a specific color temperature, and most manufacturers will tell you what this value is, measured in degrees Kelvin (K). As a guide, it's usually around 5500K. Most digital SLRs have the option to set the color temperature manually, so access the white balance settings and set the recommended color temperature so that your model's skin tones are accurately recorded. If you do not select the correct white balance, then your images are likely to appear too blue or too yellow.

LEFT *A "cool" white balance makes your subject appear to be blue in color.*

RIGHT *When you select a warm color balance, your subject takes on an orange glow.*

FAR RIGHT *Proper white balance ensures your subject's skin tones look correct.*

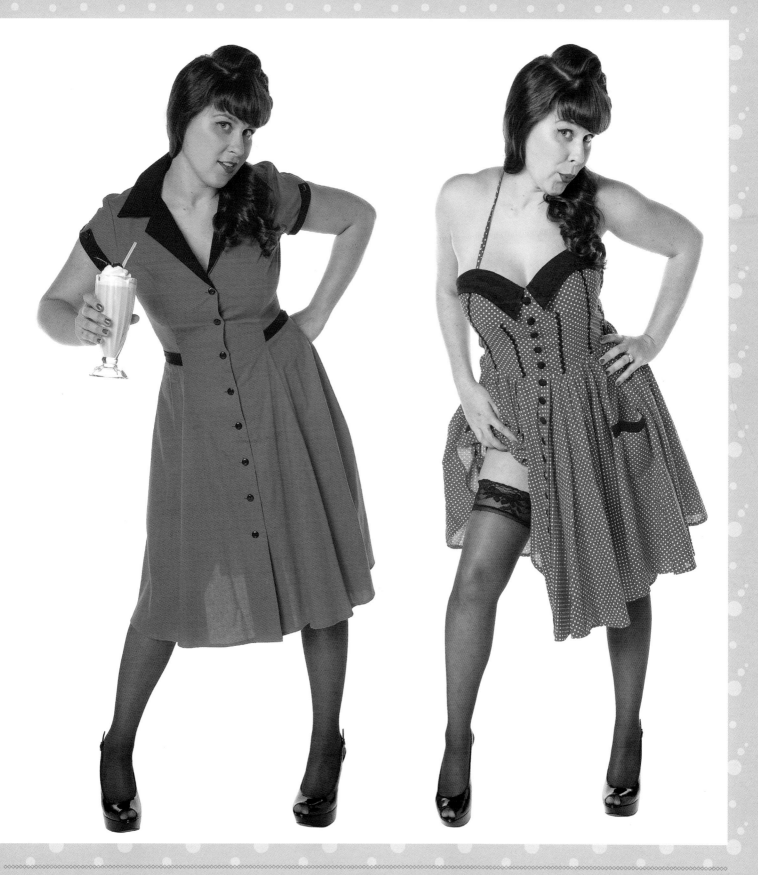

Your first pinup shoot

By now, you should have a basic understanding of what to do when a pinup girl walks into your studio; from setting up your studio, to props and posing. Now it's time to put everything together and walk through your first pinup shoot.

Before the client arrives, make sure that all of your equipment is set up and in proper working order. You want to be able to focus your attention on your client, not your equipment. The same rule applies during your shoot, as nothing comes across more amateur than a photographer who is constantly adjusting and moving equipment. The goal of a pinup shoot for both the photographer and the model is to have fun, and if you have your settings down you can concentrate on having a good time. So do a few test shots to make sure your settings are perfect.

The first thing you want to do when your model arrives at your studio is greet her and make her feel comfortable. First impressions are everything. Make sure your studio is clean, cheery, and inviting. I chose a studio with big windows and lots of natural light, and used bright colors throughout the decor. Think about what your client sees when they first walk through your door, and have examples of your work on display—showing previous work adds to your credibility and gives the client an idea of what to expect.

Now it's time to get a game plan together, so you, your model, and your assistant know how the next couple of hours are going to play out. If everyone is on the same page at the beginning of your shoot, it will help make sure that the finished product will be what your client wants and expects. If your client is familiar with classic pinup imagery, ask them if they have any favorites. This could help inspire both of you.

One of the toughest things to do as a new photographer is to direct your subject. It doesn't make it any easier when your subject is a bombshell wearing sexy lingerie or a knockout pinup outfit. If you're going to be a pinup photographer then you simply cannot afford to be shy. But remember to keep everything professional, and try to avoid using slang terms for body parts; "bust line" is much better than "boobies," for example.

Once you start shooting, avoid any and all negative conversation. Keep everything lighthearted and fun. If your model goes into a pose that just isn't flattering, or doesn't work, don't tell her that it looks bad. Instead, snap a few pics, repose her, and move on—she doesn't need to know that she ever looked anything other than fabulous! As soon as you snap a picture that you are happy with, show your model. I guarantee that as soon as she sees herself looking her best she will be a lot more confident and outgoing for the rest of the shoot.

BELOW LEFT *Always remember to strike a cool pose while you are shooting!*

BELOW *It is very important to show your model a few pics as you go. This will put her at ease and give her an idea of what the final product will look like.*

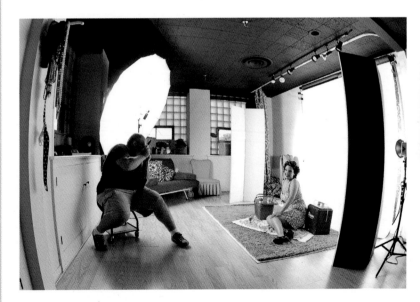

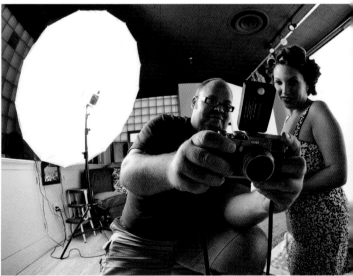

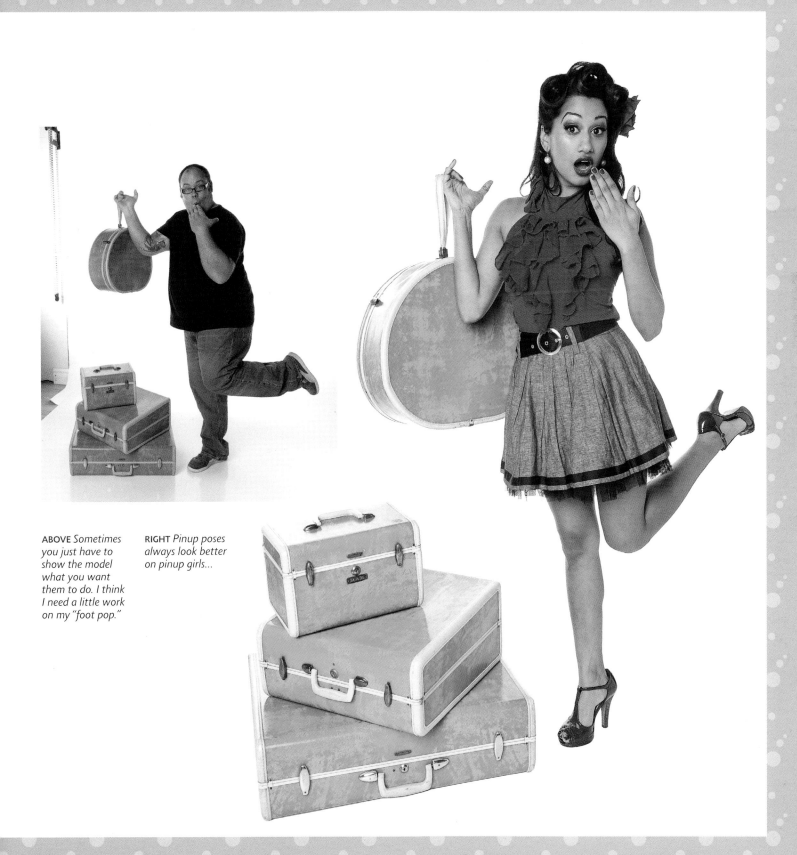

ABOVE *Sometimes you just have to show the model what you want them to do. I think I need a little work on my "foot pop."*

RIGHT *Pinup poses always look better on pinup girls...*

Your first pinup shoot

Every girl has what she thinks are "problem areas," but your role as the photographer is to make your model feel good about herself as a whole, rather than splitting it up into "good parts" and "bad parts." Most of the time your model will be having photos done for a significant other, so as well as asking her what features she likes the most about her body, ask her what their favorite features are as well. This is also a fun way to get to know your client and keep the conversation flowing.

However, my secret weapon in the studio is a great assistant. Having a fabulous assistant in the studio for all of my shoots helps make sure that small details are not overlooked. I'm normally focusing my camera on the model's face and clicking away, so I don't always notice that a toe isn't pointed, or a thread is hanging off of a dress, but my assistant, Britt, keeps an eye on all of that stuff for me. As a male photographer, I would say that it is vital to have a female assistant. Certainly I find that there are things that Britt can do or say to the client that I couldn't get away with—hooking garters for a client, for example. And by having a female assistant I avoid any "creepy male photographer" stereotypes, and my models really appreciate having another girl in the room. My assistant is also very good at being a total goof ball, which is great for creating the facial expressions I want the client to make.

BELOW LEFT *Some of the pinup poses can be difficult to pull off without a little help.*

BELOW *An assistant with humor helps. Sometimes you need your pinup girl to laugh!*

RIGHT *The biggest thing to remember when shooting your first pinup is to have lots of fun.*

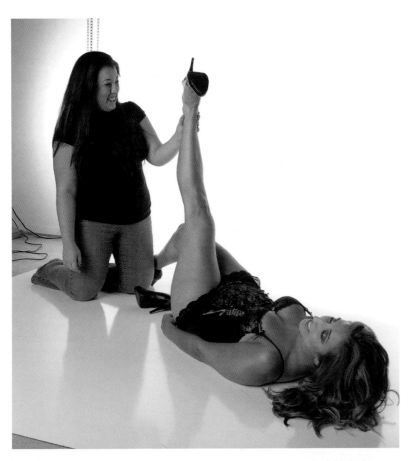

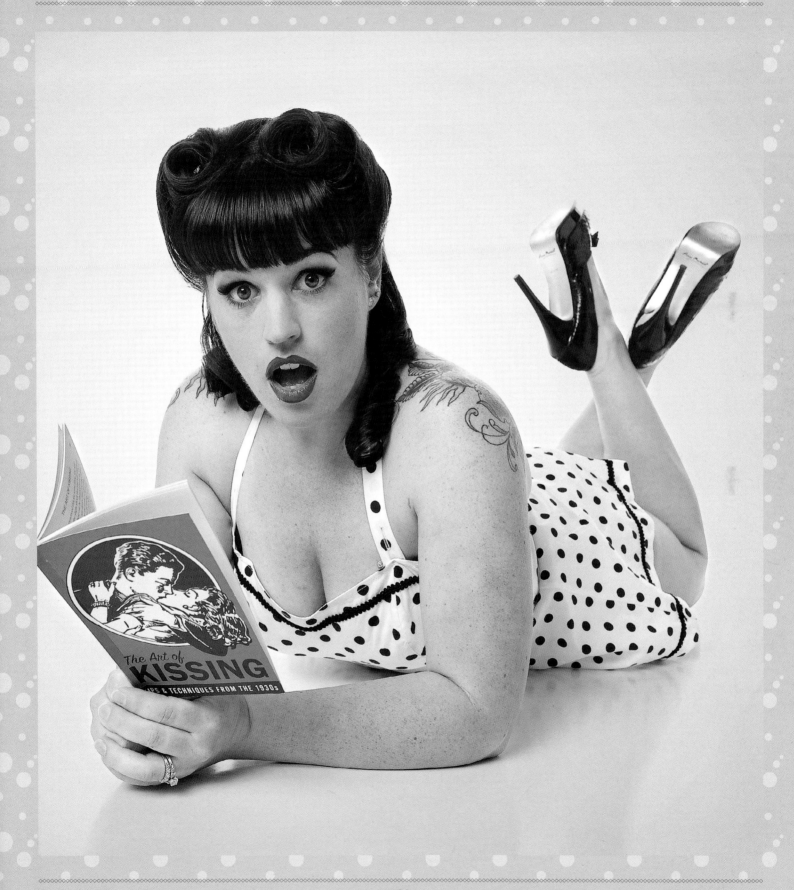

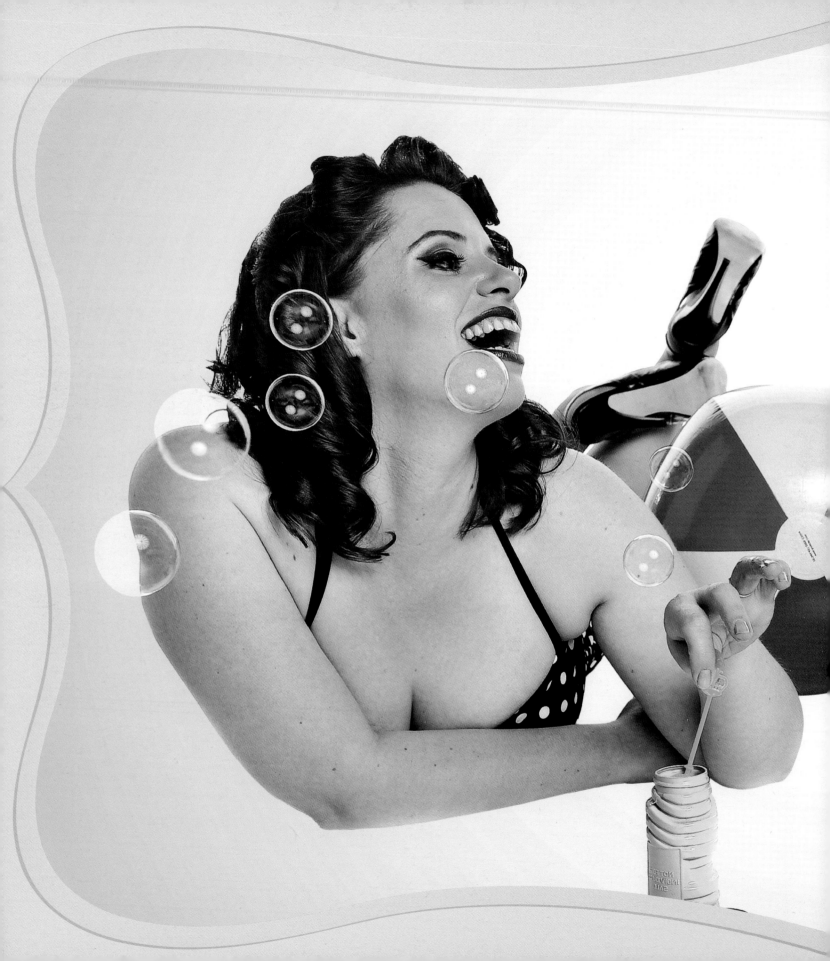

PHOTOGRAPHER'S

Pose Guide

Posing one model

MANY OF THE PINUP POSES we use at our studio are reminiscent of classic poses by the great pinup artists of years gone by. Gil Elvgren perfected most of the recognizable poses that are still used today while painting pinups in the mid 1930s to the 1970s. Elvgren always added a little humor to his photos, something I try to do as well. Many of his poses are just variations of another pose he came up with. By tweaking and making subtle adjustments, you can easily turn one pose into another.

POSE GUIDE
Pinup leg

THIS IS THE MOST basic pinup pose and the one that I will generally start with when I begin shooting, as it's so simple to do. This pose works with any outfit, but is far flirtier in a dress. The model should keep her toes pointed and one knee pulled over the other to create that much desired hourglass shape—this pose works great on curvier models. When taking photos of a girl lifting her dress, it's important for her to keep her knees together. Remember, you want classy, not trashy!

POSE GUIDE
The flirt

THIS IS ANOTHER simple pose that nearly every girl can do, and it mimics the old Elvgren pinup paintings where the girl gets her dress caught on something, causing her stockings to be exposed.
1. Your model's natural response in this situation would be shock and surprise, so you'll want to make sure her facial expression matches the pose.
2. By adding something as simple as a hand prop, you can transform your initial pose into something different and far more exciting.

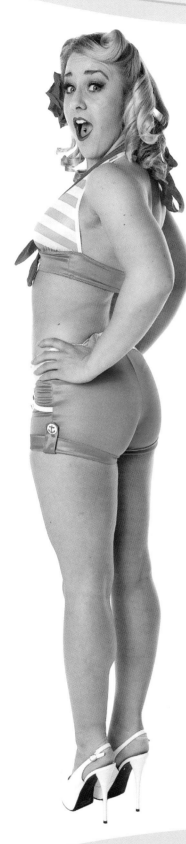

Tush push

THIS IS A GREAT pose for a girl who is a fan of her backside! The best wardrobe for this pose would be a cute vintage swimsuit or a pair of short shorts. The most important thing is to keep the negative space between her legs to a minimum—you want her legs locked and as straight as possible. Make sure your model arches her back for a little extra lift.

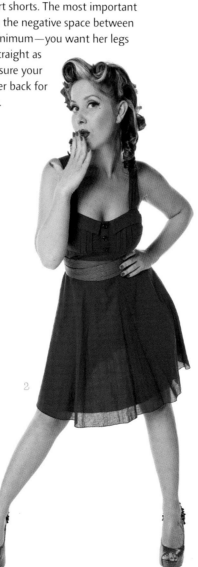

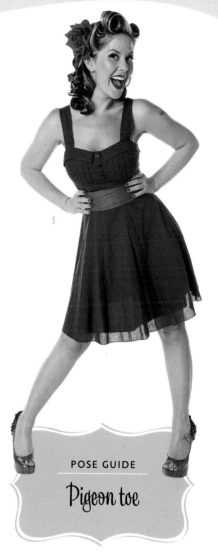

Pigeon toe

THIS IS ANOTHER really simple pose that you can use if your pinup girl isn't the most athletic, and it's great for girls who do not have naturally curvy pinup girl hips—with the right pose any girl can have that bombshell figure.

1. Have your model stand straight on to the camera with her feet about shoulder width apart.

2. You can add a lot of variation to this pose with different hand gestures—the difference between a pinup pose and a modern modeling pose is to have your model's hand(s) higher on the waist, rather than on the hips.

POSE GUIDE
Foot pop

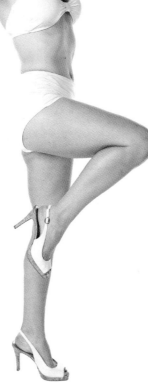

ANOTHER POSE for your pinups is the "foot pop," although it is a little more difficult for your model to keep balance while doing this pose correctly, so be quick! To help me get the shot, I have my model get the rest of her body positioned correctly, then pop her foot up when I'm ready to shoot.

Always have the leg closest to the camera as the one that is doing something fun, and remember to get your model to keep her toes pointed. If your model is having trouble picturing this pose when you explain it to her, just tell her to stand like a flamingo.

POSE GUIDE
On the shoulders

THIS IS A CLASSIC pose that you will see many times in old pinup paintings. However, I would have to give this a 10 on the difficulty scale; your model needs to be very flexible and athletic to pull off a pose like this. I've had a lot of girls do this pose in the studio and the first thing that happens is that all their blood rushes into their head, so you need to get the shot pretty quickly before this happens. Also, as your model will be concentrating on holding her legs up in the air it is easy for her to forget her facial expression—I always have her get the facial expression first, then throw her legs up in the air.

The advantage with this pose is that it can accentuate your model's legs. The model shown here is fairly short, but I wanted to make her legs look longer. Lying on the ground and photographing up at her gives the illusion that she has legs a mile long!

POSE GUIDE
Whale tail

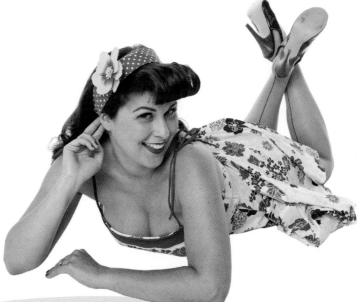

PERFECT FOR ANY body type, this pose works wonders when it comes to hiding what most women feel is the least favorite part of their body: their stomach. You'll want to make sure that she uses her arms to keep her upper body lifted, but without concealing her bust line. This pose is great if your model doesn't have much of a bust, as it will accentuate the cleavage, even if it isn't there. She can also be doing any number of things with her hands: playing with her hair, listening to records, sipping a milkshake, or putting on lipstick. It all works!

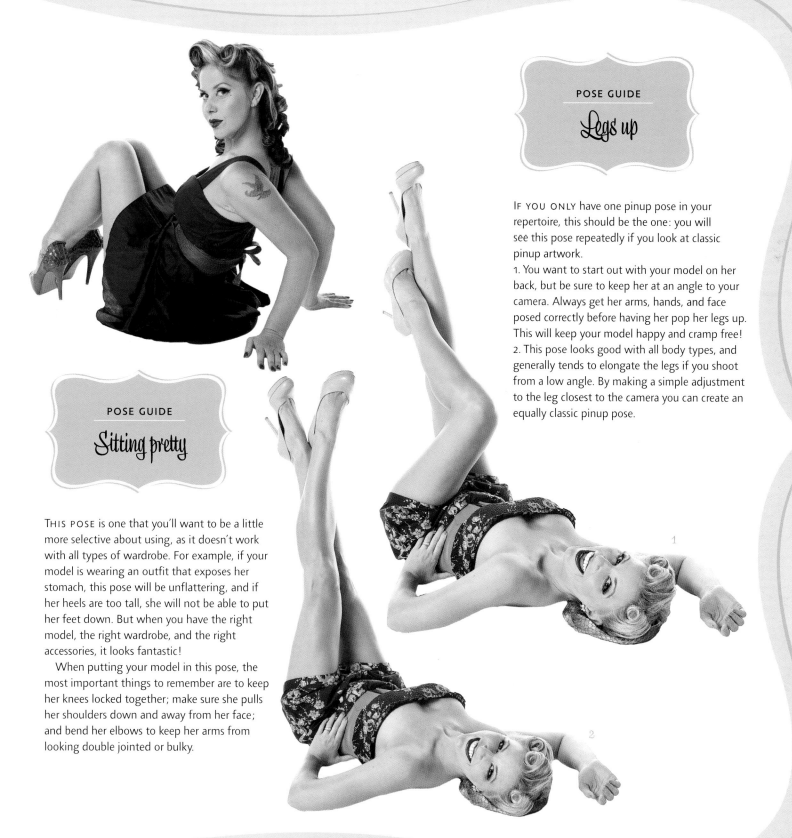

IF YOU ONLY have one pinup pose in your repertoire, this should be the one: you will see this pose repeatedly if you look at classic pinup artwork.

1. You want to start out with your model on her back, but be sure to keep her at an angle to your camera. Always get her arms, hands, and face posed correctly before having her pop her legs up. This will keep your model happy and cramp free!

2. This pose looks good with all body types, and generally tends to elongate the legs if you shoot from a low angle. By making a simple adjustment to the leg closest to the camera you can create an equally classic pinup pose.

POSE GUIDE

Sitting pretty

THIS POSE is one that you'll want to be a little more selective about using, as it doesn't work with all types of wardrobe. For example, if your model is wearing an outfit that exposes her stomach, this pose will be unflattering, and if her heels are too tall, she will not be able to put her feet down. But when you have the right model, the right wardrobe, and the right accessories, it looks fantastic!

When putting your model in this pose, the most important things to remember are to keep her knees locked together; make sure she pulls her shoulders down and away from her face; and bend her elbows to keep her arms from looking double jointed or bulky.

Posing with props

PROPS ARE A GREAT WAY to add a vintage feel to your pinup photography. They also add narrative to your photo. I always like to have my pinup girls "doing something." If you have a pinup girl who doesn't have as much experience in front of the camera, give her a prop so she has something to do. She can interact with the prop and not have to concentrate so much on everything else. Props will give her something to focus on other than herself. Props make great furniture, and furniture makes a great prop! Old chairs and drink coolers are always fantastic to shoot with.

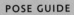

POSE GUIDE
Beach props

WHAT'S MORE FUN than a day in the sun? It's very simple to pull off a beach scene for your pinup model—all you really need are a few common items that you would normally take with you to the beach, such as beach balls, sunglasses, and sand toys. If you want to get really fancy, toss in an old surfboard. It's also fun to have your model interacting with something, maybe blowing bubbles, for example. The majority of the time, it's best to have the model lying down for these shots.

POSE GUIDE
Jiggle machine

THIS IS DEFINITELY one of the hardest props to find—for a few years I searched for one not knowing what it is actually called! As a matter of fact, I still don't know what it's called, so just call it the "jiggle machine."

Back in the day, some charlatan thought he could sell a weight loss machine that would "shake" the pounds off of you, but after failing to receive licensing, the idea was abandoned.

Some of the machines can still be found in antique malls and I was lucky enough to get one that still works. Most pinup girls that I shoot are not expecting it to turn on, so you can imagine what great facial expressions this leads to! This wouldn't be a prop I would recommend hunting for, as it is limited as far as posing goes, but if you do happen to find one in good shape, it's definitely worth getting.

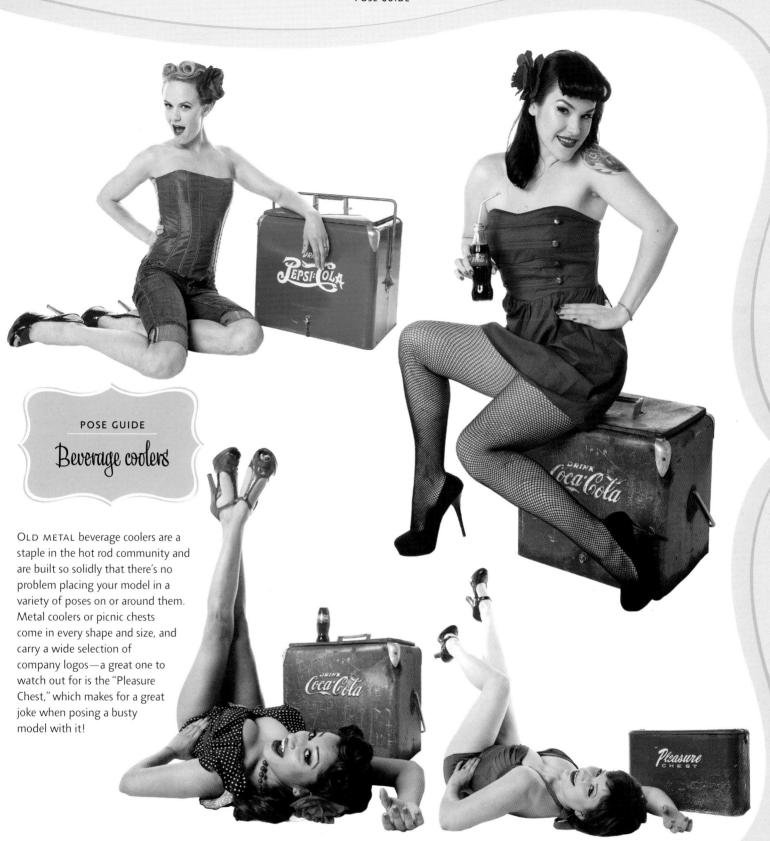

POSE GUIDE
Beverage coolers

OLD METAL beverage coolers are a staple in the hot rod community and are built so solidly that there's no problem placing your model in a variety of poses on or around them. Metal coolers or picnic chests come in every shape and size, and carry a wide selection of company logos—a great one to watch out for is the "Pleasure Chest," which makes for a great joke when posing a busty model with it!

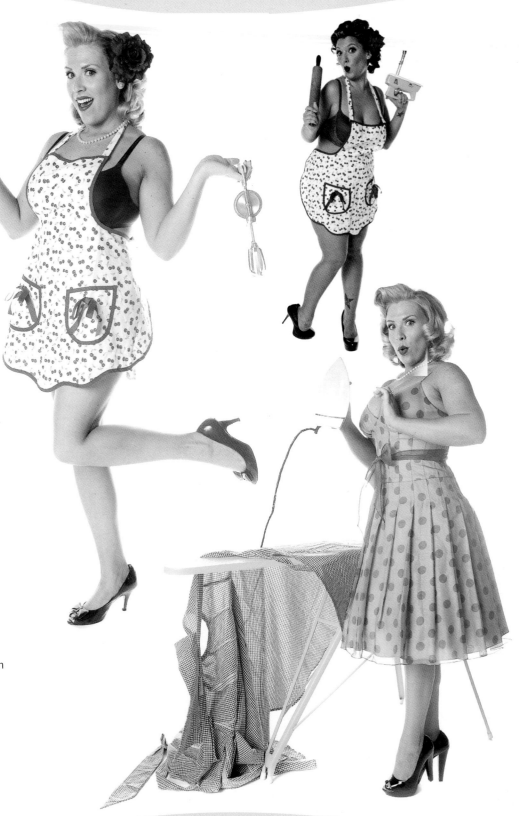

POSE GUIDE
Kitchen items

CONTINUING WITH the theme of household chores, I also use a variety of small kitchen items in my pinup shots, such as rolling pins, egg beaters, and old mixers, all of which are found readily at most antique malls. Vintage aprons are also an easy find, and if a model comes into the studio with a limited wardrobe, she can put an apron over her underwear and be an instant pinup girl!

POSE GUIDE
Ironing

SINCE THE LADY of the house did the majority of the housework in the 1950s, it's nice to pay homage to all of her hard work! One of her common chores would have been ironing her family's clothing. Old irons are very easy to find and will not set you back much money. Ironing boards are somewhat harder to source in good vintage condition though, as most of them are made of metal and tend to rust. I started out using a retro iron with a modern ironing board until I could find an old board in good shape.

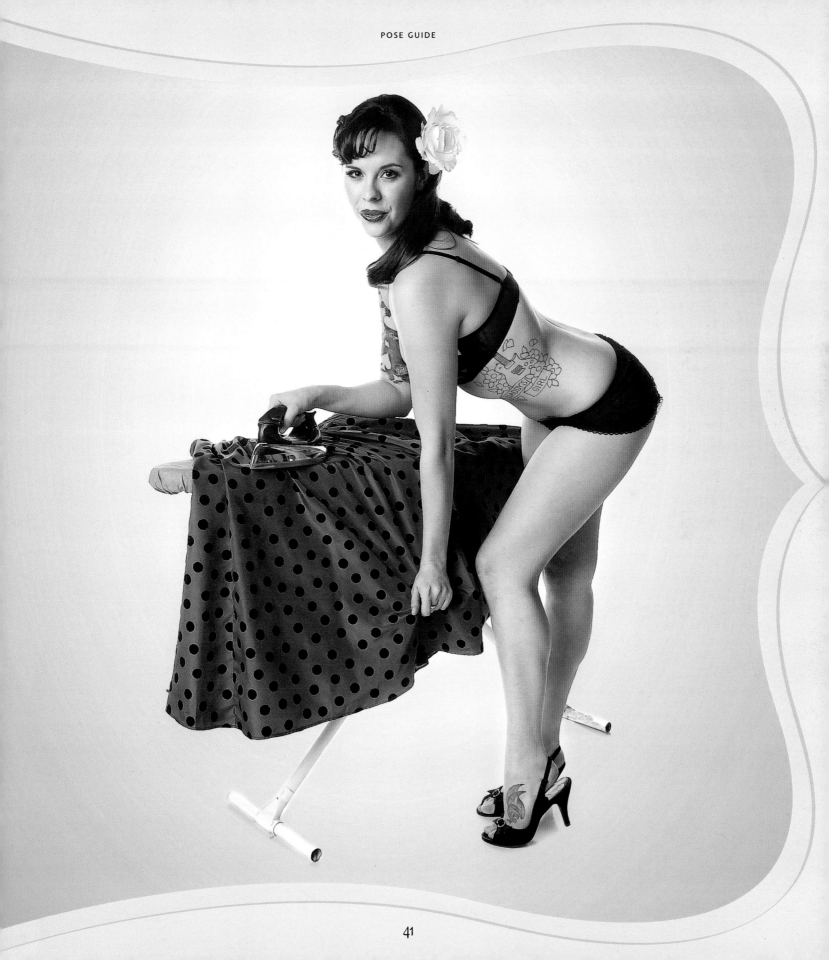

POSE GUIDE
Old telephone

OLD TELEPHONES are a very common item, since most families had at least one in their home in the past. They come in a variety of colors so one thing to consider is the phone's ability to match various outfits. Luckily, black was the most common color of phone produced, making it the easiest to find, and also the most cost effective.

When using a phone as a prop, I like to have the model twirl the cord, which gives her something to do with both of her hands. I also like to play out different phone conversations that she might be having, in order to get natural facial expressions.

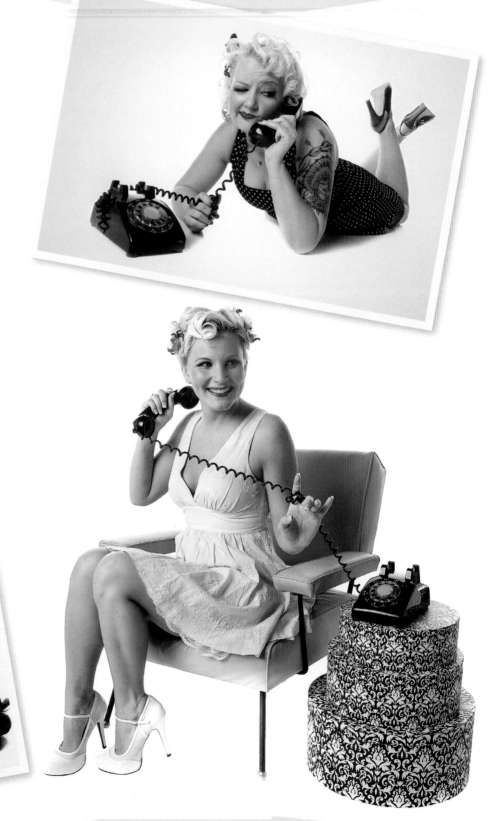

POSE GUIDE
Suitcases

VINTAGE SUITCASES are a dime a dozen and in a best-case scenario, you will discover a full set of matching suitcases in your granny's attic! I wasn't so lucky and found all four pieces in my collection at separate times and locations. The old, hard-side suitcases are sturdy enough to sit on without doing damage to them, and can be grouped in different configurations to accommodate girls of different heights. One thing I like to do with my suitcase props is to sit the girl inside one of them and scatter her clothes around her. This is a very fun pinup pose and with different sizes of suitcase, there's one for every shaped bottom!

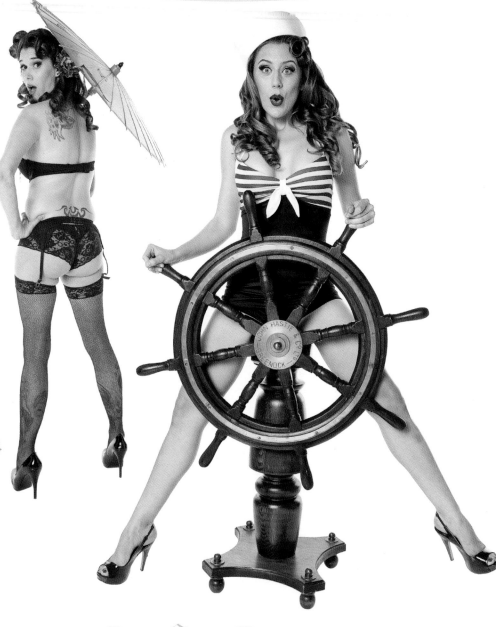

POSE GUIDE
Parasol

THE PARASOL has long been a staple in the pinup world and if you've ever attended a hot rod car show, you'll notice pinup girls carrying them to shade themselves from the sun. I like to use the parasol in the studio to give the illusion that the model is nude behind it. It can also be rested on her shoulder. This is another fun prop to use when your model has a limited wardrobe, as you won't be able to see what she's wearing behind it.

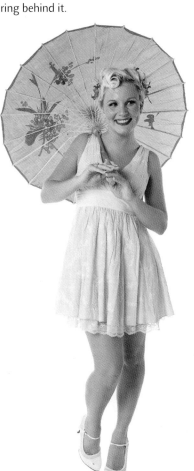

POSE GUIDE
Ship's wheel

MUCH LIKE the jiggle machine, a ship's wheel is one of the more difficult props to find. If you're lucky enough to find one that has been mounted on a stand, you can do more things with it, but make sure your model is wearing a naval or nautical-themed outfit!

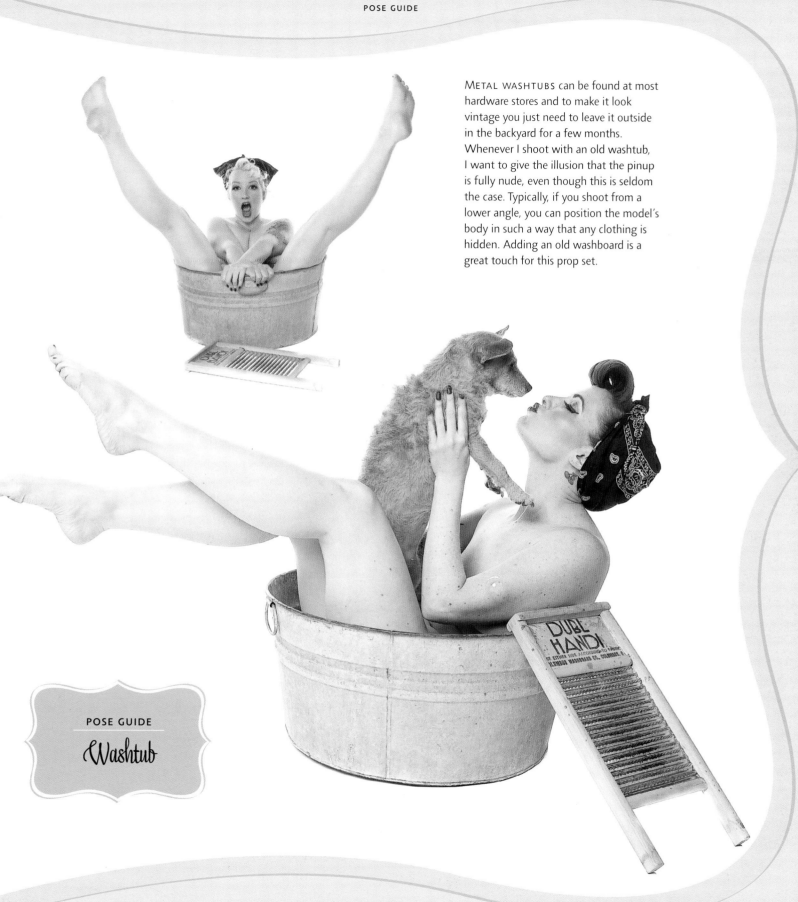

METAL WASHTUBS can be found at most hardware stores and to make it look vintage you just need to leave it outside in the backyard for a few months. Whenever I shoot with an old washtub, I want to give the illusion that the pinup is fully nude, even though this is seldom the case. Typically, if you shoot from a lower angle, you can position the model's body in such a way that any clothing is hidden. Adding an old washboard is a great touch for this prop set.

POSE GUIDE

Washtub

Posing two models

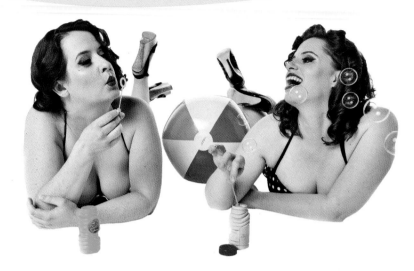

WHAT COULD BE BETTER than shooting a pinup girl? That's right, shooting two pinup girls! Since pinup photography should tell some sort of story, you are opening up a whole new bag of storylines by adding an additional model to your shots. There are so many fun and flirty ways to photograph the interactions of two pinup girls. Keep in mind though, now you have twice the posing and facial expressions to worry about. If one girl is making the perfect face, but the other girl is not, you'll have to reshoot it... The important thing is to have fun with it.

POSE GUIDE

A day at the beach

TWO PINUP GIRLS in bathing suits equals lots of fun. There is a number of things you can do to mimic a day at the beach, and something as simple as having one girl untie the other's bathing suit while she makes a surprised expression can create a fun photo. Other props can be worked in as long as they keep with the beach theme—try having two girls tossing a beach ball around or blowing bubbles to each other.

POSE GUIDE
Pinup girl photo shoot

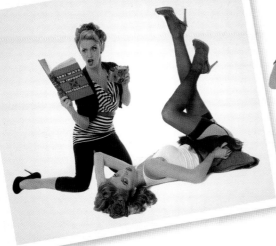

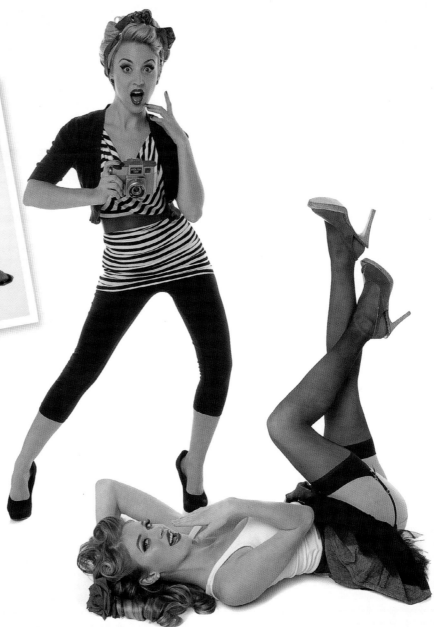

As a photographer, I have a collection of old cameras lying around the studio, so why not use one of these old cameras as a prop? You basically want to create the scenario that one pinup girl is doing a photo shoot of the other. Use any of the single model poses on your "subject," while the "photographer" strikes cute, exaggerated photographer stances. I also found a great vintage photography "how-to" book that I use as a prop to add a little something extra to this type of scene.

Keep it on ice

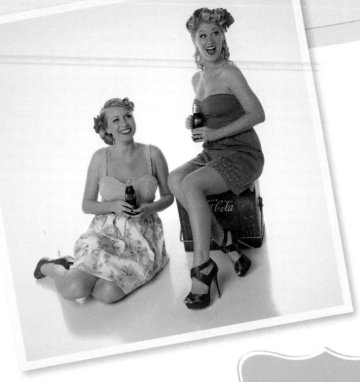

REMEMBER THOSE vintage beverage coolers I mentioned? Well, why not have two girls posing with one while enjoying a delicious, ice-cold beverage? If you are caught in a situation where your two models have a huge height difference, this is a great way to disguise the fact. Give them each a bottle and have your assistant do something funny off camera to get both the girls laughing—this one is all about fun!

Vroom vroom!

I REALIZE THAT not everyone has an awesome vintage motorcycle to use as a prop, but if you do it works fantastically with two girls. This is not a typical prop that most people would expect to see in a photography studio, so when they do, it generally inspires a lot of great poses and outrageous facial expressions—you could have the girl on the back stand up on the motorcycle, or have both girls leaning back as if they are making a quick getaway!

CORSETS ARE anything but easy to get into and, in the past, people would often joke about how one girl would put her knee in the back of the other to get the laces tight. So, if your girls come to the studio with corsets, why not recreate this scene? Get the girl doing the lacing to give a firm tug and you'll get a natural facial expression out of them both.

TWO PINUP girls having a picnic is the perfect time to break out any food related props you might have and arrange them on a vintage tablecloth with, of course, a picnic basket. Shooting this scene with two girls is great because they can engage each other with fun expressions and conversation for naturally candid photos.

Burlesque

OVER THE PAST FEW YEARS, burlesque has come back into vogue. Growing in popularity at a startling rate, burlesque troupes can be found in nearly every major city, with housewives and soccer moms now familiar with the art of burlesque. Many of the classic burlesque poses are similar to pinup poses, but they tend to be slightly more dramatic and exaggerated: if pinup is silly, then burlesque is sultry.

POSE GUIDE

Backgrounds

BURLESQUE PERFORMERS typically do their shows on a stage, so I always try to emulate this setting in the studio. A great way to do this is with a velvet or silk curtain—red always works. Another background option would be colorful tinsel curtains from a party supply store. When lighting the scene, be sure to make it dramatic, with lots of shadows to help give you an "on stage" look.

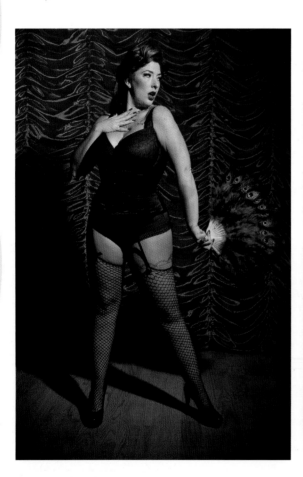
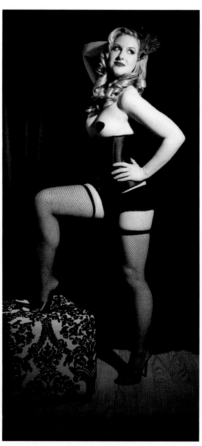
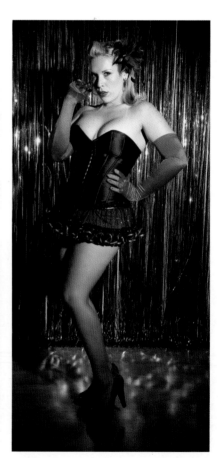

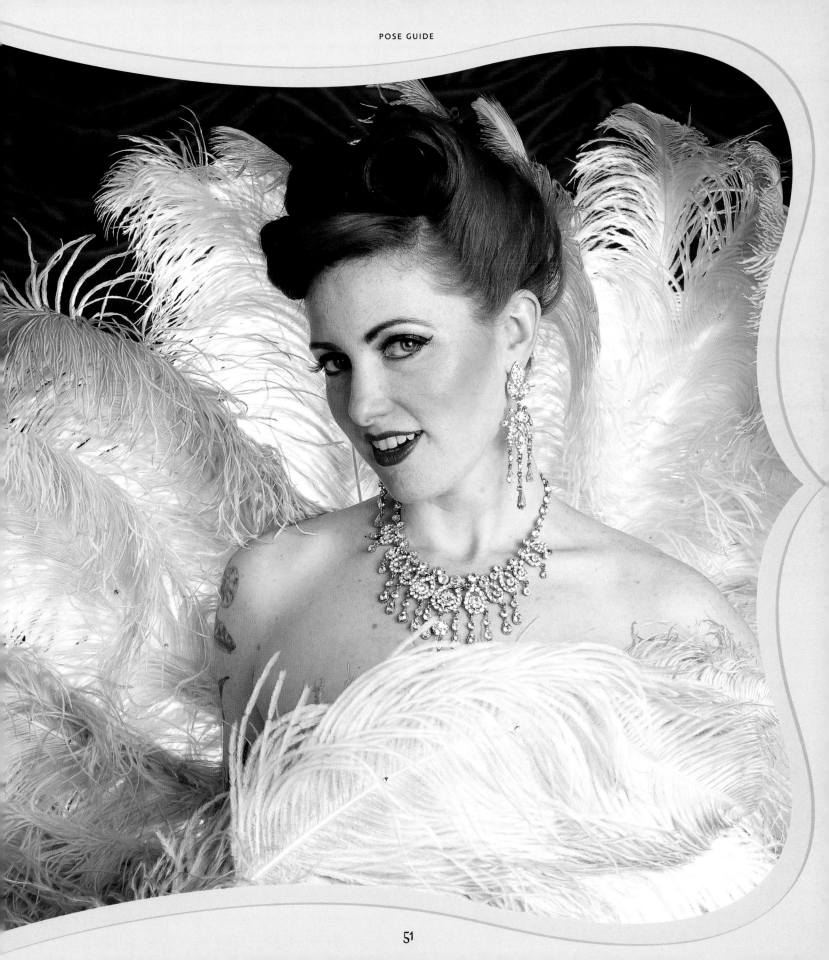

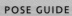

POSE GUIDE
Fans

YOU CAN'T TALK about burlesque without mentioning fans. Huge ostrich feather fans have long been a staple of burlesque performers and they make a great prop to have on hand in the studio. If a girl comes in with a burlesque outfit, toss her some huge fans and you instantly have a great photo. There are many classic burlesque poses that work with fans, but the whole idea is to slowly reveal parts of your body; it's all about the tease. It's important to keep the legs in a classic performer's stance—place one knee over the other while keeping the toe pointed.

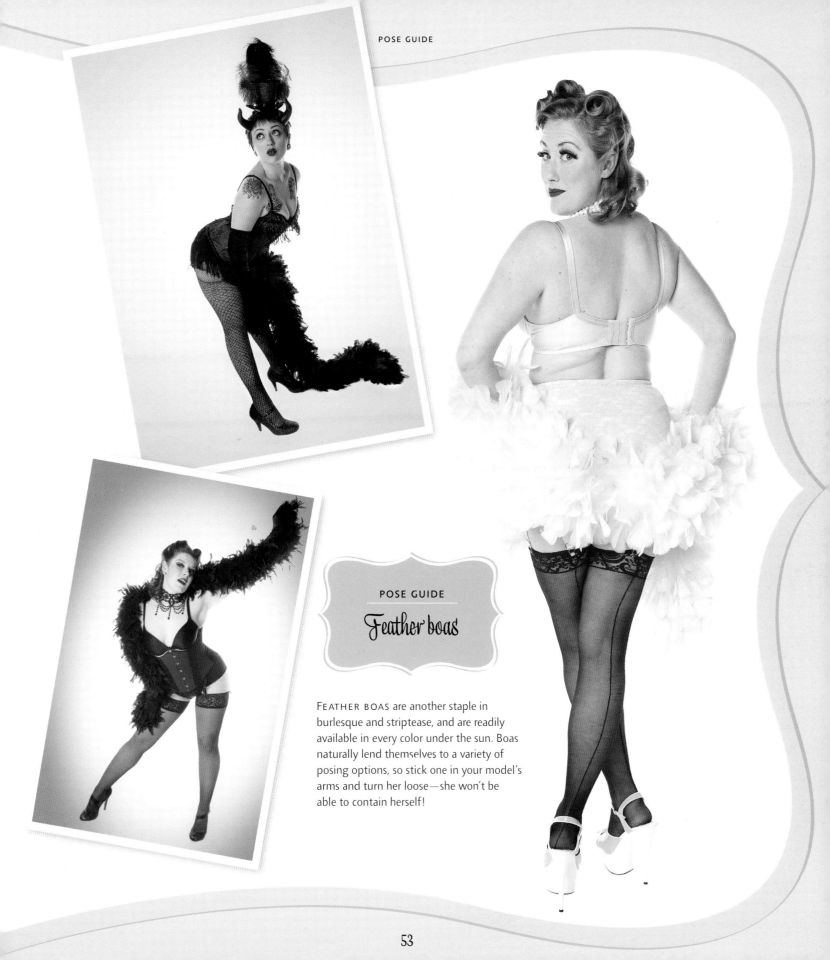

POSE GUIDE
Feather boas

FEATHER BOAS are another staple in burlesque and striptease, and are readily available in every color under the sun. Boas naturally lend themselves to a variety of posing options, so stick one in your model's arms and turn her loose—she won't be able to contain herself!

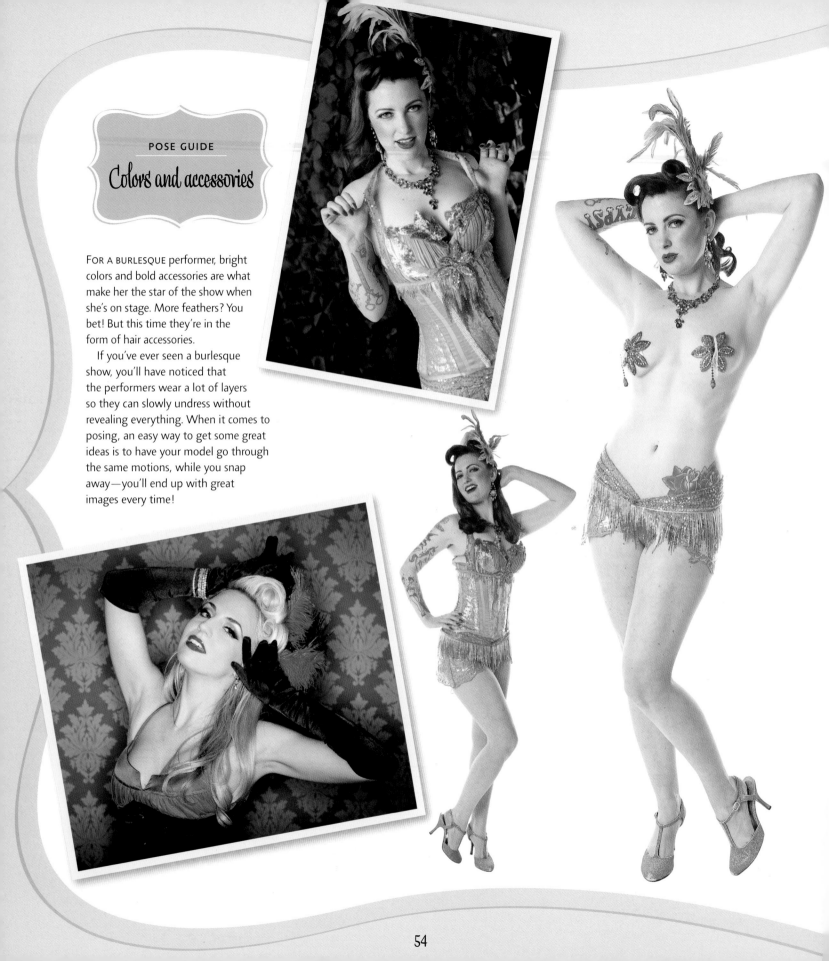

Colors and accessories

FOR A BURLESQUE performer, bright colors and bold accessories are what make her the star of the show when she's on stage. More feathers? You bet! But this time they're in the form of hair accessories.

If you've ever seen a burlesque show, you'll have noticed that the performers wear a lot of layers so they can slowly undress without revealing everything. When it comes to posing, an easy way to get some great ideas is to have your model go through the same motions, while you snap away—you'll end up with great images every time!

POSE GUIDE
The group shot

I'VE NEVER BEEN to a burlesque performance that has only had one girl, so if you're offering burlesque photography in your studio you should expect to get a few groups from time to time. Normally, I just turn them loose in front of the camera—they are performers, after all! Let them do their thing and ham it up, and you will find that you almost never need to direct a burlesque group.

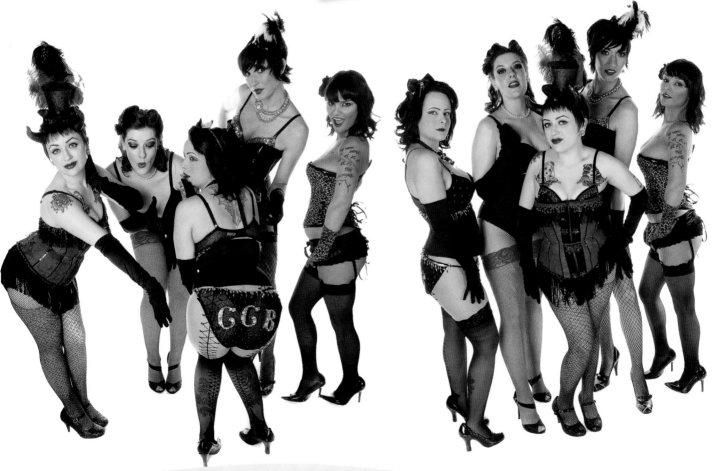

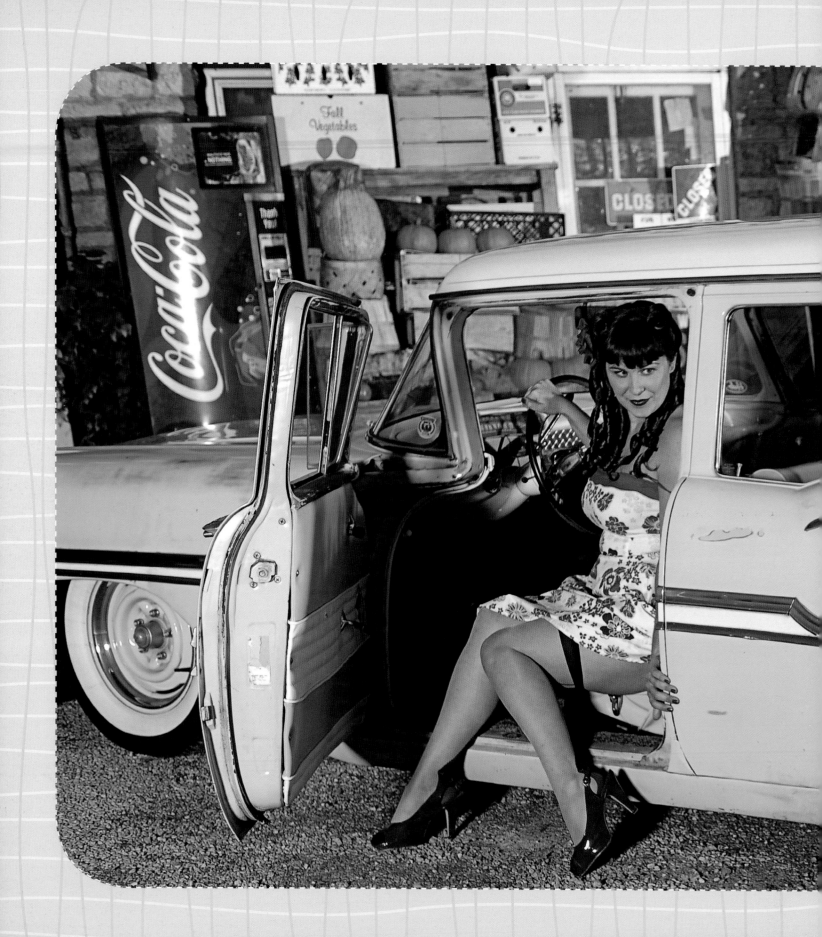

Pinups on location

Finding a location

WHENEVER I HAVE THE CHANCE, I try to get out of the studio because location shoots are always so much fun. However, you can't just shoot anywhere, as you'll be trying to capture a vintage pinup girl "in her environment." Because of this you need to consider many things when you are scouting for a pinup location.

First and foremost, does your location fit the time period you're going for? It would be impossible to shoot a 1950s' style pinup photo in front of a modern building, which is why I always find myself in downtown areas, or way out in the country—pretty much everything in between is of no use to me. I also love to visit small rural towns, as many of them (in my local area, at least) still have the old town square and a nostalgic charm. If this proves problematic, then one simple solution is to find a location free of any objects that might otherwise "date" the scene. You can shoot a picnic pinup in the middle of a city park if you want to—they had the exact same grass back in the 1950s.

Another thing to consider when choosing your location is the overall traffic of the area. By this, I mean who will be around when it's time to shoot? I once found a great location on a fairly busy street. I set the shot up and brought my pinup girl in, but quickly found that every car that went by had something they needed to yell out of the window. This can quickly make your model uneasy, so since then I've always tried to find locations that are a little more off the beaten track so I can get as close to a "closed" set as I can.

Lighting is another thing to consider when shooting on location. Will you be shooting during the day, or at night? Shooting at night can work to your benefit, as you can control 100% of the light in your scene. If you find a striking location surrounded by modern elements or other objects that might ruin or clutter your photo, then shooting at night allows you to light only what you want to include in your photo.

If you are shooting during daylight hours then you need to figure out the direction of the sun at the time you will be shooting. No matter what kind of lighting you're using, the sun will always win! You also don't want your pinup girl to melt from the heat or be squinting into the sun, so it's always best to find an area of shade for your model. I always try to use the sun to light the background of the shot, and then light the model and other key elements with strobes.

RIGHT *For this shoot, I opted for a very simple patch of grass in a local park. Nothing modern in this shot.*

LOCATION IS EVERYTHING!

It is amazing what a little bit of creative lighting can do for a location. Sometimes great locations are in not-so-great areas.

BEFORE

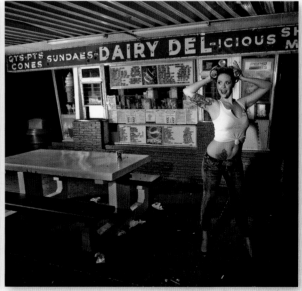

AFTER

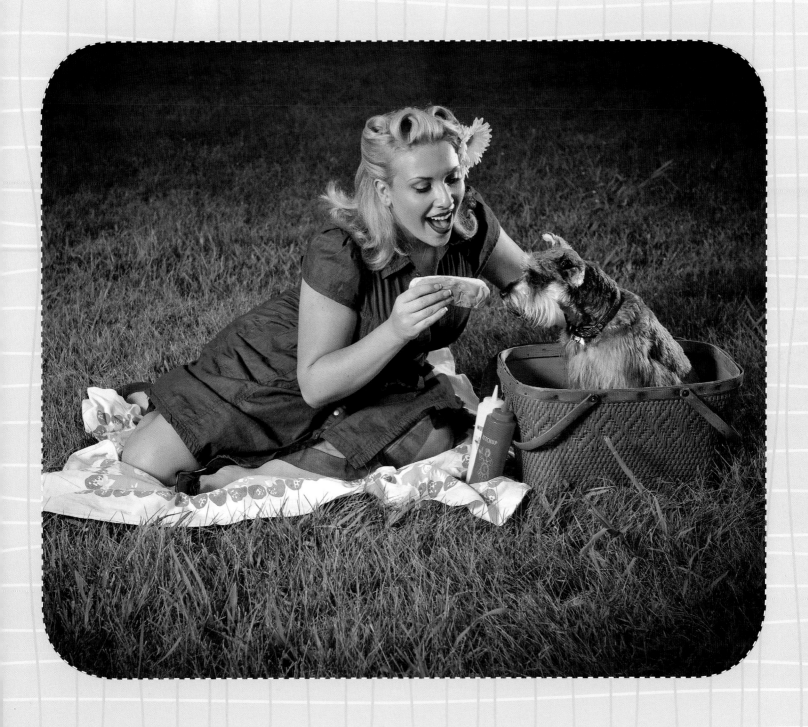

Hot rods & automobiles

WHAT'S THE BEST PROP you could possibly use for a classic pinup girl photo shoot? If you answered "a great classic car" then you would be correct, because pinup girls and hot rods go hand in hand!

First off, you need to find a car to use, and I've had great luck at classic car shows and hot rod club gatherings (and have always loved going to these type of events anyway). Car shows are basically a huge buffet of cars, and the owners are very proud of what they've done in regards to the restoration or customization of their autos. Everyone I've met seems to be very interested in what I'm doing—I'm asking them if I can shoot a tasteful pinup girl portrait with their car in the background. Every guy wants a professional print of their car hanging in their garage to show their buddies, so I've never been told no. It's like shooting fish in a barrel.

While at the show, walk around and take some time to look at the cars. Keep in mind the girl that you will be photographing, and look for potentially suitable cars—I tend to shoot rockabilly, tattooed pinup girls with "rat rod" style cars, while I'll usually photograph girls without tattoos when I find an all-original, totally restored car. But this is just my preference.

When you find one you'd like to use in your shots, go up to the owner and talk to him about his car. Ask if he has ever had photos taken of his car before and give him a brief rundown of what you would like to use his car for. I always have a few samples of my work to show off during conversation, and I also explain to them that I carry insurance, just in case anything were to go wrong...

When using an automobile in your shoot, there are a few things you should know to make sure your shoot goes smoothly. I would say the biggest thing you want to make sure you do is to protect that car at all costs. The owner worked very hard to restore or customize the car, and would probably be quite upset if something were to happen to it.

When posing your pinup girl, always have her stand at least six inches away from the car—even in shots where it appears that the girl is leaning on the car, she is actually a few inches away from that beautiful paint job. Many outfits have metal or other items that could scratch the car, and the rivets on denim jeans are notorious for tearing up a car's paint job.

Another popular pose involves the pinup girl lying on the front seat of the car, with her legs in the air. This creates all kinds of problems. Nine times out of ten, your model will be wearing high heels. These can tear up the headliner fabric of the roof of the car, as well as scratching the dashboard, so I always have the girl take off her shoes when she get into the car. My assistant then helps her into the pose I want to shoot and then she puts the model's shoes back on.

When it comes to photography, hot rods can have lots of chrome and very shiny paint, so when you place your lights, be sure to keep them to the sides to limit the number of "hot spots" that appear. Another trick is to use a polarizing filter on your camera, which will help decrease the unwanted reflections on the metallic surfaces of the car. You also want to make sure you keep yourself out of the reflections in the chrome—nobody wants to see the photographer in the photo!

RIGHT INSET *Local car clubs are great places to find hot rods for your photo shoots.*

RIGHT *It's always great when you find a car that looks as good on the inside as it does on the outside.*

DON'T RUIN A CAR'S SNAZZY PAINT JOB WITH YOUR STUDIO STROBES

One of the biggest challenges when lighting a car is making sure your lights aren't adding a big bright spot on the car. This is easily taken care of with Photoshop.

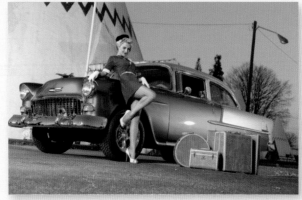
BEFORE

AFTER

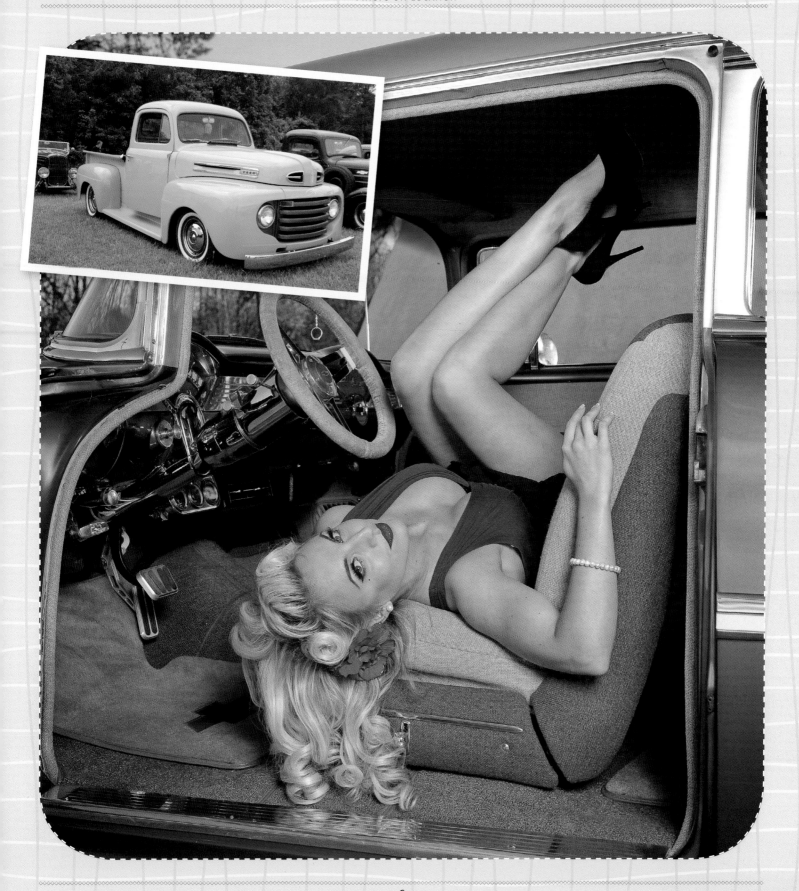

Models

LOCATION SHOOTS are my absolute favorite. It's always fun to get out of the studio and I love the challenges these shoots bring. When everything falls into place, they always end up being fantastic. One of the most important aspects of a location shoot, other than the location, is your model: a fun model will always give you better photos when you're out and about.

Many location shoots are undertaken in less than ideal situations. No matter how good you are as a photographer, or how well you plan your shoot, you have no control over some aspects of the environment, so you want to be sure that your model is easy going. If you're outside and it starts to rain, or the wind is blowing her hair around, it's always nice to have a model that can laugh that sort of thing off. I have often achieved great shots with a relaxed model in challenging situations, which may not have worked out so well with a "diva." In the photo on the facing page, for example, it rained and we had to wait for a break in the rain and thunderstorms to grab our shots, but I think the raindrops on the car actually add to the picture.

As a rule of thumb, I never photograph a model for the first time on location. Every girl I've shot on location started out as a client in the studio. Whenever I find a client that has the look I want for a particular location, I always size her up. If we had fun in the studio, I will ask her to go on location at a later date for a photo shoot. Clients are always flattered when you ask them to model for another of your photo shoots, which I believe is why they give it 100% during the shoot. As a result, I hardly ever use working models for my location shoots, and find that your "everyday girl" has more fun, and takes direction better than a professional model. This makes your life as a photographer a lot easier.

For the best results, you want to make sure that you pair the right girl with the right location. For example, I had a very over-the-top and fun client in the studio. Her personality was so infectious and her posing so exaggerated, I knew that I wanted to use her for a bumper car carnival shoot. This often happens when I'm shooting in the studio—if the girl I'm shooting is giving me great facial expressions and poses, I instantly start thinking about location shoots!

THE PERFECT MODEL MAKES FOR A FUN PHOTO SHOOT

We tend to use clients that were a lot of fun in the studio instead of professional models for our on-location shoots. If they were fun in studio, they tend to be even more fun on location.

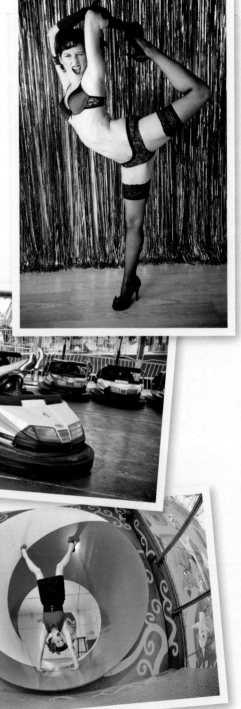

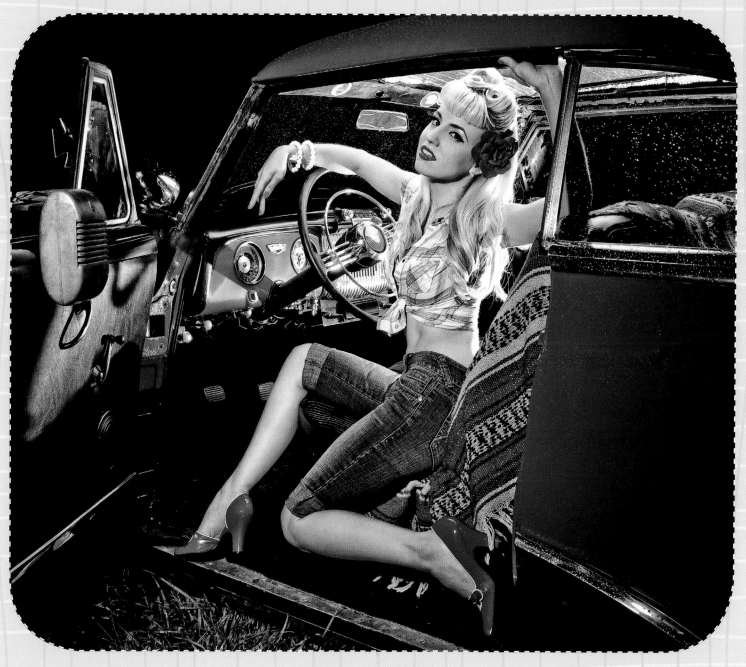

ABOVE *As you can see by the raindrops on the car window, sometimes the weather doesn't cooperate. It's always nice to have a girl that can have fun in any situation.*

Equipment for location shooting

I SPEND A LOT OF TIME scouting locations and finding the right elements to include in location shoots, but the best way to make sure you have a good time while out on location is to be prepared. There is nothing worse than arriving at a location—sometimes after traveling hours to get there—only to find that you've forgotten something. The first thing you start to do is panic; then you go into compromise mode and instead of shooting your original concept, you end up settling on something else. But if you are prepared, you can get the shot you wanted to start with—no compromise.

I have a huge rolling camera case that holds all of my equipment for a location shoot. This thing is big enough to carry everything I might need when I'm shooting away from the studio and I highly recommend you invest in something similar. Since I shoot with three strobes in the studio most of the time, I will normally travel with three strobes as well. Occasionally, I will bring a few extra strobes, but generally three is all I need to light just about everything I shoot. Since I am bringing strobes, I also need all the items that will allow me to use them out in the field, including a few big battery packs to power them as many locations do not have power, or power would not be convenient to obtain. If I do find a power outlet that I can safely use power

from, I use a heavy-duty extension cord that I keep in the back of our car, but be sure to bring all of the power cords for your strobes as well.

With the power under control, it's time to figure out how you want to modify your light. Most light modifiers are very large and bulky, but I found a company that makes double-fold umbrellas that fold down to a very small size, so I carry two silver-lined, black-backed umbrellas, as well as two white shoot-through umbrellas. Also included in my bag is an assortment of grids, which take up very little space and are a great way to light a specific part of a scene, as well as a set of standard reflector dishes.

Strobes are great for location shooting, but you can't just place them on the ground; you need a sturdy set of light stands as well. I always use air-cushioned stands to prevent the strobe crashing down if the stand is loosened without being held. This would usually break the delicate flash bulb in your strobe, and possibly end your shoot.

You will also need a way to trigger your strobes, and I use the same wireless triggers I use in the studio, taking three receivers and two transmitters on location. I wouldn't recommend using a sync cord to "hard wire" the camera to your strobes as this will invariably end up being a huge trip hazard.

ADDITIONAL KIT

In addition to essential camera and lighting equipment, I also pack a few items that are equally important:

❋ I shoot a lot of behind-the-scenes videos, so I always keep a shoulder rest for the camera, as well as a small stabilizer system.

❋ An LED headlamp will make your life much easier when shooting at night, keeping your hands free.

❋ A first aid kit is always a good idea—you never know when your pinup girl will take a spill in her high heels.

❋ Snacks and drinks make everyone comfortable. It doesn't have to be too extravagant—I keep granola bars and water on hand.

❋ Trash bags can really come in handy—they can be used to cover equipment if it starts to rain, as well as for actually cleaning up after you're done.

❋ You can never have enough extra batteries so take plenty of spares for your camera, wireless triggers, and anything else that needs them.

❋ Gaffer tape and Velcro straps are great for securing items on set.

❋ Since all of my strobes use the same flashbulb, I keep a spare with me at all times.

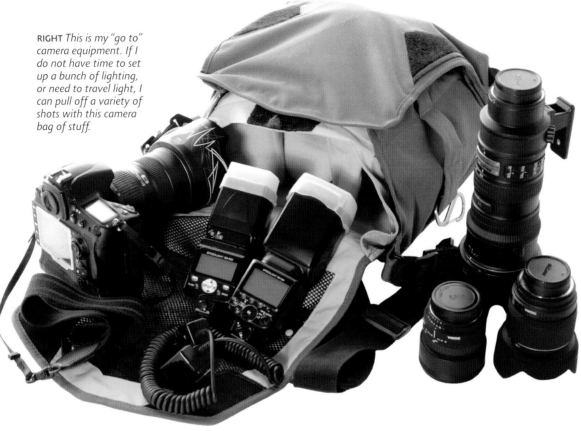

RIGHT *This is my "go to" camera equipment. If I do not have time to set up a bunch of lighting, or need to travel light, I can pull off a variety of shots with this camera bag of stuff.*

BELOW *A solid equipment case is a must. I LOVE my Think Tank Logistics Manager.*

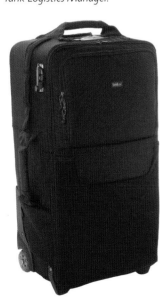

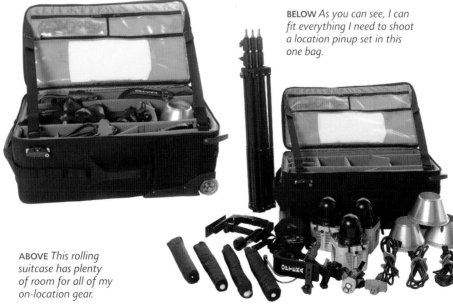

BELOW *As you can see, I can fit everything I need to shoot a location pinup set in this one bag.*

ABOVE *This rolling suitcase has plenty of room for all of my on-location gear.*

Setting up

Now that you have your location, your model, and your fabulous hot rod, it's time to set up the shot. This is the fun part, as all of the hard work in preparing for the shoot is behind you—if you made good decisions during your preparation, the shoot will be a piece of cake!

I always approach a shoot as a "layering" process. I start with the largest elements of the shoot and work down to the fine details. I then do the same with my lighting and equipment.

First, I figure out what aspects of the location I want to use in the shot. I want to be sure to use whatever makes this location stand out. If this is a location that other photographers have shot previously, then I need to be especially careful to find a unique angle to shoot it from. It is also important to make sure any modern day items are out of shot. After I decide on an angle to shoot, I position the car (if I'm using one). Since this is the largest movable item in shot, I want to make sure I get it placed just right. Make sure not to block key elements of your background and check the reflections of the car's chrome and shiny paint—is there anything modern that is reflecting back? If there is, a slight angle adjustment is all it takes to fix this.

Next comes the model. Get her positioned in the scene you are creating, but explain to her that you are just getting everything into place so she can relax. Get her into the general area she will be posing in for the shot and give her any props that might be used during shooting.

Finally, set up your lighting. I always start with the background and work my way to the model. Most of the time I use ambient or available light to light the background, unless I'm shooting in total darkness. Once you have your background lighting set, move on to the car and model. As mentioned earlier, lighting a car takes a little finesse so this will probably take up most of your set-up time.

Once everything's set, you're ready to shoot, and this is when you need to remember to have fun. If you over-work your model, she won't enjoy herself, and if you keep the car's owner on set too long, he won't have fun, so let people know what they need to do, but don't be overly dramatic about it—just take a few deep breaths and snap away.

RIGHT INSET *Shooting from a low position gives the illusion of longer legs. It also makes the car really stand out.*

RIGHT *Sometimes, the shots taken while goofing off turn out to be keepers!*

THINK OF YOUR SHOT AS A LAYERING PROCESS

When I set up a location shot, I always build in layers starting with the largest objects first. Once I have all the key elements in position, I place my model and begin setting up my lights.

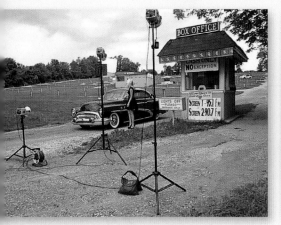
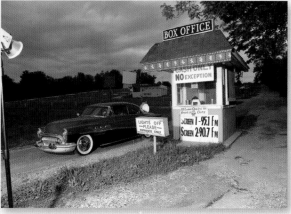
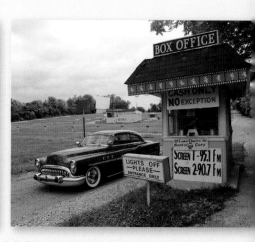

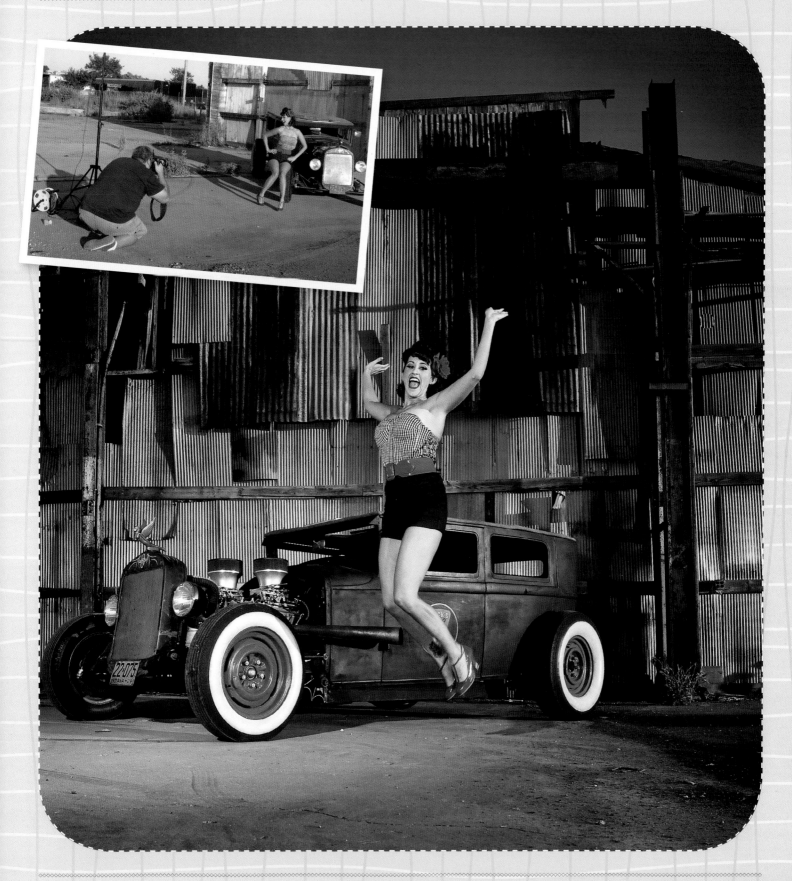

Setting up

IMAGINE A PHOTO SHOOT with the best pinup model in the world: she's dressed to kill, her hair and makeup are perfect, and her wardrobe is accurate for the time period. Now, imagine she's standing on a busy street corner with brand new, late model cars on the street behind her—your whole image is ruined!

It doesn't matter how much time you spend making sure you have the perfect location or model if you totally neglect the small details. If you're trying to shoot a 1950s' style pinup at a gas station, for example, it may well be that the building and gas pumps are period accurate, but what type of signage is on display? Are the signs advertising products that didn't exist in the past? Other technologies can get in your way as well. Utility poles always seem to end up right in the middle of a scene I am trying to capture, and while small things like this can be taken care of in post-production, it's always better to get it right in camera if you can.

The more elements you have in shot, the more things you need to watch out for. When you first start shooting on location I would recommend that you find a spot out in the countryside to shoot. When there are few distractions in the shot, you can concentrate on getting your lighting correct—as well as practicing your interaction with your model—without worrying about the little details required for a period-accurate shoot.

Most times it's pretty difficult not to have some modern items in your location shots. It doesn't matter how hard you try, how much planning you do, or how creative you get with your shooting angles, it's unavoidable, simply because locations from the past are slowly disappearing to make room for newer buildings. However, this doesn't mean that period locations don't exist. Hop in your car, take a drive, and look out for locations you'd like to use. When you see something with potential, take a few shots and review them when you get home—does everything look period correct? If not, can it be resolved somehow?

RIGHT *Nothing ruins a retro pinup photo shoot quicker than a Toyota Camry. Modern street signs just do not fit into the vintage feeling of this photo.*

MAKE SURE YOUR LOCATION IS PERIOD ACCURATE

Many of the great locations from the 1950s are being torn down. I like to think that by using these locations, I am somehow preserving them. Finding the right location is everything in my opinion.

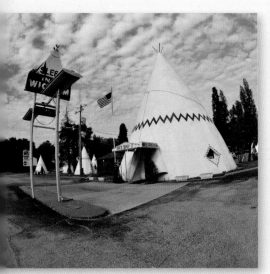

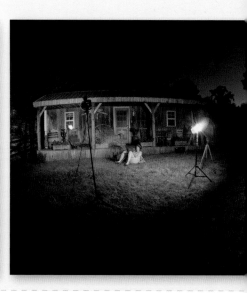

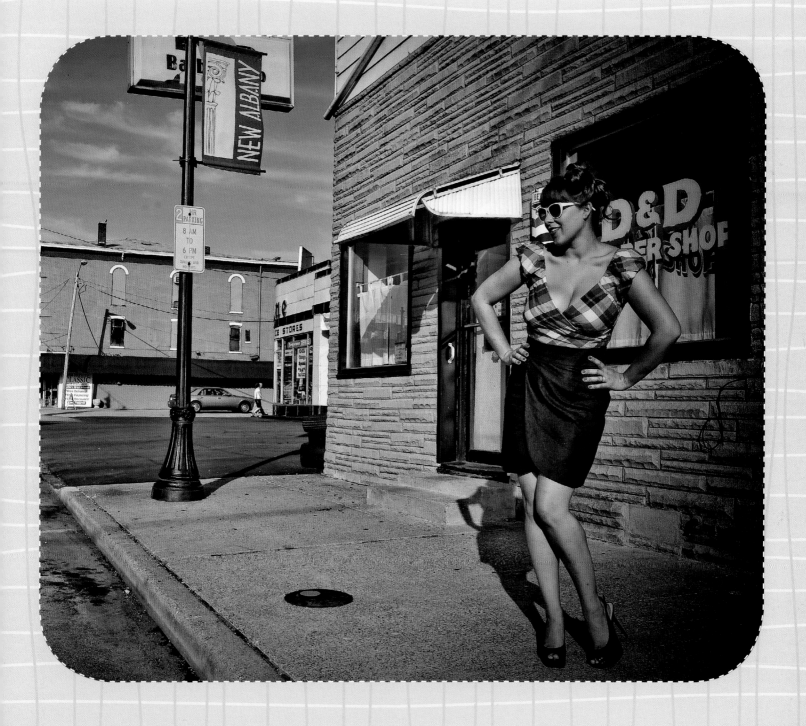

Turning day into night

T's GREAT TO SHOOT on location at nighttime, or at sunset, but for many reasons—model/staff schedules or location restrictions, for instance—this isn't always possible. However, with just a few simple adjustments you can use your camera settings to turn day into night, and give your photos a little added drama.

Shown here is a photograph, shot using my camera's Full Auto mode. Straight out of the camera it's a pretty boring, shot, but it doesn't take much to make it look a little more interesting. Probably the easiest way to add a little moodiness to your images is to use a technique "high speed sync" flash. For this, you will need to put away your studio strobes and break out the portable camera flashes that you'd normally fit to your camera's hotshoe.

The first thing you need to do is determine if your camera and flash units actually support this feature, as high speed sync will only work with dedicated TTL systems; Canon calls it "High Speed Sync," while Nikon calls it "Auto FP High Speed Sync."

After activating this feature, you need to determine the aperture and shutter speed to use. To do this, I put my camera into Full Auto mode—yes, you read right, Full Auto—and take a shot of the scene I want to photograph. I take a note of the settings, switch my camera into Manual mode, and apply the aperture and shutter speed settings used for the Full Auto picture.

Next, I increase my shutter speed by three to four stops (from 1/60 sec to 1/500 or 1/1000 sec, for example), which will darken the sky significantly. I'll make a few test shots to determine the precise shutter speed I want to use, and when I get the dramatic look I want for the sky, it's time to light my model.

Since daylight is usually bright, you'll need to have your flash(es) set to quite a high power output; I normally end up with the flash set to full or half power. Make adjustments to your flash power, or adjust the flash to subject distance until your subject is exposed correctly. The result is a well-exposed model in a brooding, nocturnal landscape.

AS A PHOTOGRAPHER, YOU CONTROL THE LIGHT

Many times, you will find a location that you want to shoot, but you are required for whatever reason to shoot it at a certain time. As a photographer, you can control what your final image looks like by using creative lighting. Now there is no reason to stay up past your bedtime to get the perfect shot.

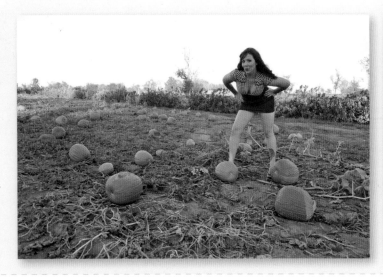

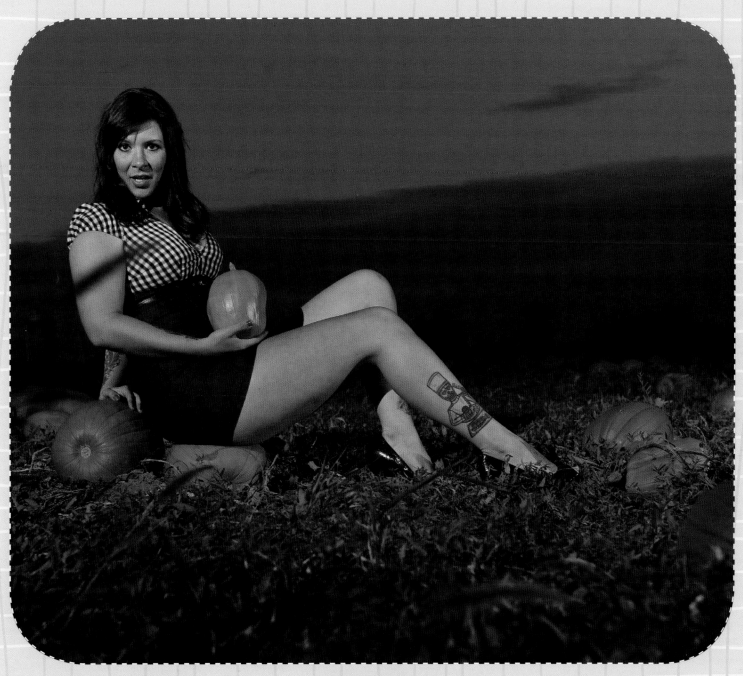

ABOVE *By bumping the shutter speed a few clicks, we can darken the sky giving it a more moody appearance.*

Lighting

WHEN SHOOTING ON LOCATION, lighting is your best friend! I often find locations that would be perfect for a pinup shoot, but the available light just isn't what I want it to be. If the sun never hits your location from the direction you want, you're never going to change that, but with artificial lighting you can have 100% control of the entire scene.

Many of the locations I shoot are huge in scale, and there would be no way for me to light the entire scene without a truck-load of strobes. To help me assess a location, one of the first things I do is to enter the location into the LightTrac iPhone app. This is an incredibly handy tool that brings up a map of any address you enter, and displays the position of the sun at any time during the day, so you can see which direction it will be coming from. If you then think of the sun as a giant studio strobe you can control this "strobe" by changing the time of your shoot.

Once you have figured out the best time of day for your shoot, it's time to figure out how to light the rest of your scene. Think of lighting as a layering process: once you've established your background lighting, move on to other major elements that you want to include in the photo. Is there a building you want to show off? What about a hot rod? Make sure you get these large items lit well before you move on to your model.

Light modifiers play a very important role in the overall appearance of your final scene. My style leans toward the dramatic when it comes to lighting, and my modifier of choice is the grid. Grids alter the width of light coming from a strobe and I keep 10, 20, 30, and 40 degree grids in my location kit: the 10 degree grid produces a 10 degree wide path of light, which is great for spotlighting a very specific part of the scene, while a 40 degree grid will light a whole car if it's placed back far enough.

In addition to grids, softboxes and umbrellas are probably the most common light modifiers used. I use a small shoot-through umbrella if I want a softer light on my model, and these are also great for headshots. Softboxes are useful if you want an even light on your model, but most of the time I do not want this style of lighting for my location shoots. Softboxes can also be big and bulky, so do not travel well, but I always tell photographers to be prepared for anything. If you have a working knowledge of lighting, and have brought the gear required, you should be able to get whatever shots you desire.

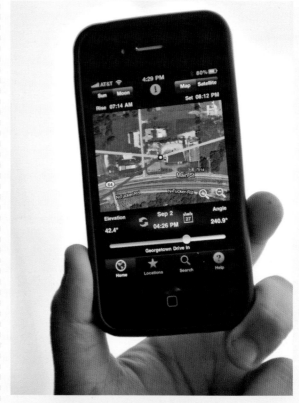

LEFT *With an iPhone app, I can tell the exact path of the sun at any time of the day.*

BELOW LEFT *Grids are a simple way to spotlight your subject.*

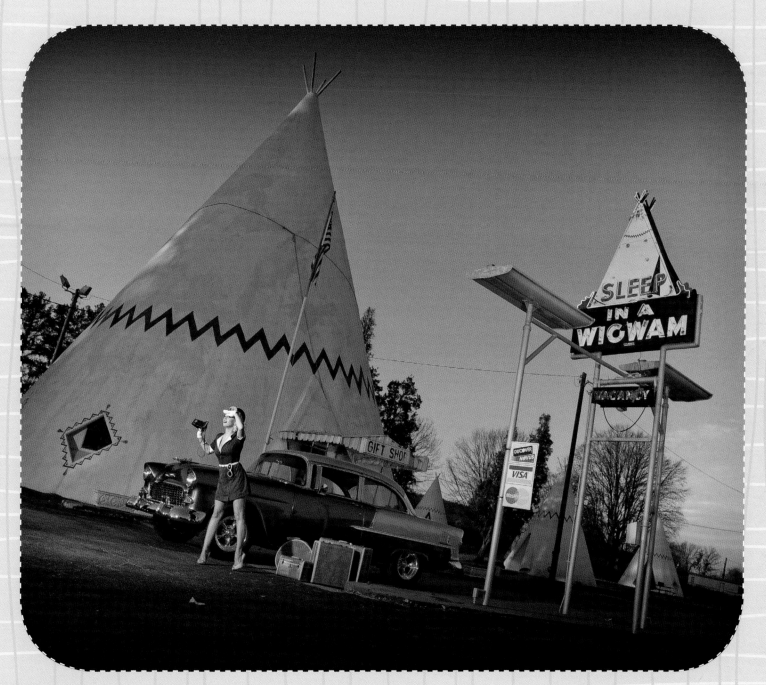

ABOVE *By using multiple strobes with grids, I can highlight different parts of the photo.*

Drive-in movie theater

THIS LOCATION is an old drive-in movie theater, which not only looks great on camera, but is accurate in terms of the period of shot I was going for. When we arrived, the first thing I did was scout out the location for the first set of images. I quickly discovered the ticket booth and main gate area, both of which give the viewer an insight into the location and immediately "place" the shot. However, another key element in the shot is the hot rod, so I needed to make sure I could fit the car—as well as the ticket booth—in the frame, while still leaving enough room for my model to move around and pose.

Once I had figured this all out in my head, I started to place the large elements of the picture, determining where the ticket booth would be in the shot, and then positioning the car and model. When I had everything where I wanted it, I began to set up my studio strobes. For this series of shots, I used three strobes. I fitted the first with a 30-degree grid, aimed at the ticket booth; a second, with a 20-degree grid, was on the car; and the third strobe lit the model, this time with a 40-degree grid. By lighting each of the three major elements of the picture independently, I had full control over the final image: if I wanted the car to stand out more I could simply increase the power on the relevant strobe, for example.

Another major aspect of any location shoot is the ambient light, and although it was mid afternoon when I shot this, I wanted a dramatic "night-time" look. To start with, I made sure that the depth of field was sufficient to keep the background in focus by setting the aperture to f/11, then I took an exposure reading for the sky. I increased the shutter speed from this exposure reading to darken the sky, while making sure that the strobes would expose the various elements correctly. The end result is a dramatic sky that looks as if it was shot at sundown.

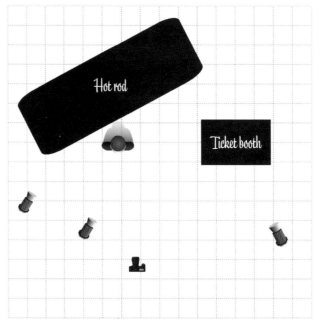

LEFT *As you can see, I use a studio strobe for each item in my shot. This allows me to highlight one or more of the objects.*

RIGHT *Don't forget the small details. I used an old popcorn box since we were at a drive-in movie theater. It also gives our pinup girl something to do.*

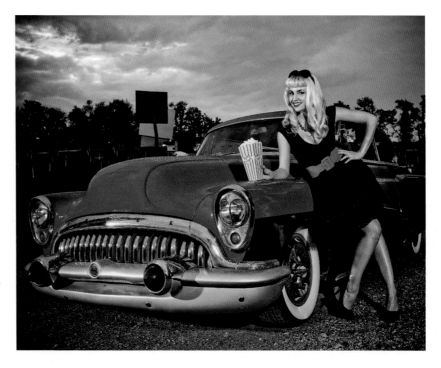

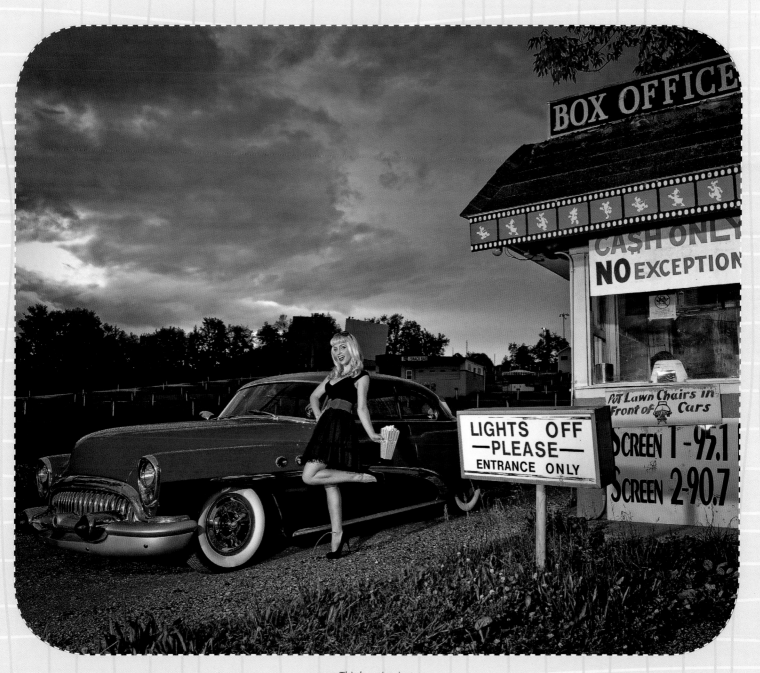

ABOVE *This location just screams pinup girl photo shoot. It's a shame, most of the drive-ins have been torn down over the past few years.*

Tilt-a-whirl

BEHIND THE PICTURE

WHAT COULD BE MORE FUN than shooting two gorgeous pinup girls on a tilt-a-whirl? For a few years I had wanted to do a pinup shoot on one of these iconic carnival rides and, with the assistance of the organizers of the Kentucky State Fair, I managed to get access to a 1950s' tilt-a-whirl the day before the fair opened. This was a fantastic result, as I wanted to be able to shoot on a closed set for many reasons; I didn't want people in modern dress walking around in my shots, and I didn't want people "cat-calling" my models!

Setting the shot up was simple: to one side of the ride was a modern building and lots of modern-day elements that I didn't want in shot, while to the other side were colorful food vendor signs and other carnival rides that I did want for my backdrop. The only problem was this meant I needed to shoot right into the setting sun, however I quickly solved this by using the sun as my backlight.

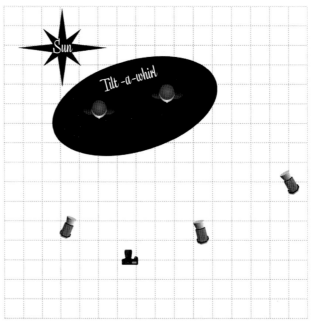

LEFT *When shooting during the day, don't forget to use the sun as another studio strobe.*

BELOW LEFT *Since this shot was taken from a slightly wider angle, I applied a vintage wash in Lightroom that included a vignette to bring your eye in to the girls.*

BELOW *I'm glad I decided to use two pinup girls for these shots. One just wouldn't have worked so well.*

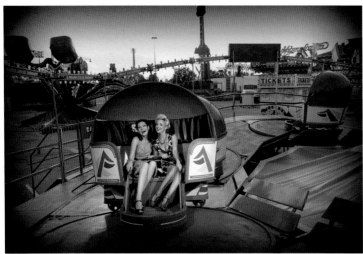

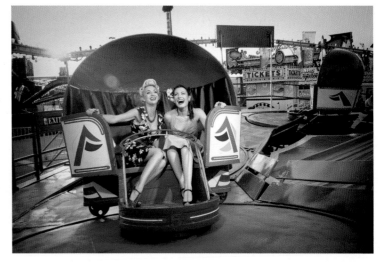

Both of my pinup girls would be sitting in the ride's car for the shoot. This would block them from the sun's backlighting, so I used a studio strobe with a 30-degree grid to light each of them. I placed the strobes on light stands about 12 feet away, at head level. To light the ride's car, and the area to the right of the car, I used a studio strobe with a 40-degree grid placed on a stand about two feet off the ground, and aimed it down the side of the car.

I set my camera to manual and dialed in my settings: ISO 200 with a shutter speed of 1/60 sec to give the scene a bright, fun feeling as the sun was setting. I set my aperture to f/8 to maintain some detail in the background and once we started shooting I had my assistant go behind the car—without the pinup girls knowing—and start moving it from side to side. Their reactions gave me the perfect facial expressions.

RIGHT *It's hard to believe by looking at the girls that the car was not moving. They did a great job at faking it.*

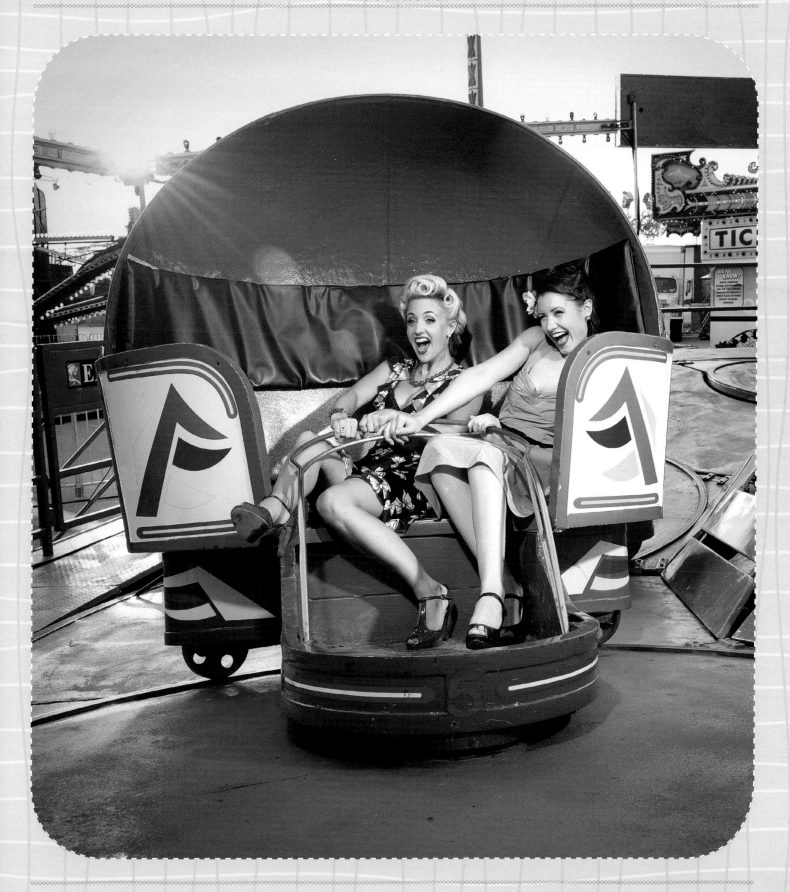

Ferris wheel

BEHIND THE PICTURE

HOW CAN YOU GO TO A CARNIVAL and not shoot a Ferris wheel—the biggest, most recognizable ride? It also lights up with lots of pretty colored lights, making it the perfect background for a pinup photo shoot.

For this shot, I wanted to capture the Ferris wheel right as the sun went down. I'm sure you've seen that awesome cobalt blue sky that shows itself for just a few minutes after the sun sets: that was the light I wanted to set the tone for my photo. The only problem is that this lighting only lasts for about ten minutes, and it changes every second, so this shot needed to be taken very quickly.

We arrived at our location about 20 minutes before the time of the "magic light," which gave me just enough time to get everything set up and the girls in place. I broke out two 12-foot light stands and two studio strobes, fitting one with a 40-degree grid and the other with a 20-degree grid. The 40-degree grid would be used to light the girls, while I used the 20–degree gridded strobe to throw a little light at the bottom of the Ferris wheel.

With the lights in position, I made sure that my models were in place and gave them a few sticks of cotton candy to use as props. This turned out to be a very bad move—cotton candy hates the Kentucky humidity and it turned into a pile of goo! As time was short, I used it anyway...

As my assistant began posing the girls, I started snapping photos, knowing that these early shots were not the shots I wanted—we were still waiting on that beautiful cobalt blue sky, but I wanted the girls to be in their groove the second the light was right. During this time I fine-tuned my lighting and camera settings.

I knew I wanted to have the girls and Ferris wheel sharp, so I decided to set the aperture to f/9 for sufficient depth of field. When we started shooting, I had the shutter speed set to 1/125 sec, but after just five minutes my shutter speed was down to 1/15 sec as the daylight faded. Once we got into that period with the brilliant blue sky I wanted, I stayed at f/9 and 1/15 sec until I finished. The total time spent on this shoot was less than 20 minutes from start to finish.

Ferris wheel

LEFT *I used a very simple lighting setup considering how big this shot was.*

BELOW LEFT *Expressions really are everything. I am sure there was something very entertaining going on...*

RIGHT *Shooting at sundown just seemed like the right thing to do with this shot. There was still enough ambient light to light up the Ferris wheel.*

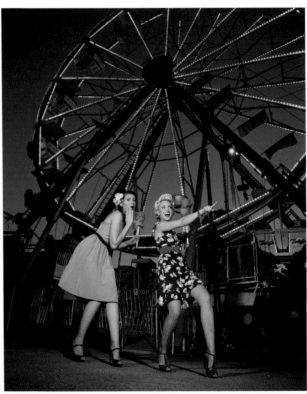

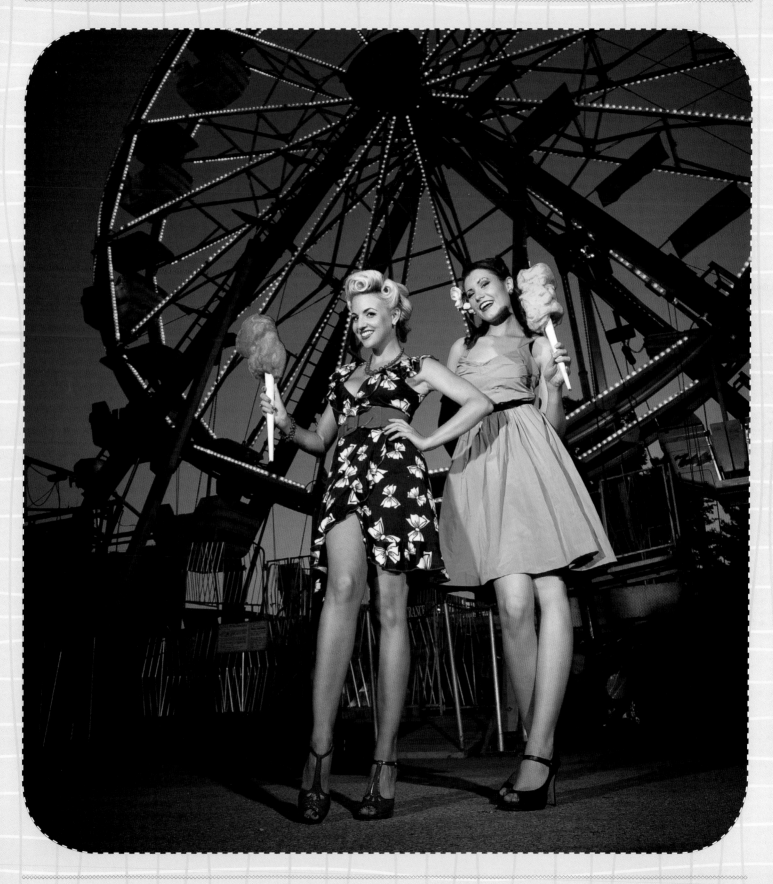

Girl in a tub

BEHIND THE PICTURE

J UST ABOUT EVERY PINUP ARTIST has drawn, painted, or photographed a bathing pinup girl in an old washtub—it's a fun and flirty way to pose your pinup, and I have shot this exact same photo dozens of times for clients in the studio. It is always cute, but I really wanted to shoot one on location, as this would allow me to have a garden hose spraying into the air as well—something I wasn't particularly keen on doing in the studio.

One of our hair and makeup artists has friends that live on a farm, and they had decorated the face of their garage with old reclaimed barn wood to make it look like an old house or general store. This was the perfect backdrop for my photo shoot and the owner was kind enough to let us use it. I decided to shoot this session after the sun went down for two reasons: firstly, it was the middle of summer in Kentucky, which means temperatures of around 95°F (35°C) with very high humidity and, secondly, total darkness meant I would have total control over the lighting.

For this shoot I used three studio strobes. My main light was just out of arm's reach to the right of the camera position, with a silver 40-inch umbrella fitted to soften the light slightly. A second strobe with a 20-degree grid was placed up high and to the left of the camera, aimed down onto the washtub, giving me a great fill light that made the grass really "pop" around the tub. Finally, a third strobe was used without any modification. It was placed as far behind the model as I could get it (without it being in the shot) to throw light through the spray from the garden hose.

I had my model sit in the washtub and told her I wanted to do a series of "leg up" pinup poses. After a few of the poses, we gave her the garden hose and had her continue. Soon after, a frog jumped right into the washtub with her! She didn't miss a beat—just picked the frog up and gave it a kiss. What a great shot (see photo right)!

My camera settings were pretty simple for this shoot—f/8 at 1/250 sec—but the beauty of the shot, other than the pinup girl, was the backlit water spray from the garden hose. The total darkness of the shoot made it quite easy for the studio strobes to capture the water droplets. Also, having the model hose herself down on a hot summer's night with ice-cold water meant it was easy to get exactly the right facial expressions.

LEFT *The key to making this shot was the backlight that lit the water drops.*

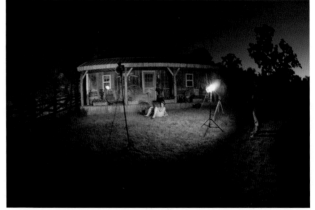

LEFT *A simple out-building was transformed into the perfect pinup set with just a little creative lighting.*

BELOW and RIGHT *It's always great when you have a client that is willing to go that extra mile for the perfect shot.*

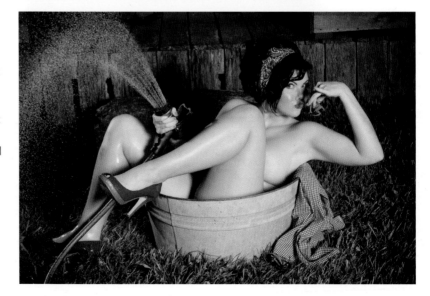

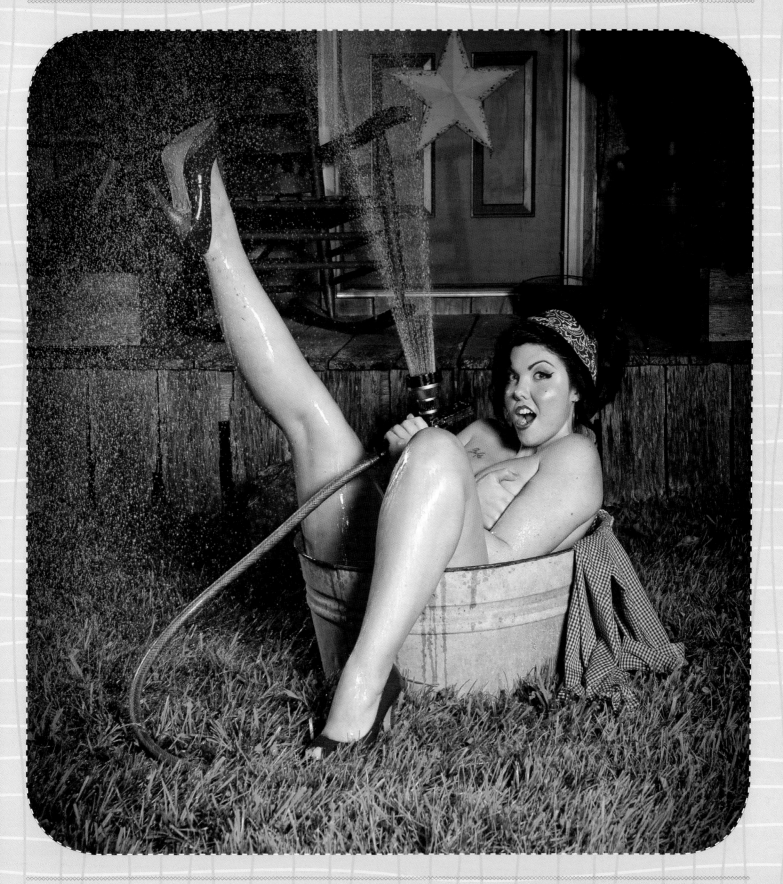

Hot rod garage

BEHIND THE PICTURE

WE ALL KNOW that hot rods and pinup girls go hand in hand, so when a friend of mine showed me his hot rod garage, I knew I had to set up a photo shoot in it. The garage is packed full of really cool old hot rod memorabilia; every surface is covered with cool stuff—lots of bright colors for me to shoot. I called my friend to see what car he had in the garage currently, and he told me he had an old Chevy "Gasser," that was just waiting to be shot.

When we arrived, I unloaded three studio strobes. I used one strobe, placed on a light stand behind the car to light the ceiling and wall to the left of the frame. My second strobe was directed down the driver's side of the car and would also light the wall next to it. To light my model I used a third studio strobe with an 82-inch parabolic reflector—the same light modifier I use for most of my studio pinup shoots. I wanted to use the parabolic reflector to light the girl, as well as the whole front of the garage, but it also lit most of the car as well, giving me lots of lovely even light.

The hardest part of lighting this scene was dealing with the shadows that were cast by all the great stuff hanging on the walls and ceiling. This is why I had my first bare strobe in the back of the garage: the big parabolic provided light from the front to cancel out the shadows so that everything was evenly lit.

Since we were not dealing with any ambient light and were shooting inside, I treated the garage as if it was my studio, setting the ISO to 200, the aperture to f/8, and the shutter speed to my camera's maximum flash sync speed of 1/250 sec.

Car

LEFT *With this busy a set, it is very important to backlight your subject.*

BELOW LEFT *It's always nice to have friends with such great garages. Thanks Shawn!*

BELOW *Letting my pinup girl know what is in store for her.*

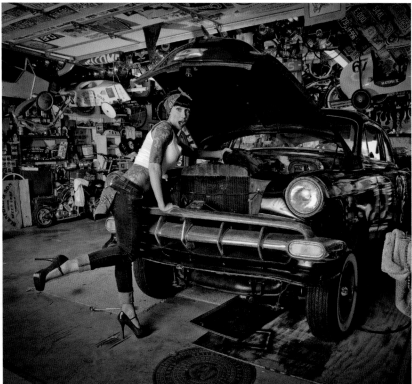

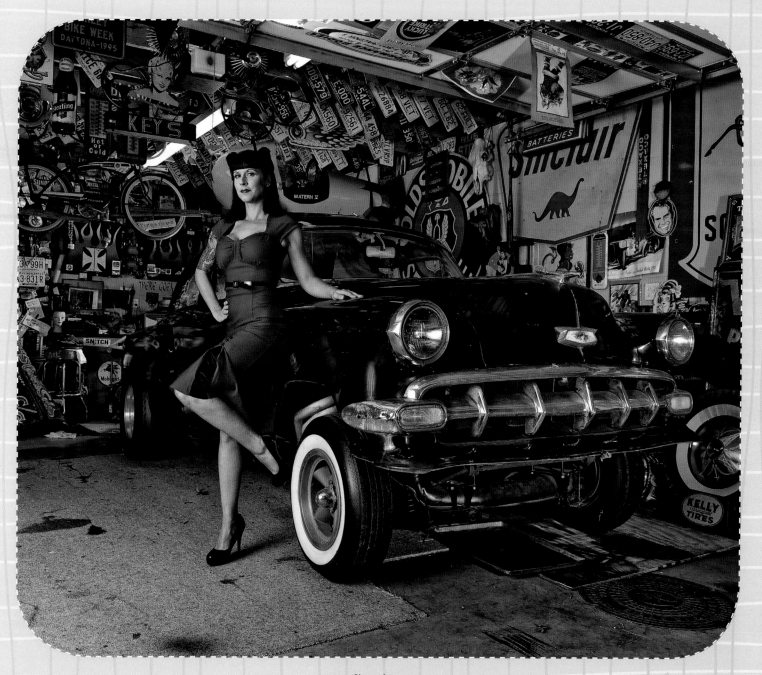

ABOVE *Since there were so many red items in the garage, we decided to have our pinup girl wear a red dress. It really stands out against the black car.*

Pumpkin patch

BEHIND THE PICTURE

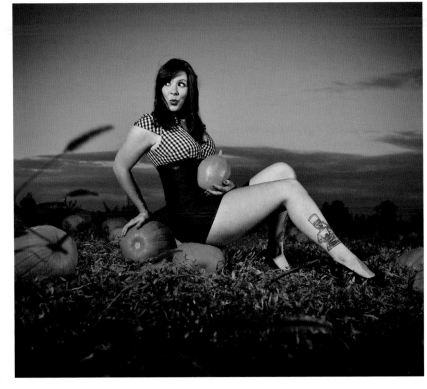

THIS WHOLE PHOTO SHOOT happened by accident. We were on a farm for a pinup shoot and left to run back into town. On the way, we drove past this great pumpkin patch a few minutes before sunset. I immediately saw the potential and, as my model was still dressed in her pinup dress, I made the driver pull over, hopped out of the car, and started grabbing equipment.

The sun was setting fast, so I didn't have a lot of time for fancy set-ups—I simply grabbed two Nikon SB800 flashes and a pair of light stands. I wanted to shoot with the awesome sunset in the background, which largely dictated my shooting angle, and while my assistant told the model where to sit and what pose to have, I set up and tested the lights.

My main light was placed just to the left of the camera, with my second flash set at a height of about ten feet, just behind the model. There was no need or time to break out any type of light modifiers, so I just ran the lights bare, setting my main flash to 1/4 power and the backlight to 1/2 power (I needed a little extra out of the backlight since it had to be further away to keep it out of the frame).

Next up came the camera settings, which were tricky given the time of day. The setting sun was still lighting up the background and the pumpkin patch very brightly, so I set a shutter speed of 1/320 sec to darken the sky. I wanted the pumpkin patch to go slightly out of focus as it disappeared into the background, so I chose an aperture of f/5.6. We snapped away for about five minutes, packed up what little gear we had, and continued our trip back into town. All in all, I think we got some great images for such a spontaneous, unplanned photo shoot.

ABOVE *What a great sky. I'm a sucker for bright colors. What better way to add extra color than shooting at sunset.*

BELOW *A good "shooter's stance" is the most important thing you can have!*

ABOVE *A simple cross-lighting setup was all that was needed to light our pinup girl.*

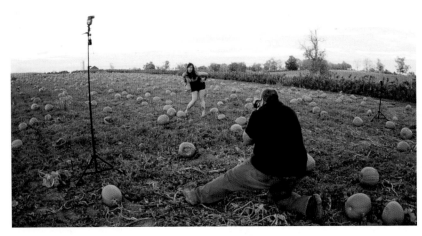

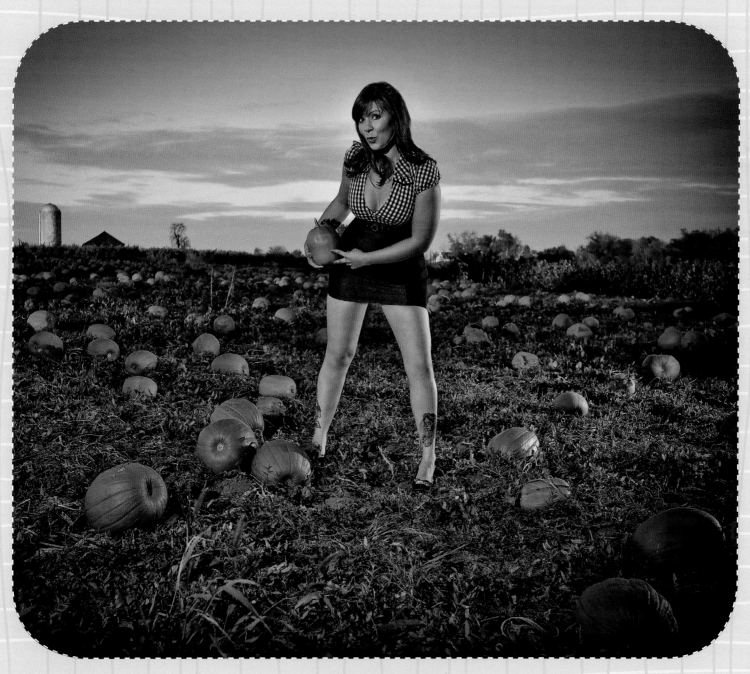

ABOVE *My favorite part of this photo is the light skimming the top of the grass and pumpkins. I think it adds a very cool effect to the final image.*

Picnic with a puppy

BEHIND THE PICTURE

MY FRIEND AND MODEL, Kitty, flew in from Texas to shoot with me on what I think was the hottest day on record here in Louisville, Kentucky—the heat index was around 115 degrees! Kitty wanted to shoot a pinup girl on a picnic, which I've done many times in the studio, but she wanted to shoot outside. We would also be working with another "model" during this photo shoot; my dog, Henry.

Working with animals poses a lot of problems. Most of the time they don't want to sit still, and they also don't much like the bright lights flashing in their faces, or the constant laughter that tends to surround a shoot. To try and avoid this, Henry was taken for a very long walk before we began shooting in the hope that he would just want to sit in the picnic basket we were using, and relax. As well as the basket, I also styled the shot with a vintage tablecloth, and stopped at the neighborhood market to grab a few hot dogs.

I shot this set in the middle of the hot summer's day, but even though there was lots of natural light, I still wanted to break out a few strobes to create a different light to that being provided by the sun. I used a strobe with a 40-degree grid as my main light, and another strobe with a 30-degree grid as my backlight, both set to 1/2 power. My pinup picnic was set right in the middle of the two strobes and I shot at f/8 the whole time, with a shutter speed of 1/125 sec.

Once Henry was settled, it was time to start posing my model, but since she is an experienced pinup girl I just turned her loose and let her do her own thing: she was great and the pictures we got were fun and playful.

BELOW LEFT *Sometimes a simple location works best. We used a local park to get this great shot.*

BELOW *This is my Mini Schnauzer, Henry. He likes pinup girls and hot dogs.*

ABOVE *I decided to use my cross-lighting setup again for this shot. There was enough ambient light, but I wanted the subjects to really POP!*

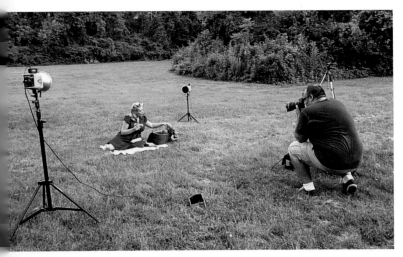

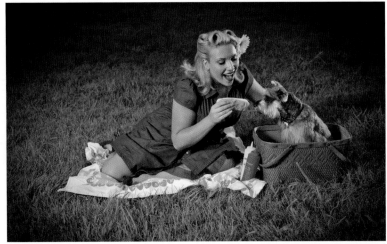

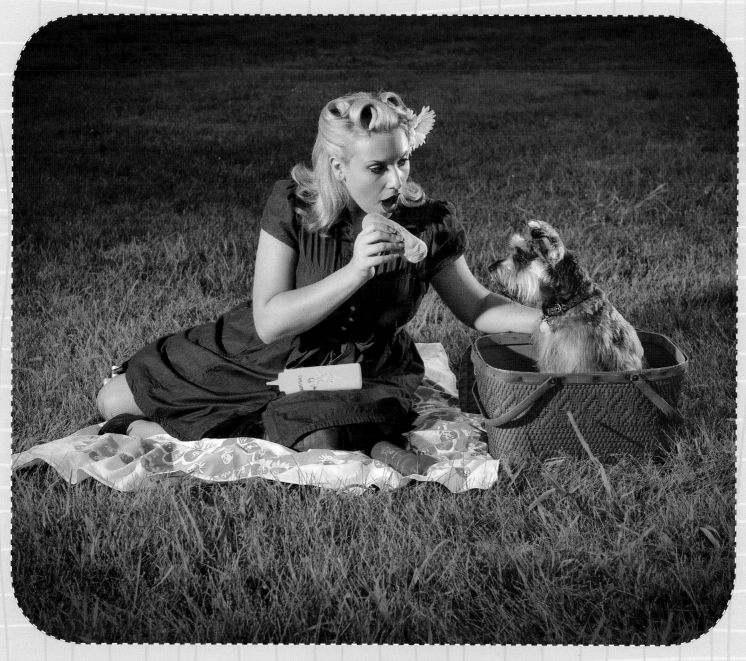

ABOVE *Working with animals is always a challenge. Lucky for me, Henry was well behaved for this series of photos. I had our pinup girl hold the hot dog by way of distraction. His eyes stayed on it the whole time.*

Ice cream parlor

I ALWAYS LOVE IT when I'm driving around and stumble on a great building to use for one of my location shoots. This old vintage ice cream shop was just that kind of place; it had plenty of interest to it and was in great shape. The only problem was that the area surrounding this place was not that pretty. The simple solution? Shoot it at night!

As I was shooting this location after hours, I needed to provide plenty of light and ended up using five strobes, all fitted with 40-degree grids. My main light was placed at eye level, just out of arm's reach to my left, with another strobe bouncing light up onto the canopy above the model for a little fill. The third strobe was firing through the window of the ice cream shop to kill the shadows created by my main light, and the fourth strobe was placed under the canopy so that it was illuminating the face of the ice cream shop to light the background. The fifth strobe was placed low to the ground and was aimed right at the front of the truck to light both the model and truck.

I wanted a "tough girl," rockabilly-type pinup girl for this and I found a girl with some great tattoos, rolled her hair with beer cans, and gave her a cigarette—the general theme for this shoot was "trashy!"

LEFT *I guess if you throw enough lights at a scene you can illuminate anything.*

ABOVE *I actually caught this shot while the model was in between poses. I think it is kind of funny.*

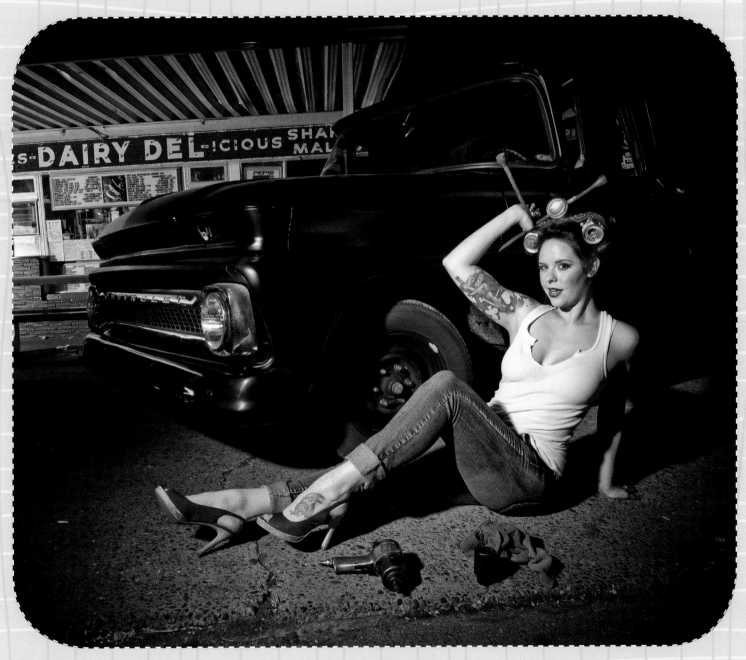

ABOVE *I had our hair and makeup artist roll the model's hair in old beer cans. Nothing says "trashy" like beer-can hair rollers!*

Wigwam Village

BEHIND THE PICTURE

BEFORE AMERICA'S interstate system was built, roadside attractions dotted the landscape, but this has almost all now disappeared. Only three of the original seven Wigwam Village roadside motels are left in the US and I am lucky enough to have one right here in Kentucky. I knew I wanted to shoot a pinup session here as it had every element I look for when choosing a location; it was retro, fun, and all original.

Since this is a roadside motel, I needed to find a suitable vintage car to use for this shoot, so I made arrangements for a local enthusiast to drive his 1955 Chevy Belair to the Wigwam Village. I wanted to create a story where the pinup girl pulls up to this roadside motel to check in for the night, so remember those great vintage suitcases I use all the time? Well, I used them in this photo shoot as well.

We positioned the car right in front of the main wigwam, working fast as the sun was setting. I had my assistant position the suitcases as I started placing my three studio strobes. My main light was at a height of about six feet, and shot into a silver umbrella, with a second, bare strobe pointing right at the wigwam. A third strobe, fitted with a 30-degree grid, was used to backlight the model and the car.

When I started shooting, my shutter speed was at my camera's maximum flash sync speed of 1/250 sec, but by the time I finished shooting, the sun had set and I was shooting with a shutter speed of 1/50 sec. I kept my aperture set to f/8 for the duration of the shoot to maintain a constant depth of field.

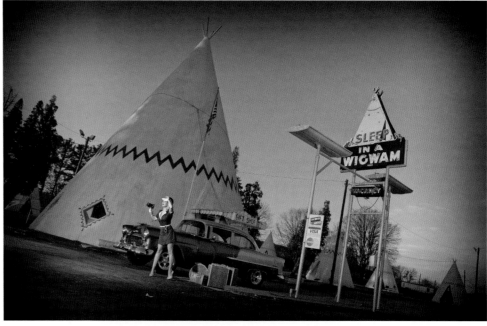

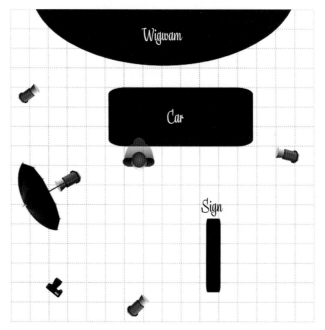

ABOVE *This is actually a recreation of a vintage postcard that was shot at this location. I decided to add a pinup girl to it though.*

LEFT *With a scene this large, I needed to use four lights to light all the major elements in this photo.*

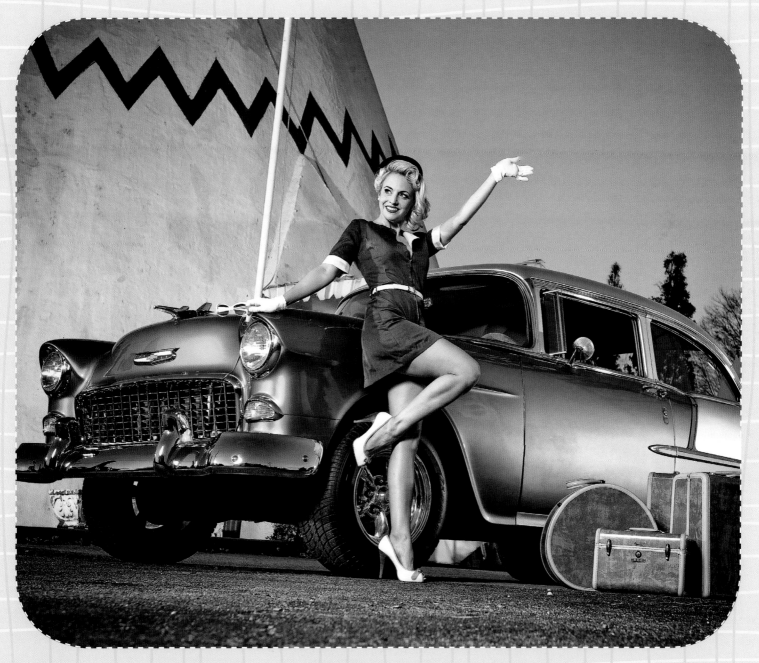

ABOVE *It's funny how a shot comes together. Our pinup girl was actually waving at passing traffic when I snapped this shot.*

Bumper cars

BEHIND THE PICTURE

Bumper cars have been a staple carnival ride for decades, and since the 1920s people have been slamming these electric-powered cars into one another for fun. So I thought this would be the perfect setting for a pinup shoot, but this location proved to be somewhat tricky. The main problem was that the inside of the bumper car ride was fairly dark, but the light outside was very bright. To complicate things further, the floor and ceiling of the ride were black so there would be no chance of bouncing light to fill in the scene.

I decided I would shoot using three portable Nikon flash units, and set the first flash—without any light modifiers—immediately adjacent to the bumper car my model would be riding in. The other two flashes would be at ground level; one just out of frame on the left, with the other one hidden behind the bumper car.

After getting the flashes positioned, I began getting my model into place. I was lucky enough to have a very limber girl for this shoot, and we decided it would be funny if she had both legs straight up in the air, as if she was being hit by another bumper car. After a few dead legs and a little tinkering with my flashes, I started to shoot.

I began by snapping a quick shot of the scene in Full Auto, noting the exposure for the background, and switching my camera into Manual mode. I overexposed the ambient light by one stop, which put my shutter speed at 1/250 sec, and because I wanted the background rides and scenery to be a part of the final image, my aperture was set to f/8.

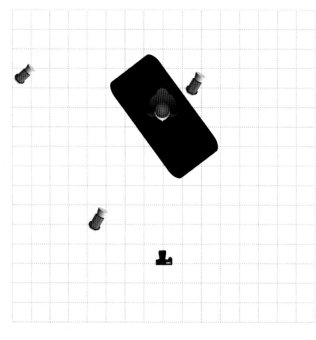

LEFT *A carefully placed light behind the bumper car illuminated the back row of cars perfectly.*

BELOW *Since the background had a few modern elements to it, I decided to blow out the highlights. This keeps your focus on our pinup girl.*

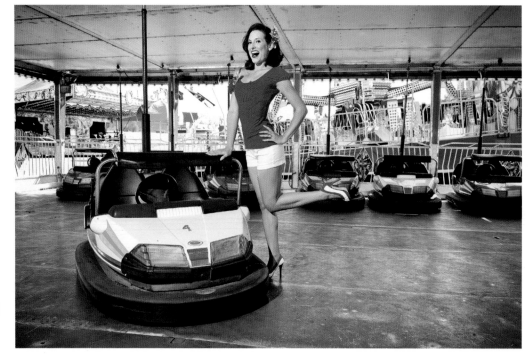

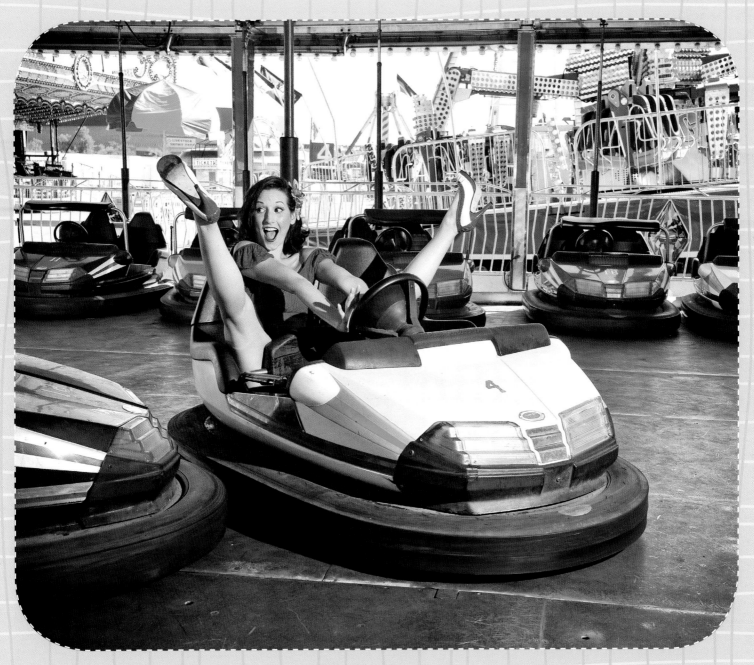

ABOVE *What's better than a pinup girl that is super flexible? That's right, nothing! The legs in the air truly make this shot.*

Rat rod

BEHIND THE PICTURE

A GOOD FRIEND OF MINE has spent the past few years building this great rat rod out of an old 1929 Chevy Sedan, and it was just crying out to be included in a pinup shoot. Since the car is a rat rod, I wanted to find an "industrial" location with lots of rusty metal and such, and while driving around the "wrong side of town" I found this great abandoned building. The bonus? I couldn't see any "no trespassing" signs anywhere!

When we arrived at the location for the shoot, I noticed that the entire area was in direct sunlight, and as we had arrived about an hour before the sun would set, I decided to shoot a few photos using studio strobes as fill lights. It wasn't the look I wanted, but I realized that there was a building in the distance that was about to throw our set into shadow. This worked out great because it meant the sun lit the building we were using as a backdrop, while the building behind us provided shade for our pinup girl and the car. Now I could light everything separately.

As the sun would be lighting my background, I set my exposure for that. I started by setting my shutter speed to my maximum flash sync speed of 1/250 sec (as I would also be using strobes), and ended up with an aperture of f/11 to darken the scene a bit. With an aperture of f/11 and my pinup standing in the shadows, I now needed to light her, as well as the car, so I broke out three studio strobes and began placing them around the scene.

For my main light, I wanted to match the direction of the sun's path, so any shadows in the image would make sense. This meant that the main light would be placed to the right of the camera, and I raised the light stand to about eight feet and fitted the strobe with a 40-degree grid. I placed another strobe to the right of the camera, out of frame and directed toward the rear of the car. My last strobe was placed just out of frame on the left side, aimed at the front of the car. Both of the strobes aimed at the car had 30-degree grids fitted to help control the light beam. With the lighting in place, it was time to start shooting, and even though we were shooting in a rough location, I wanted the shots to be fun. Our pinup girl nailed it!

LEFT *When I shoot on a bright sunny day, I always use lights to fill in any shadows and to highlight my subject.*

BELOW LEFT *I always shoot from a low angle. It makes legs look longer and leaner.*

BELOW *The sun did a great job at lighting the huge metal wall.*

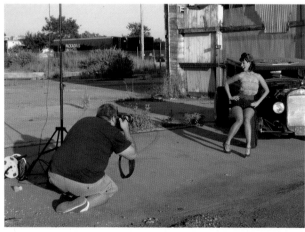

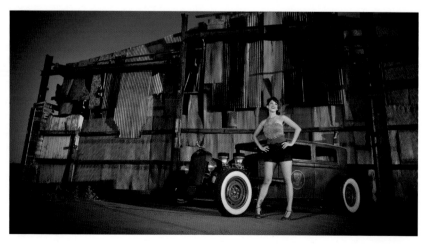

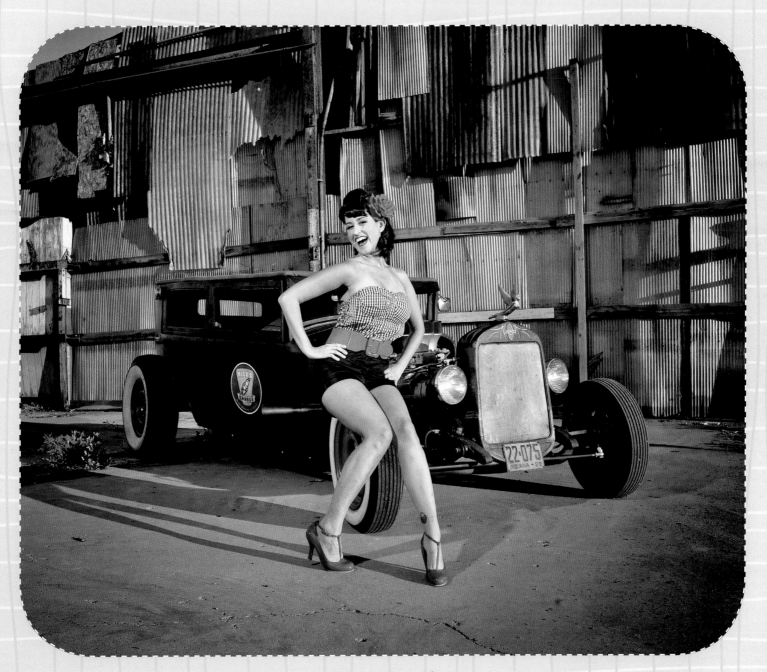

ABOVE *Great poses and fun facial expressions always make for a great shot.*

4

STUDIO SHOOT

Boudoir

From pinup to boudoir

AT MY STUDIO, I am constantly shifting gears between shooting retro pinup images and classic boudoir photos, and as I bill myself as a "Boudoir and Pinup" studio many clients want both styles during their photo shoot. This makes for a very interesting finished product, and the contrast between the two styles complements each other very well.

Shooting boudoir requires a totally different mindset to shooting pinup: pinup tends to be more fun and playful, while boudoir is more sensual and seductive. That doesn't mean you cannot have fun with your boudoir images, and there are candid moments during a boudoir shoot that can generate fantastic finished shots.

As far as camera settings go, the biggest difference between boudoir and pinup styles would have to be the depth of field. When I'm shooting pinup, I tend to use apertures of around f/8, but I'll use much wider apertures for boudoir shots. This is because the shallow depth of field allows you to highlight a particular body part, leaving other areas of the body to the imagination. This is a very flirty way of shooting boudoir, there's no need to give it all up at once. It also means that various parts and pieces can be blurred out all together, so if you have a client who is very self-conscious about a certain body part, you can pose her in a way that allows that area to slip out of focus.

The lighting also varies between the two styles. Whereas pinup lighting tends to be direct and hard, when I'm shooting boudoir I will go for a softer, more diffuse lighting setup. The softer lighting works well with the wider apertures I use, and the wide aperture also means that less studio lighting is needed to light your subject.

As with pinup work, it is very important to have a talented hair and makeup artist working for you—a lot of boudoir images are close-ups, so you want your client to look her very best.

At my studio, I am fortunate enough to have separate studios for pinup and boudoir shoots. This makes things very easy, as the two spaces can be tailored to each type of photography: my pinup studio is full of brightly colored props and decorations, and has upbeat music, while the boudoir studio uses softer colors, softer lighting, and mellow music for a more romantic feel. The environment helps set the mood for boudoir photography, but even when I had one studio room to shoot in, I would always make sure to dim the room lights and switch music when making the jump from pinup to boudoir shooting. It's amazing how this affects your client and places you in the best possible position for a successful shoot.

BELOW LEFT *We always like to blur the lines between boudoir and pinup. Pinup hair and makeup look great with boudoir.*

BELOW *The girl in this photo has similar hair and posing, but is paired with pinup props.*

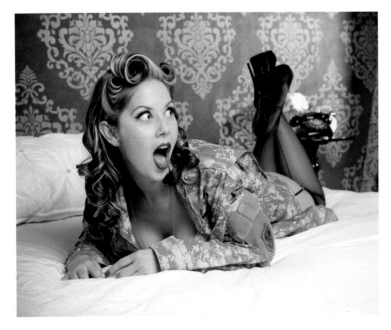

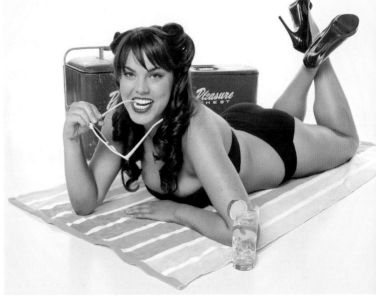

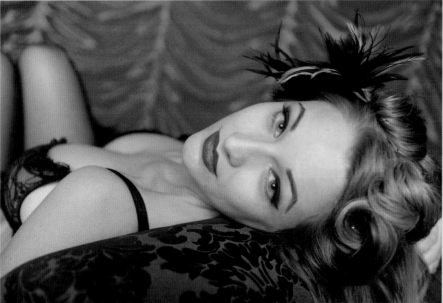

ABOVE *When shooting boudoir, I tend to go for a softer method of focus.*

LEFT *This is another vintage boudoir shot. Pinup hair and makeup style with a classic boudoir pose.*

Setting up a boudoir studio

A BOUDOIR STUDIO needs to be set up a little differently to a normal photography studio. Since your female clients are going to be getting partially undressed in front of what amounts to a stranger with a camera, it should be a calm and inviting place, and first impressions are everything. One of the biggest ways to make a great first impression is with the use of color. Stay away from dull, boring, or dark colors—you want your studio to be bright and cheerful. I am lucky enough to have a good-sized studio with a bright entrance, as well as a very comfy client lounge. Both of our big shooting studios are painted white and have huge windows to let in natural light.

Every item in our studio serves a double purpose, so the big plush couches in the client lounge are also used while shooting—that stuff is way too bulky not to serve a double duty! I recently added a huge bed to our studio and it's nice to have a dedicated bedroom set that is ready to go at all times. It may seem obvious, but boudoir photography sort of needs a bed.

It's not just the photography area that needs to have attention paid to it—I provide full hair and makeup with all of my packages, so that is another integral part of the overall experience that needs to be considered. Since I have many hair and makeup artists coming and going, I wanted to create a great area for them to do their thing, so I actually turned a corner of our client lounge into a 1950s-style beauty parlor. I found a great beauty shop hairdryer

chair, as well as a styling chair, and after recovering them with red sparkly vinyl, they were ready to go. The styling chair points strategically at a flat screen TV that rolls a slideshow of our past shoots, giving the client something to watch while in hair and makeup.

A dressing room is another must-have. Even though your clients will be wearing next to nothing while they are in front of your camera, they will still want a private area to change in. If you don't have the space for a dedicated dressing room, purchase or make a large dressing screen and place it in a corner of your studio. Be sure to stick a small garbage can in there as well—we always end up with buckets full of stocking packages and lingerie tags.

Finally, don't forget the finishing touches: scented candles, good music, and a few beverages always do the trick. Remember—treat your clients as if they were guests in your own home.

BELOW LEFT
Selecting a "cool" color makes for a bright and inviting environment.

BELOW *Comfy seating is a must. I also cross promote my commercial photography business with a few canvases on the wall.*

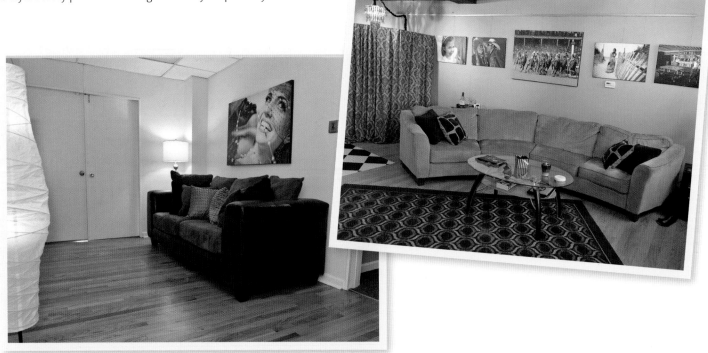

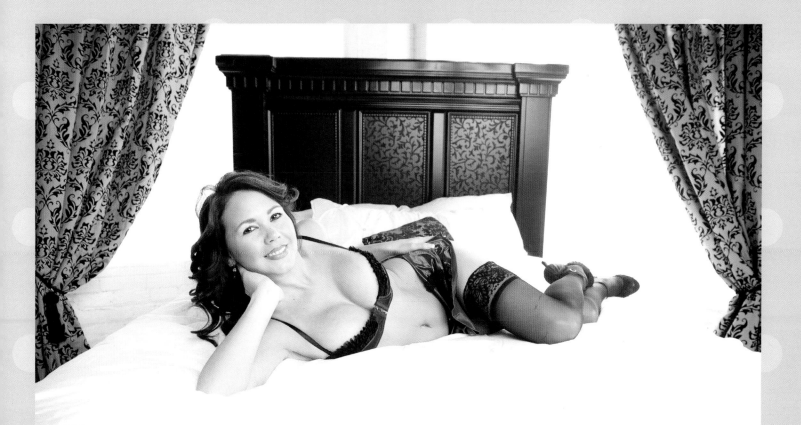

ABOVE *Every boudoir studio should have at least one awesome bed. After all, boudoir does translate to "bedroom."*

FAR LEFT *Our hair and makeup area is packed full of vintage beauty salon items. It makes a great shooting set as well.*

LEFT *Don't forget the small items. Fresh flowers, candles and candy always work wonders.*

Boudoir props

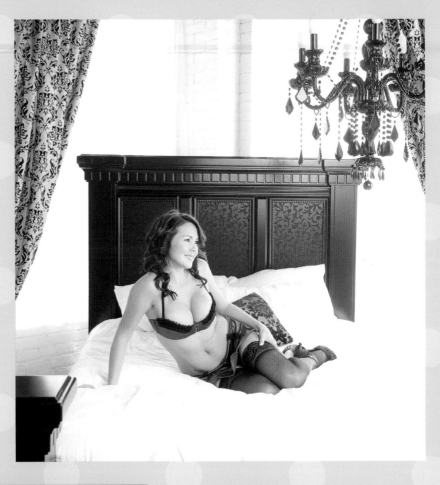

HE TERM "BOUDOIR" can be translated directly to mean "a woman's bedroom," and that is the illusion you are trying to create with your boudoir photography. You want the viewer to think that they're looking at a picture of a gorgeous girl lounging back in a high-end hotel or elegant mansion, and not your downtown studio. It's actually very easy to create a boudoir set in your studio or home and you just need to add fancy bedding, a luxurious backdrop, and creative lighting to transform it into your very own luxury suite.

PROP GUIDE

Bed

IT GOES WITHOUT SAYING that you need a bed to recreate a bedroom, and if you have the space in your studio, I highly recommend purchasing a great big bed. Try to get a bed that is in a color or finish that will work with a variety of bedding. I chose a very ornate black bed, as black goes with every color and style of lingerie and bedding that we would ever want to use.

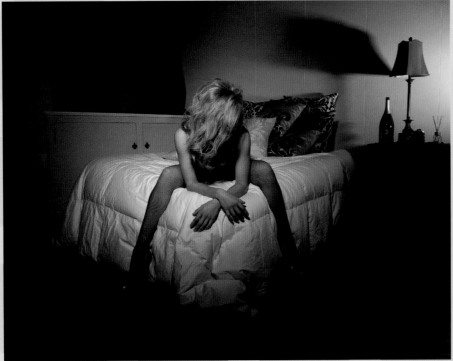

PROP GUIDE

Air mattress

IF YOU DON'T HAVE THE SPACE for a real bed, grab yourself one of those double-thick air mattresses that is about the height of a regular bed. Purchase a queen-sized air mattress and cover it with a king-sized comforter or bedspread. Don't have a headboard? No problem—just toss a pile of decorative pillows into the mix and you'll never know the difference.

In addition to a bed you will need to add other props to the scene to create the illusion of a bedroom, but this doesn't mean spending more money. The night stand in the photo shown here is actually one of our vintage suitcases turned on end and opened up. I placed a small piece of plywood on top, covered it with a tablecloth, added a table-lamp and a few small knickknacks, and I was ready to shoot.

ANOTHER OVERLOOKED studio prop is flooring. If you've got a pretty floor then there are some great shots to be had with the client posing on it.

REMEMBER THE OLD CHAIRS that I used in some of my pinup photos? They can also be used during a boudoir photo shoot—even though the prop is the same, everything else about the shot is totally different.

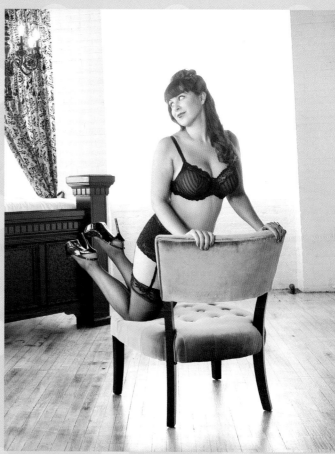

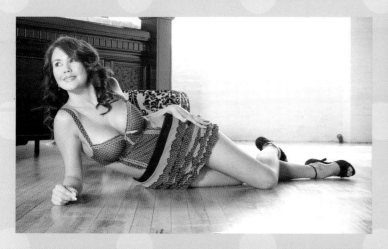

SMALL, CLOTH-COVERED CUBES are a great boudoir prop. Many large retail stores have these for sale in a wide range of colors and patterns. They are very inexpensive, take up little to no space in the studio, and there are quite a few ways that you can shoot with them. I often use them as a seat, but having your model stand and place one foot on the cube, acting as if she is pulling up her stocking also works great.

Boudoir backgrounds

SETTING THE RIGHT MOOD for your boudoir photo is very important, and one of the easiest ways to change the appearance of a photo is to change the background. One of the most popular designs used in boudoir photography is the classic damask. This timeless pattern is available in a wide variety of color combinations, and you can also find damask patterns on pro photo backgrounds that are great for setting the boudoir mood. If you want to have a fun and flirty feeling to your photos then consider using a brighter background, but when the shoot demands something with a sexier, naughtier edge, you can easily change the mood by using a darker colored backdrop.

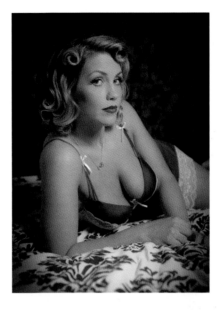

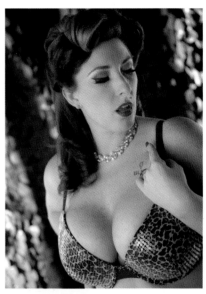

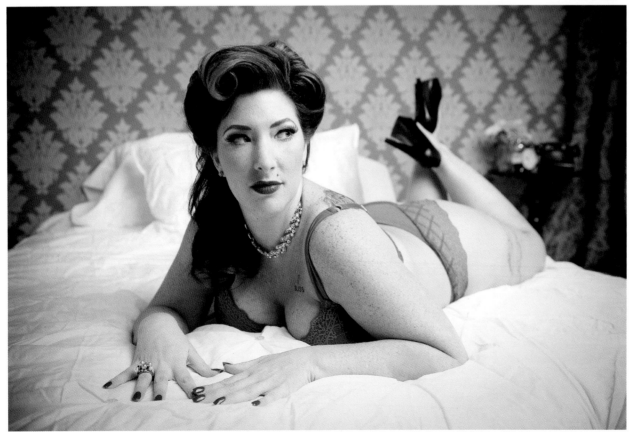

ABOVE LEFT *Use a color gel to add a pop of color to your backgrounds.*

ABOVE *This is the same background as the one to the left, but without the color gel on the background light.*

LEFT *Damask backgrounds give a photo that classic boudoir look.*

RIGHT *Always remember to choose a background that works well with the outfit your client has chosen to wear.*

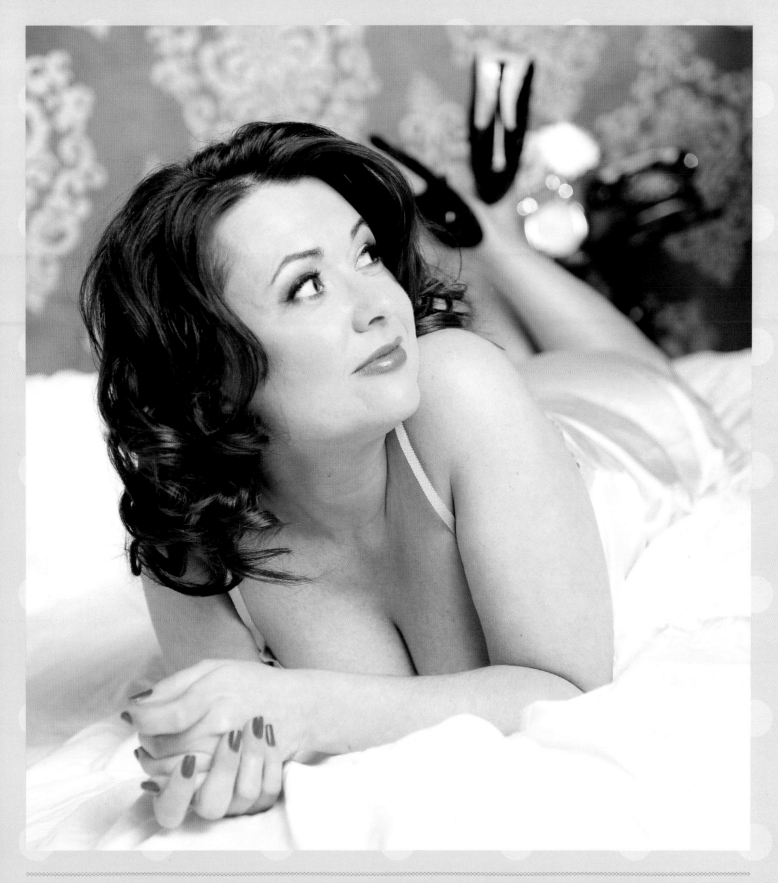

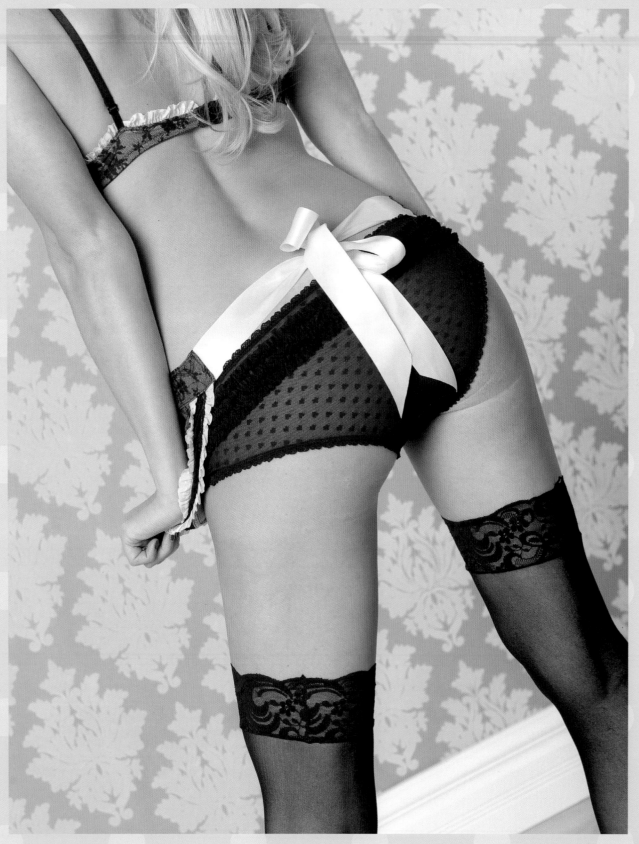

LEFT *By hanging the background flat on the wall, it gives the illusion of vintage wallpaper.*

RIGHT *To complete the vintage wallpaper look, I added a painted baseboard to the wall as well.*

There are many ways to use a backdrop, but the most popular is to let the backdrop hang like a huge curtain. When you use background lighting skimming across the background you can achieve some very dramatic shadows. Another trick that I love to do is to stretch my backdrop across the wall, to give it the smooth appearance of wallpaper. As a result of my previous shots, I've had many clients coming into the studio for the first time expecting to find a bunch of swanky room sets with fancy wallpaper, but it's all smoke and mirrors.

Backdrops are available in a variety of sizes, but if you plan to shoot full-length shots then you should consider a nine-foot x nine-foot background as the minimum size. Even though you (probably) won't be shooting nine-foot tall women, you will want to have your subject three to four foot off your background, so you will need some additional space around her. Believe me, it's a huge pain to extend a damask pattern in post-production, so save yourself a lot of time and effort by getting yourself a big background to start with.

If you'll only be shooting headshots, or half body shots, then you can obviously get away with a much smaller background. An excellent option is to get a few shower curtains, as they come in a range of colors and have a very versatile square shape. Simply hang one long curtain rod in your studio and hang four or five shower curtains on it; they can be slid into place as needed, making it very easy to switch backgrounds if you need to.

BELOW *Patterned curtains work great for boudoir headshots.*

BOTTOM *I always try to include a few headshots with all of my sessions.*

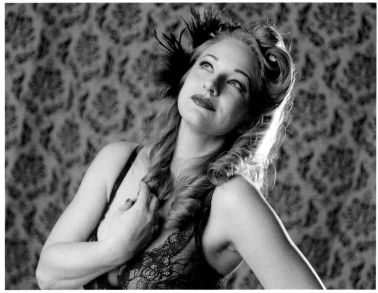

Boudoir hair & makeup

WHEN A CLIENT ARRIVES at the studio, one of the first things I do is take a look at the bag of lingerie they have brought with them as this helps us determine what style of hair and makeup they will want. Often, the client has little or no opinion on this and gives us full creative control, so looking through the outfits they have bought along for the shoot really helps us figure out their individual style. For girls who don't usually spend too much time on their hair and makeup, we might ask if they'd like a more fun and flirty look for the shoot, while we tend to go a little more dark and dramatic with the makeup on girls that are a little more outgoing.

The first thing that comes to mind when thinking about a classic boudoir look is going to be something along the lines of a Victoria's Secret model. Part of the allure of visiting a boudoir studio is for the model to feel as if she's the center of attention, or she could be the next angel in the Victoria's Secret lineup, and making the client feel that way is very important.

You'll notice that all of the models in the Victoria's Secret catalog have big, long, bouncing curls. This is great if your client has got long hair already, and to achieve this look we will typically use a one-inch or two-inch curling iron, depending on the hair's thickness. Throw in random curls all over, run your fingers through it to break it up, and hose it with hairspray. The idea is not to make it look too structured; think messy bed hair. This is a great style for boudoir because you don't have to worry about messing it up during the shoot, as that's the idea.

Of course, if your model has short hair, you'll need to come up with another style for her. Thankfully, clients with shorter hair are usually great at giving you ideas of what they want as they're used to working with a more limited style. Typically, you'll just want to give the hair a lot of body, while throwing in some curls if you can. You'll definitely need a smaller size curling iron—perhaps using one with a 1/2-inch barrel.

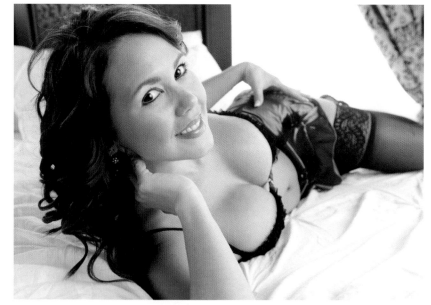

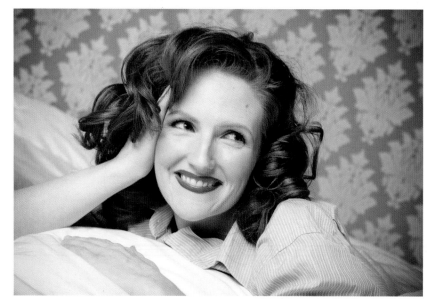

TOP *Loose curls are a fun and flirty choice for a boudoir hairstyle.*

ABOVE *Loose curls work on both long and mid-length hair.*

BELOW *We get asked all the time for the classic lingerie model look.*

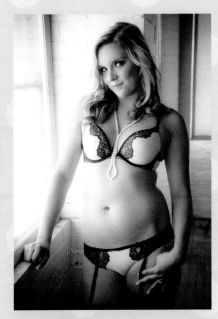

ABOVE *Mid-length hair works great with a little bit of curl. Too much curl and you make her look like she has short hair.*

RIGHT *Who says short hair can't be sexy?*

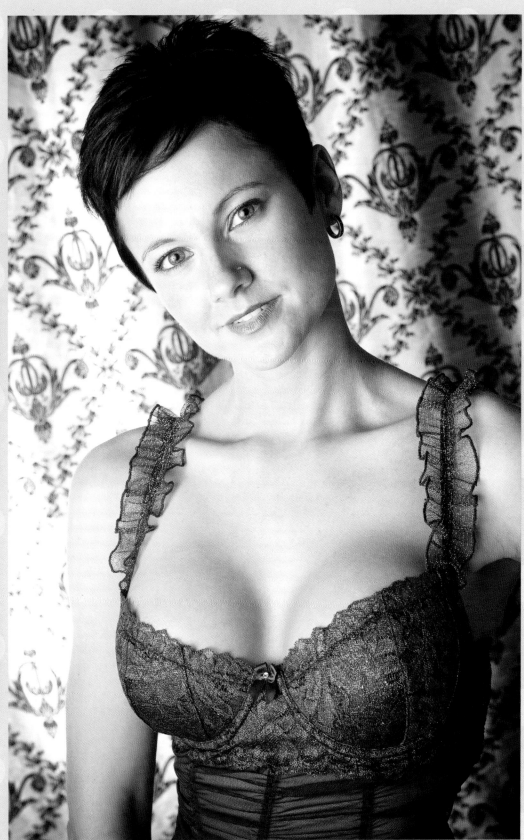

Makeup also plays a key part in boudoir photography, especially the dramatic and sultry "smoky eye" look. To pull this off, you will need to be sure to use a good eye primer. Working with darker colored eye shadows can be messy, so using a primer will help to keep all of the eye shadow on the eyelid, rather than it falling onto the cheeks or under the eye.

It is a common misconception that you can only do a smoky eye with black eye shadow, but this is definitely not true—you can still achieve a smoky eye with other colors, and it's a useful trick to really make your client's eye color pop. For example, if you have a client with green eyes, smoke it out with shades of purple and black to make her green eyes appear more vibrant.

When using a lot of dark colors on the eyes, you want to make sure that you are using an eyeliner that's even darker. Use a black liquid liner to set off the colors and shape you create with the eye shadow, and consider using a pencil black liner and applying it on the inside of the lower lid, remembering to keep the line nice and thin.

Next, you need to define the eyebrows. You want to make sure you're defining the arch in the eyebrow and lengthening it if needed, rather than just making it bigger. No smoky eyes are complete without a set of faux lashes, and this will add the "wow" factor that most of your clients will not be used to having—it really sets the look apart from the everyday. We apply lashes to nearly every client that walks through the door, and they look fantastic in photos.

Also, keep in mind that you don't want to have a lot of color on the lips. When you have such contrasting eyes going on, you need to keep the lips simple. Try using just a sheer gloss so it will catch the light, but won't be overly distracting. Remember that the eyes compete with the lips for attention on a girl's face, so it's one or the other—either do a bold lip color, or dramatic eyes, but not both. If you are doing the makeup yourself, it goes without saying that you should be sure to practice before jumping in with smoky eyes on a client—you don't want your model to look as if she's got two black eyes!

As mentioned before, most of the time the client doesn't have any input on the hair and makeup—they want you to do "whatever you think looks best," so it's your job to gauge what look you think will complement the outfits they have brought to be photographed in. They may want a vintage look, but are terrified of having those big rolls on top of their head, or they'll show up with lingerie that has a slightly vintage look. This is what I refer to as a "hybrid" look, which blends certain elements from pinup and boudoir styling.

First off, we will typically take the fun "cat eyeliner" style from the pinup look, but use color on the eyelid to make the eye color pop. As for the hair, we still want to curl it all, and if the client is comfortable going even more vintage, you can try parting her hair and making a large loose pin curl on either side to give a classic Hollywood glamour feel, but without taking it all the way to pinup.

ABOVE LEFT *We choose a more vintage look with most of our boudoir clients.*

ABOVE *A soft cat eye always looks great.*

RIGHT, TOP LEFT *Lighter eye shadow colors worked best for this client's soft complexion.*

RIGHT, TOP RIGHT *Shades of pinks and purples work great for more of a fun boudoir look.*

RIGHT *False eyelashes complete the boudoir look. Everyone that comes through our door gets them.*

Boudoir wardrobe

ONE OF TWO THINGS usually happens when the client walks into my studio: she's either carrying a huge rolling suitcase stuffed full of shoes and lingerie, or she walks in holding nothing but a purse. What's common to both is that you have to be prepared for either scenario. Sometimes, a client will bring lots of outfits because they don't know what will photograph best, and that's where you have to be decisive about helping them choose. It's important to know what will look good on camera, and also what will be flattering to your model.

One of my favorite outfits to shoot with is a simple matching black bra and panty set. This is something that pretty much every woman has, and you, as the photographer, can make them look like a sexy lingerie model with something they already own and probably wear all the time.

However, I can't stress enough how important the little details are. A garter belt and thigh-high stockings are the simplest way to give the outfit visual interest and they can also serve as an excellent prop—your model can be adjusting her stockings, or attaching her garter belt while you snap away. Most girls don't have these things just lying around, but they can be found cheaply and easily. Stockings are also a great way to hide any imperfections that would otherwise be unflattering or distracting in a photo; that bruise she got chasing the kids around, or that scratch from her new kitten can vanish. Plus, they're extremely sexy, so it really is win-win!

Another way to spruce up a boudoir outfit is with jewelry. Girls love having an excuse to wear the jewelry that usually just sits in their drawer at home, so why not take that over-the-top necklace that never seems to have an appropriate occasion and pair it with lingerie. Using jewelry also gives something for your model to do with her hands while they lie in bed.

ABOVE *Simple bra and panty sets work great. The bright purple looks awesome with her red hair.*

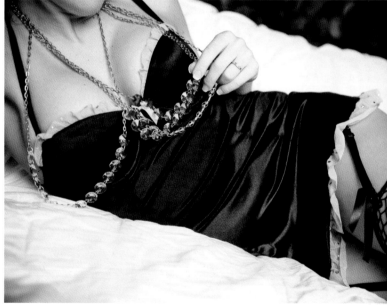

ABOVE *Don't forget the jewelry. Big chunky necklaces look fantastic when worn with lingerie.*

BELOW *Stocking and garter belts have always been considered a go-to piece of boudoir wardrobe.*

RIGHT *Corsets are a great opportunity to grab a few detail shots.*

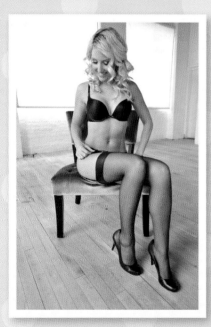

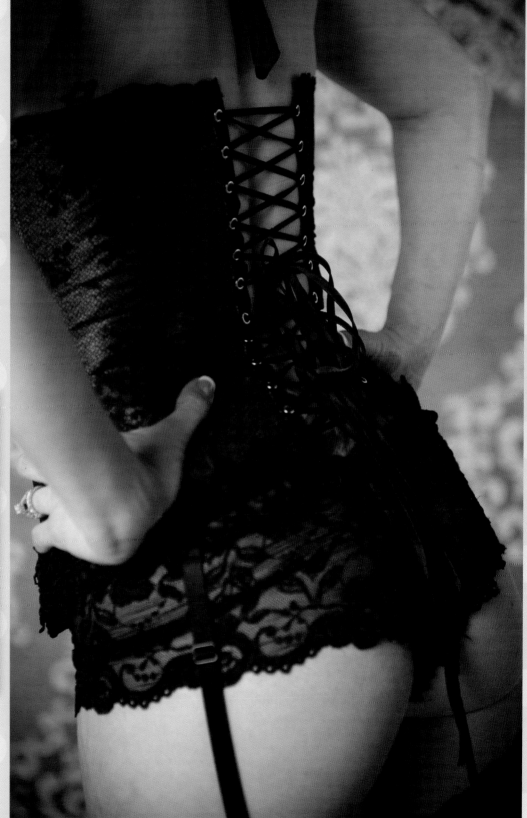

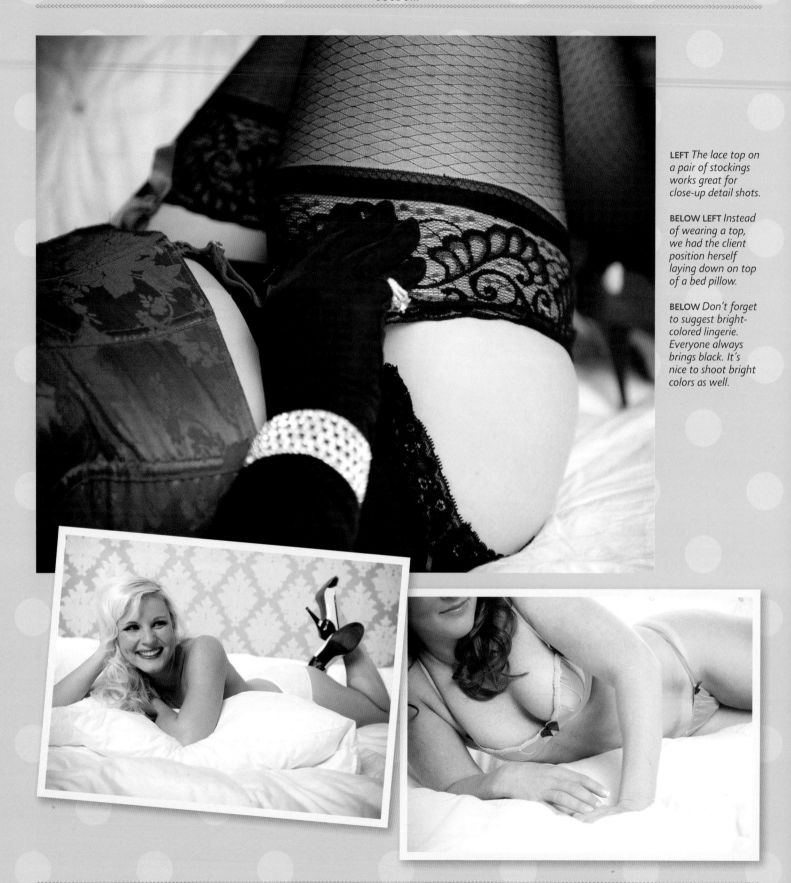

LEFT *The lace top on a pair of stockings works great for close-up detail shots.*

BELOW LEFT *Instead of wearing a top, we had the client position herself laying down on top of a bed pillow.*

BELOW *Don't forget to suggest bright-colored lingerie. Everyone always brings black. It's nice to shoot bright colors as well.*

When talking with my clients, I always ask them what their favorite body parts are. I don't ask what they don't like, as I want to keep the focus positive and away from things that might make them feel self-conscious when they're in front of the camera. If you then keep the attention on the parts they— and their significant other—like the best, you can concentrate on that part of their body and they will be happier with the overall selection of photographs.

When selecting outfits to photograph, make sure you have a variety. For example, if you're only shooting three or four outfits, you don't want them to all be the same color or style. If some outfits look similar, choose the one that will look the best and move on. I usually ask the client to put out all of the options, and then ask them which are their favorites—these will be pulled from the pile and set aside straight away. It's also much easier for you and your clients to select outfits when you can see them next to each other. Remember, that it's not your job to critique them, though. If they have a favorite outfit, and you're not a fan, keep in mind that they are the client and they are paying for these photos: the bottom line is if they want it, you shoot it. When a client asks you for your opinion, you want to be polite and objective. Don't say "that will make you look fat, so we're not shooting that one"—instead, suggest that a different outfit may photograph better.

Sometimes the best boudoir outfit is nothing at all, but I don't photograph nudes. However, I shoot implied nudity all the time. There are lots of celebrities who have done risqué shoots over the years, and sometimes our clients want to recreate a specific look. If your client doesn't have a large selection of wardrobe to choose from, this is an excellent suggestion, but you need to have a variety of materials in your studio to help achieve this. It would also be wise to practice shooting this type of set in your own time, so that when the time comes for you to photograph a model, you'll know exactly what you're doing. You don't want to be anything less than professional at any point in your shoot, especially when working this type of set.

You should pay particular attention to what your model wears on her feet—although you're implying nudity, there are very, very few cases where I will let a client go without heels in the studio, and the taller the better! Most of the time, I end up using the same pair of super tall, black heels for every outfit, but try to avoid using a shoe that will come up around the ankle, as this appears to shorten the leg in photos. Girls love them, I know, but when you tell them that this is what happens when they wear them in a photo, they'll want to listen to your professional expertise.

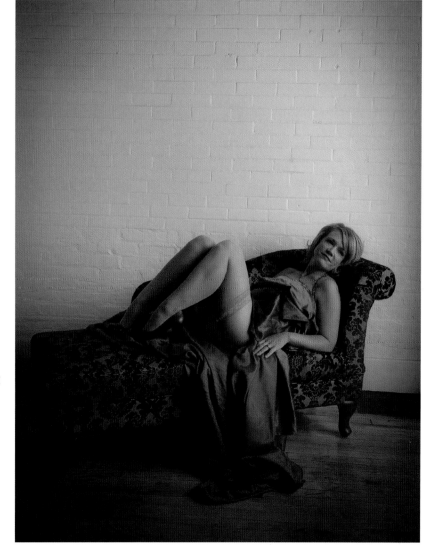

RIGHT *Sometimes the best piece of wardrobe is no wardrobe at all. A satin bed sheet is all that was needed for this shot.*

Setting the scene

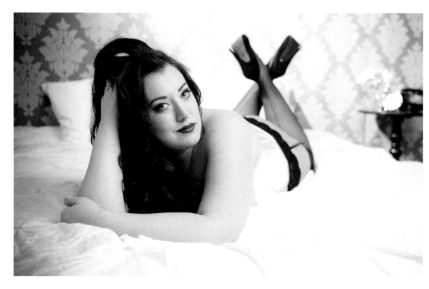

WHEN SHOOTING CLASSIC BOUDOIR photography, setting up the right scene makes all the difference. If you want your model to feel sexy, then you need to make sure that the scene you are creating is sexy as well, so your client has no problem acting the part. I have several different boudoir scenes that I use, but the most popular are bedroom scenes. I'll fix one of our sets up to look like a cozy, vintage-inspired bedroom, with a series of movable damask backdrops on the rear wall. Where the backdrop meets the floor I'll use a huge white painted baseboard to give the illusion that the backdrop is a wallpapered wall. Since I use this set for both standing and lying poses, I use a futon-type bed that I can put in front of the wall and dress it to look like a bed. All that I need to add is a small night stand with a few vintage bedside items such as an old clock, a telephone, or a vase full of flowers, and the look is complete.

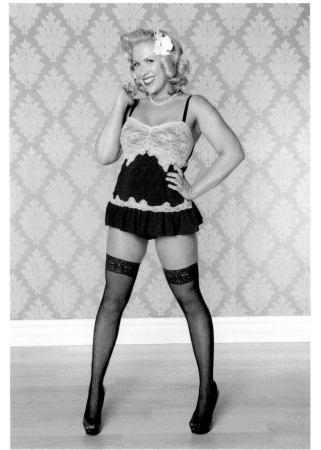

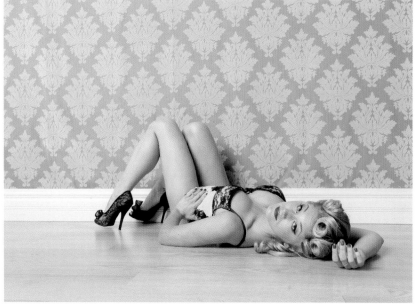

LEFT *By adding a baseboard on top of my background, I give the illusion that the wall is covered with wallpaper.*

ABOVE *If you do not have a bed, lay your client on the floor. Just remember to sweep and mop.*

TOP *Add a nightstand to complete the bedroom look.*

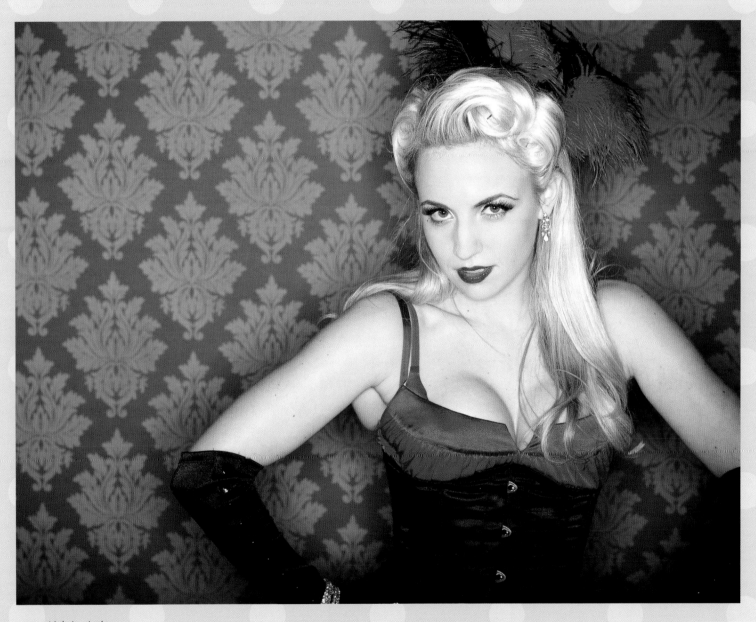

ABOVE *Lighting is the easiest way to set the mood for your boudoir shot. This is the same background that was used in the photos to the left. Instead of lighting the background, I only lit the client. Instant drama!*

LEFT *By tightly cropping your shot, you can get by with a very small shooting area. No big background needed here!*

ABOVE *A simple curtain and red chair were all I needed to create this boudoir set.*

RIGHT *You can't shoot boudoir without a big fluffy bed.*

BELOW RIGHT *By using a mirror, we are giving the client a two-for-the-price-of-one kind of shot.*

BELOW *Floor mirrors make great boudoir photo props.*

As well as the "vintage" set, I also use a set that looks more like a swanky city loft. The studio is in an old industrial building, which I have renovated to look like a loft space. A huge black bed is placed in the corner, and I'll add white bedding almost all of the time as this black-and-white combo goes well with any lingerie the client might be wearing. As the ceilings are really high in this space, I hang a black chandelier from the ceiling and let it dangle just over the bed. Long damask curtains complete the look. Because this is a full working set and not just a wall backdrop as in the vintage set, it can be shot from a variety of angles, which allows me to mix close-up shots with wider angle shots.

Another popular set is the dressing mirror, which is a great way to show off both sides of your client in one photo. There is something naturally sexy about a girl getting ready, so I found a full-length mirror that I use for shooting, but I quickly found that I had to be careful how I positioned it. Initially, there were a lot of ugly studio items reflecting in it (clients do not want to see parts of the studio and light stands in their photos!), so I moved it into the bedroom set so the reflection is now of the bed.

If you have limited space, you can still set up a very nice boudoir scene using just a shower curtain and a chair. As your client will be sitting, you don't need a huge background, and comfy chairs are easy to find. A big, overstuffed chair makes posing your model very simple, so you can concentrate on taking great boudoir shots.

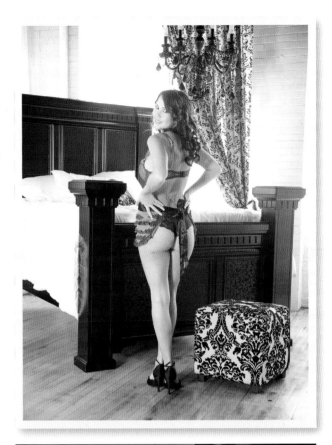

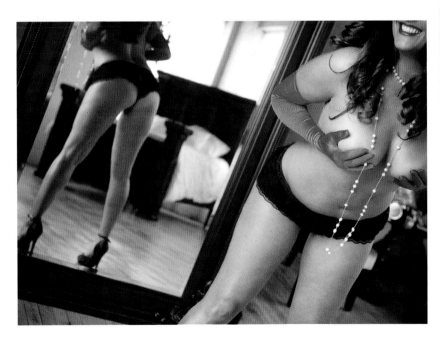

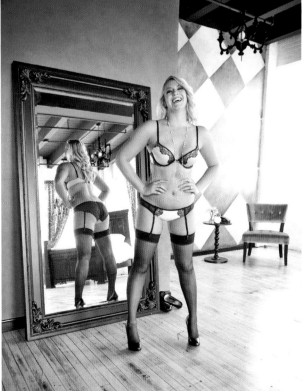

Boudoir poses

IN THE STUDIO, we always joke around with our clients. We tell them, while we are shooting boudoir, all they need to do is lay there and look fantastic! What they do not know, is that we are making subtle adjustments to their bodies as well as our camera angles to insure they are indeed at their sexiest. Every shoot starts off with a basic pose. It's good to have a few "go tos" in your collection.

POSE GUIDE

On her back

IT IS A GOOD IDEA to have poses you can go to that will flatter all body types, such as this classic boudoir pose, but it will work especially well with curvy girls.

At my studio, I am mostly photographing "girl next door" types, not working models, so I am almost always shooting clients who are insecure about one part of their body or another. Instead of telling a client "that doesn't look very good, let's try this," it is always better to know what poses work for each body type. Since this client was rather busty and had gorgeous eyes, I chose this pose to show off those features.

POSE GUIDE

On her side

THIS POSE IS ONE that I tend to use a little more selectively. You wouldn't want to use this on a curvier girl wearing an outfit that showed off her midsection, for example. You could, however, use it if she had a less revealing outfit to wear. One of your model's arms should be used to prop herself up, but make sure the other can be seen. If she has any part of her body that she wants to hide, she can rest her other hand on the bed in front of her. If not, keep the hand in sight by placing it on her hip.

POSE GUIDE
On her stomach

THIS POSE WORKS for everyone, but it is especially good when your client says that she wants to hide her tummy. If a client comes in with an outfit that is really revealing her midsection, but she tells you she doesn't like her stomach, this is the pose to shoot, and it is also one to go for if she wants to create more cleavage. Just remember to keep your model at a 45-degree angle to the camera so you can see more than just her head and shoulders.

POSE GUIDE
"Stocking pose"

THIS IS ONE OF MY FAVORITE poses, but only if the client has stockings on and preferably a garter belt. I call it the "stocking pose" because you see it on most packaging for thigh-highs. Any girl can do this one and if she likes her backside, or wants to enhance it for the camera, this is an excellent choice. Have your model stand with her feet crossed (right over left) then ask her to place her hands on her waist and arch her back. Voila— gorgeous booty!

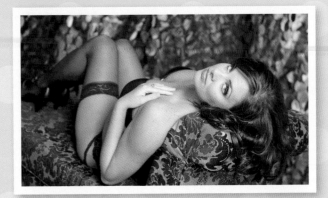

POSE GUIDE
Lounging

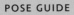

OCCASIONALLY I LIKE to spice things up a bit and pull out some prop furniture—a chaise longue is a great addition to any boudoir studio, or you can use a couch. Any body type can be photographed on it, but you need to be careful at what angle. It provides the same benefit to laying a girl on her back, but offers a greater variety of angles. A client who favors her bust will love how those detail shots look!

POSE GUIDE
Getting ready

I OFTEN LIKE TO MAKE IT APPEAR as if my model is in the act of "getting ready." She could prop her leg up onto a chair to attach her garter straps, be undressing, or getting ready for a night out—lots of sexy moments can be photographed when you put your client in any one of these scenarios. These shots tend to have more of a candid feel, rather than being perfectly posed, so it is up to you to make subtle adjustments as you go that show off her assets.

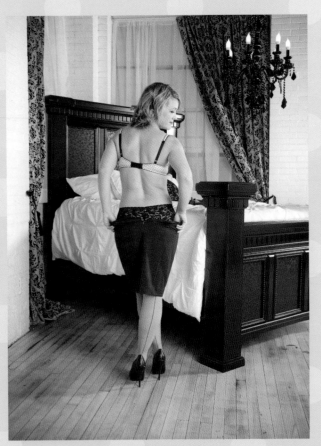

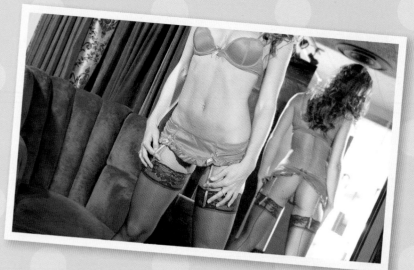

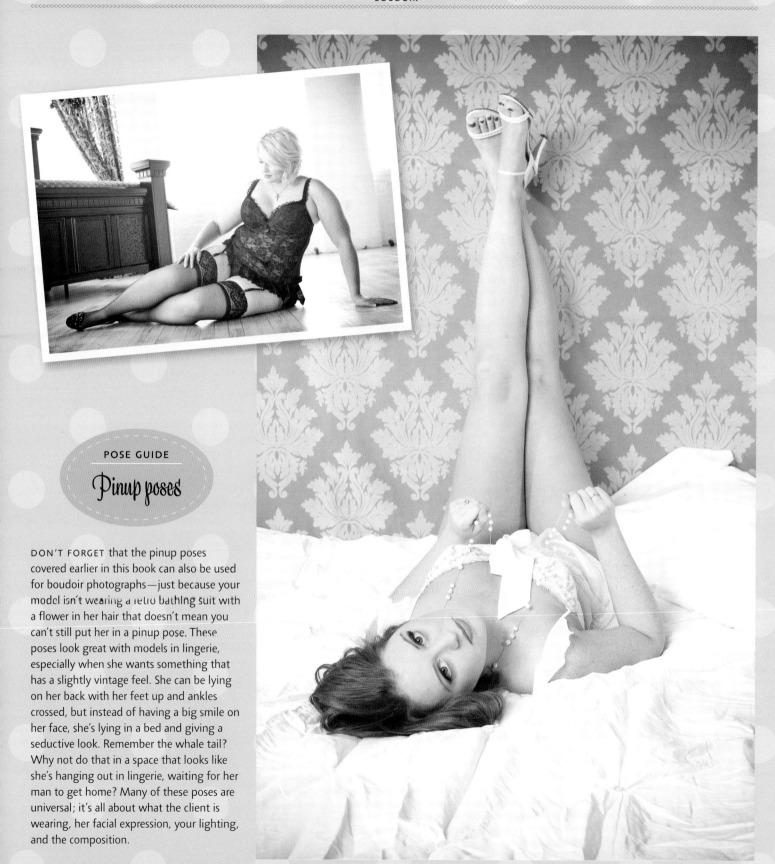

POSE GUIDE
Pinup poses

DON'T FORGET that the pinup poses covered earlier in this book can also be used for boudoir photographs—just because your model isn't wearing a retro bathing suit with a flower in her hair that doesn't mean you can't still put her in a pinup pose. These poses look great with models in lingerie, especially when she wants something that has a slightly vintage feel. She can be lying on her back with her feet up and ankles crossed, but instead of having a big smile on her face, she's lying in a bed and giving a seductive look. Remember the whale tail? Why not do that in a space that looks like she's hanging out in lingerie, waiting for her man to get home? Many of these poses are universal; it's all about what the client is wearing, her facial expression, your lighting, and the composition.

Boudoir lighting

LIGHTING A BOUDOIR SET is very different to lighting a pinup shot. This is due mainly to the vastly different camera settings used for boudoir photography, as you will see on the following pages. A lot of my boudoir images are shot with natural light, which is made very easy thanks to my studio's large windows. However, not every day is bright, and some shoots are scheduled for night-time, at which point I need to break out the studio strobes.

I use the same studio lighting equipment that I use for my pinup photos, but the big difference is the power settings I use. Pinup shots are typically taken using a much smaller aperture setting than boudoir photographs, so for boudoir work my strobes normally stay at their lowest power settings.

When setting up my boudoir lighting, I first determine whether I want a moody and dramatic feel to the photo, or a lighter, fun, and flirty feel. Switching between the two is most easily done by changing the angle of the light; if you shoot with your main light straight onto your subject, the light falls evenly onto her face and body, but if you move your main light off to the side, you introduce shadows, which gives the photo more drama. The same applies to your background lights. If you light your background evenly, the mood will be light and airy, but move your background light(s) so shadows are cast along your

background wall, and you've added some drama. You can also try taking things from around your studio and placing them in the path of your background strobe to create shadows—you'll be surprised how much of a difference this can make to the look of the shot.

As with pinup photographs, I use various light modifiers when shooting boudoir, although this time they are generally used to soften the light from my strobes. If I want a soft headshot, for example, I might break out our softbox, while a full-length shot of a girl lying in bed will have me reaching for my big parabolic reflector. If I want to shoot boudoir photos that have the look of a model's portfolio, then I'll use a beauty dish. All three of these light modifiers will give a unique look and they are great tools to have at the ready.

One other light source worth mentioning is a continuous video light. Normally, I prefer to use strobes for everything, but when shooting at wide aperture settings video lights work well. They are also a very cost effective way to start experimenting with lighting. On top of all this, they are very easy to work with, because what you see is what you get—the light stays on all the time so you can simply move it around until you get the precise look you are after.

BELOW LEFT *An inexpensive video light works great when shooting at f/2.8. What you see is what you get.*

BELOW *A large parabolic provides smooth, even light.*

BELOW RIGHT *Shooting during the day is a breeze when you have tons of natural light.*

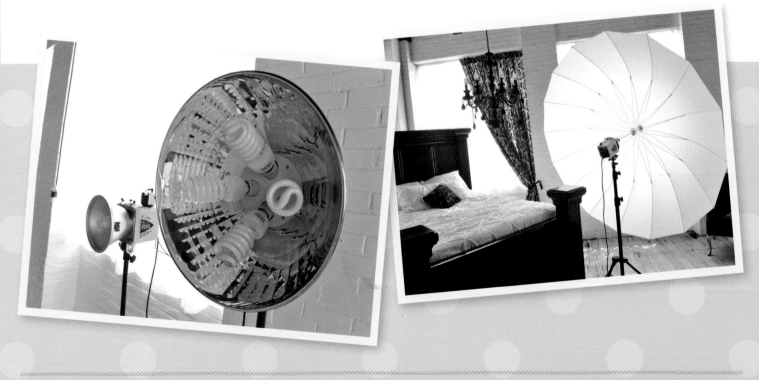

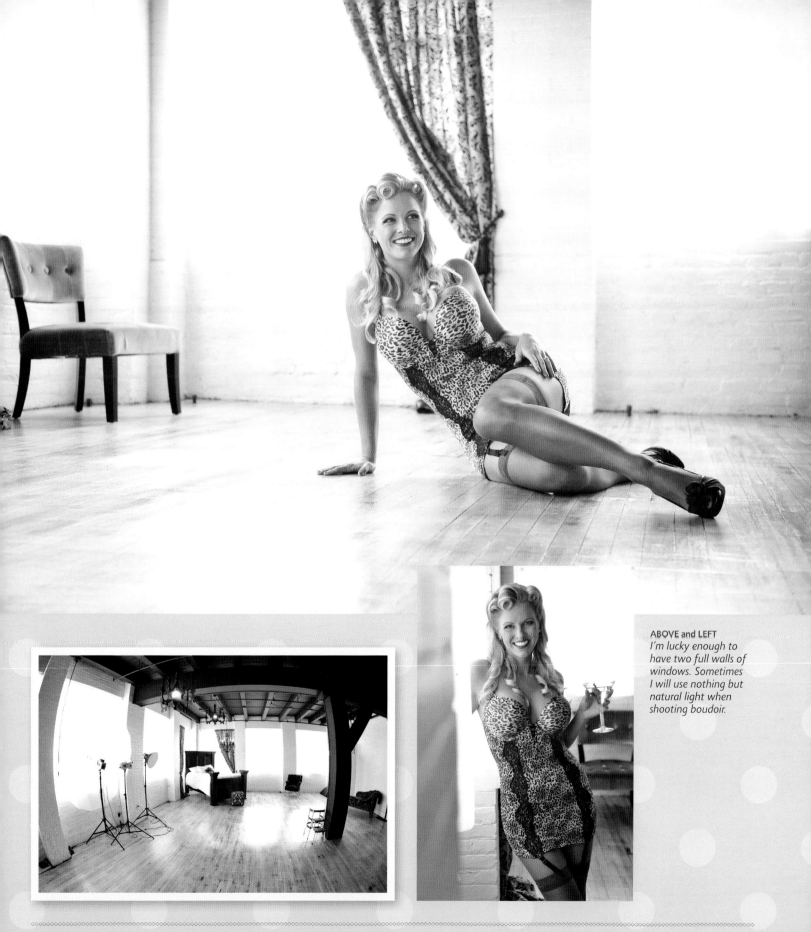

ABOVE and LEFT
I'm lucky enough to have two full walls of windows. Sometimes I will use nothing but natural light when shooting boudoir.

Camera settings

T HE CAMERA SETTINGS I would recommend for boudoir photography couldn't be any more different to the settings for pinup work. With pinup images I always shoot with an aperture around f/8, as pinup shots need to be tack sharp throughout the frame. However, boudoir photography is often shot with the aperture wide open. This makes prime lenses great for this style of shooting, as some will open up to f/1.4 or f/1.8, whereas even the fastest zoom lenses have a maximum aperture of f/2.8. The reason I shoot at this aperture is because it gives a very narrow depth of field, so it's quite easy to highlight a specific part of the body—if you want the bust line to be in focus, the rest of your model will be out of focus.

When shooting at such a wide aperture, you will be faced with a number of difficulties, but the biggest would have to be focusing, because if the focus point is slightly out it can ruin the shot. One way to overcome this is to set your camera to its Continuous focus mode, and you may also want to keep your camera in single point auto focus. In this mode, you can select the focus point you want to use, which is quicker and more accurate than allowing the camera to choose from multiple AF points.

While shooting a boudoir client, I will utilize the depth of field, moving the focus point around to showcase different parts of the model's body. Lingerie always has lots of detail, and clients are normally wearing jewelry as well, so all of these items can be picked out by the shallow depth of field.

INSET *When shooting at a wide open aperture setting, you can control what part of your client's body the camera is focused on.*

RIGHT *Just a slight adjustment in your focus area changes the entire look of the photo.*

Now that you've dealt with the aperture, you can figure out what shutter speed you need to use. If you're trying to go for a dramatic scene, you'll probably want to set your shutter speed to the camera's maximum flash sync speed, which will be somewhere around 1/250 sec. This relatively fast shutter speed will darken the exposure for the ambient light in the scene and allow your studio lighting to dominate.

If you want a more light and playful feeling for your photo, then you can use a slower shutter speed that will allow the ambient light to impact on your exposure more. The actual shutter speed for this will depend solely on the amount of ambient light in your room and your preferred look; I like to overexpose my backgrounds when shooting with natural light, for example.

ABOVE *The shot above was taken with the aid of a studio strobe. I wanted to slightly darken the room, so I increased my shutter speed.*

RIGHT *The photo to the right was taken with natural window light. By slowing down my shutter, I can control how bright the room is.*

Vintage hat

BEHIND THE PICTURE

Clients love this photo, and it has got to be one of my most popular boudoir styles. It has a very vintage feel to it and works with the majority of clients that request it.

The very first thing I do is ask the model to put on the vintage hat, and then I explain that throughout this part of the shoot she needs to remain very still. The reason for this is because I shoot with an aperture setting of f/1.4 to minimize the depth of field, and also to make sure that the netting that's pulled down over her face disappears totally, making her eyes visible. All of this means that the slightest movement will change the point of focus entirely, so I will have the model sit down to make it easier for her to stay still.

Since I always shoot this at f/1.4, I set the aperture manually, and also set the ISO to 200 (its lowest setting) for optimum image quality. With that out of the way, I just need to determine the shutter speed. I want a little bit of ambient light from the room to light what little of the background is visible, so I take a few test shots to determine the shutter speed, and also to see whether I need just a little more light on the model's face to make the photo pop.

If more light on the face is needed, then I use a single studio strobe with a big softbox. However, rather than use the flash, I simply turn the strobe's modeling lamp on, and aim it at the model's face. The softbox turns the modeling light into a large wall of light and I can simply move it closer to the model, or further away from her, until the lighting is just right.

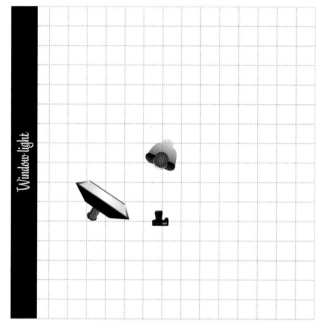

Window light

ABOVE *A simple one-light setup was used for this series of shots.*

BELOW LEFT *Window light controlled the ambient light in the room and a softbox added nice even light to my client.*

BELOW *With this type of shot, I always focus on the eye closest to me.*

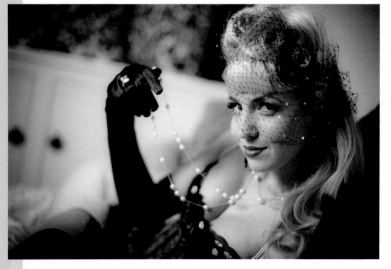

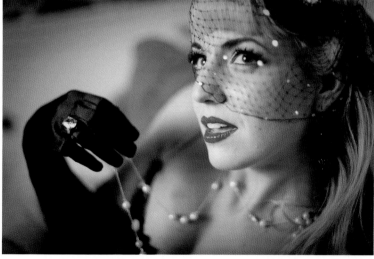

ABOVE *With an aperture of f/1.4, the depth of field is very shallow. Notice how the veil is blurry, but her eye is in focus.*

Laying in bed

BEHIND THE PICTURE

WHEN I SHOOT A BOUDOIR PHOTO SESSION, I like to include a variety of shots for the client: different camera angles, detail shots, and full-length body shots. The best way to fit all of this in—without spending an excessive amount of time on the shoot—is to have a lighting setup that you can set once and forget about. When your lighting remains stationary and consistent, you can move around and give your shots some variety, but you're not constantly adjusting the lights, so you have more time to relax and shoot your client well.

For this session my client wanted something fun and flirty, so I decided to go with a well-lit set using my loft-style bedroom. I began by lighting the background; it was a bright sunny day and I had plenty of window light, so I only needed to add a little bit of light for extra pop. To do this, I used a beauty dish on one of my studio strobes and raised it about nine feet into the air on a heavy-duty light stand. For my main light, I used a second studio strobe shot into my 82-inch parabolic reflector, which was about six feet in the air, tilted down toward the bed.

I set my ISO to 800 and shutter to 1/125 sec, which gave me the bright, well-lit background I was after, and as I wanted a little bit of separation between my client and the background, I set the aperture to f/5. I started out shooting with my model lying on her back, taking a few full-length body shots, as well as moving in for close-ups—with this lighting setup I could pretty much move anywhere I wanted to and snap away. After getting a good variety of shots, and building my client's confidence by showing her how well they were turning out, I had her roll over onto her stomach. After she was reposed, I got out my stepladder to get some overhead shots of her lying in the bed with the fancy black chandelier in the foreground. Again, I didn't have to adjust any of my lights, so the session could flow smoothly from one sequence to the next.

Bed

LEFT *A simple two-light setup gives nice natural lighting for this type of shot.*

BELOW *The "bed shot" is a staple in boudoir photography.*

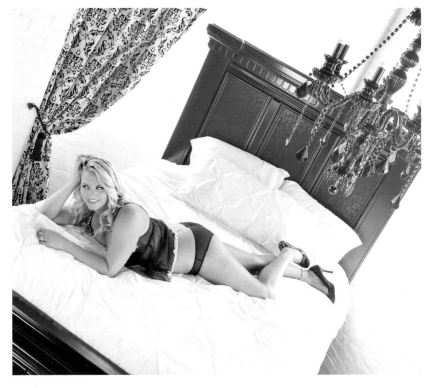

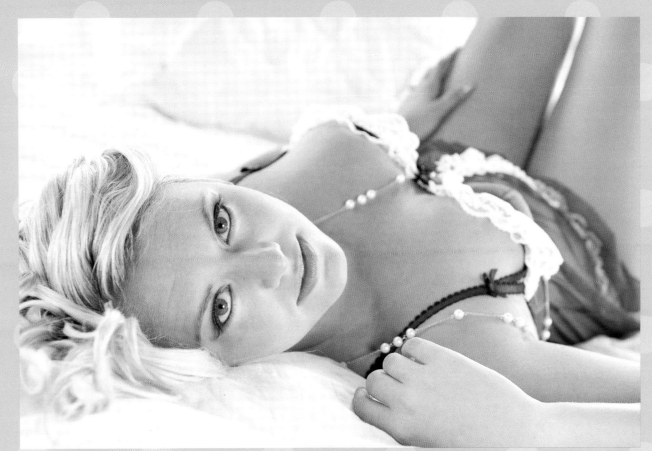

RIGHT *When shooting a tighter cropped shot like this, I always focus on the eyes.*

BELOW RIGHT *Be sure to shoot a mixture of close-ups and wide-angle shots during your photo shoot.*

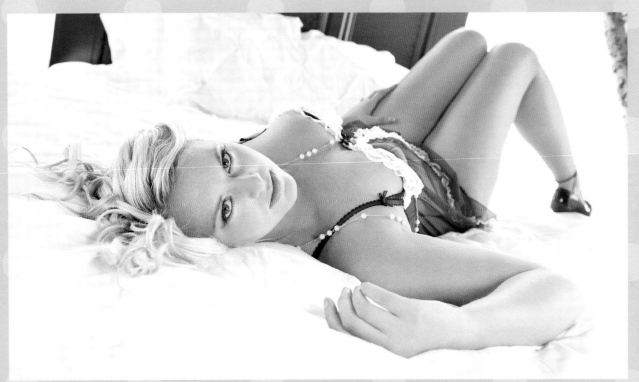

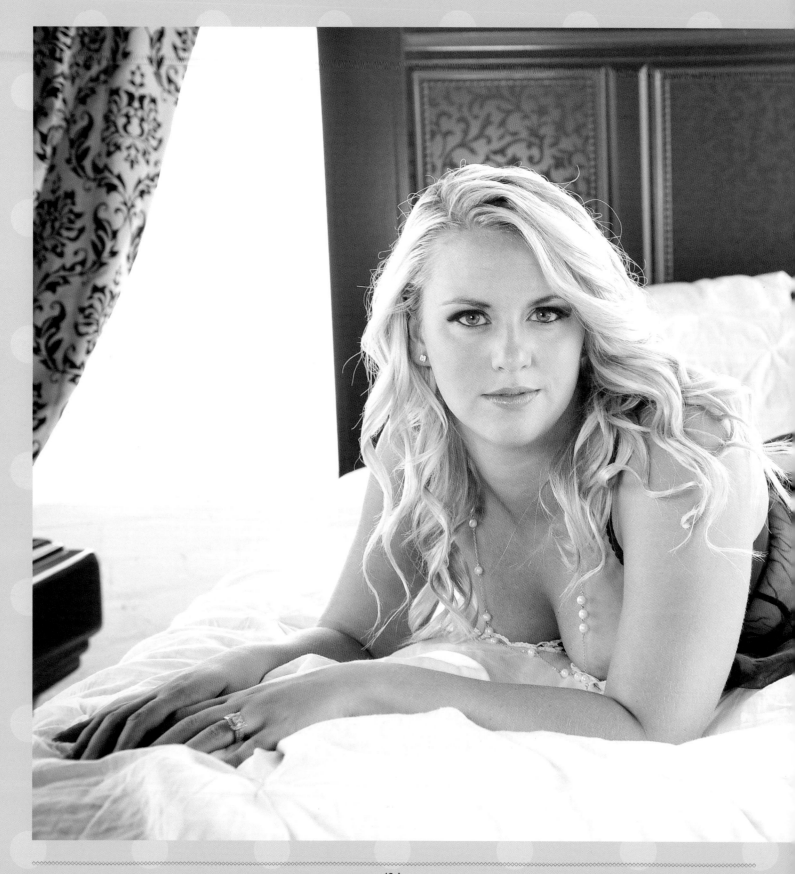

LEFT *I like to keep my camera on the same plane as the client's eyes for this type of shot.*

BELOW *If you have a large set, be sure to pull your camera back for a few shots and capture it.*

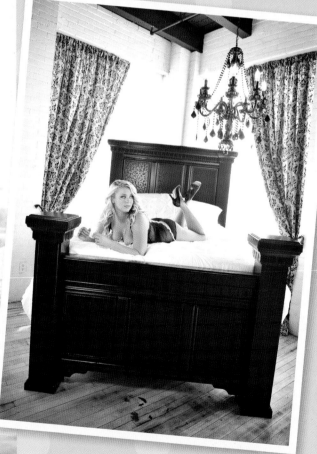

Dressing mirror

BEHIND THE PICTURE

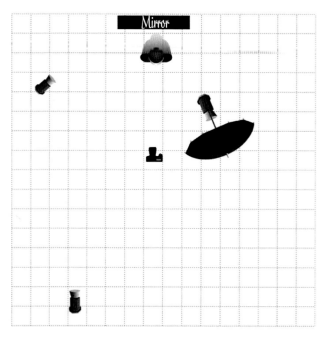

F YOU'RE LOOKING FOR A CHALLENGE, try shooting your boudoir client with a large mirror. Not only do you have to worry about what the front of your model looks like, but you also need to focus on what her backside looks like, as well as paying close attention to what is reflected in the mirror.

The mirror in the images shown here was actually in our studio for the models to use when they were changing and I had never really considered using it as a prop. That changed when a client came in who had seen some photographs in a magazine of a model posing in lingerie in front of a large mirror. She looked over at our mirror and said "kinda like that mirror." At this point, I had never shot with a mirror before, but figured what the heck—I couldn't tell her no.

I had my assistant give the mirror a good clean, and started to position my lights. I knew I had to light the side of the model facing the camera, so I started with that. I stuck a studio strobe on a light stand and added my big parabolic. I had this to the right of me and aimed straight at her. With the big parabolic sitting at an angle to the mirror, I could not only light the side of her that was facing me, but also the side that was facing the mirror, thanks to the light it reflected back.

Next, I used a strobe with a 30-degree grid positioned about 12 feet away from the mirror on the left and aimed at the top left corner of the mirror. The light would graze the model's head (adding a little pop of light to her hair), as well as reflect from the mirror to backlight her hair as well.

LEFT *Be careful when placing your lights. You don't want to see them in the mirror's reflection.*

BELOW LEFT *The mirror shot works great for clients with no problem areas.*

BELOW *I always have them act like they are getting dressed or undressed...*

Finally, I needed to light the rest of the room, as this would show up in the reflection. To do this, I used a bare strobe at the back of the room, aimed straight up at the ceiling.

With all the lights in position, I brought in the model and told her to just do her thing and have fun with it. As she did, I got some great shots, and as she was moving around I noticed that if I let a little bit of the hair light hit my camera via the mirror, I got a small amount of flare that resulted in a very cool, high fashion kind of look.

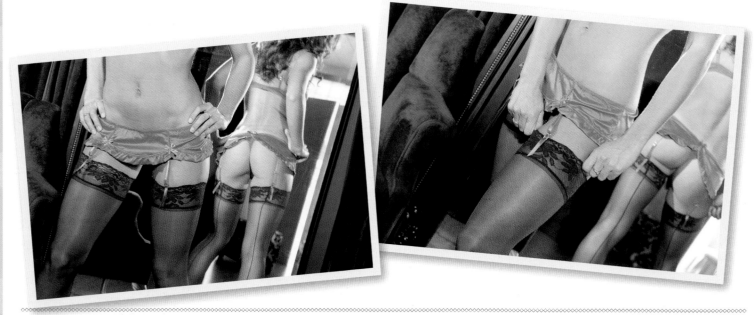

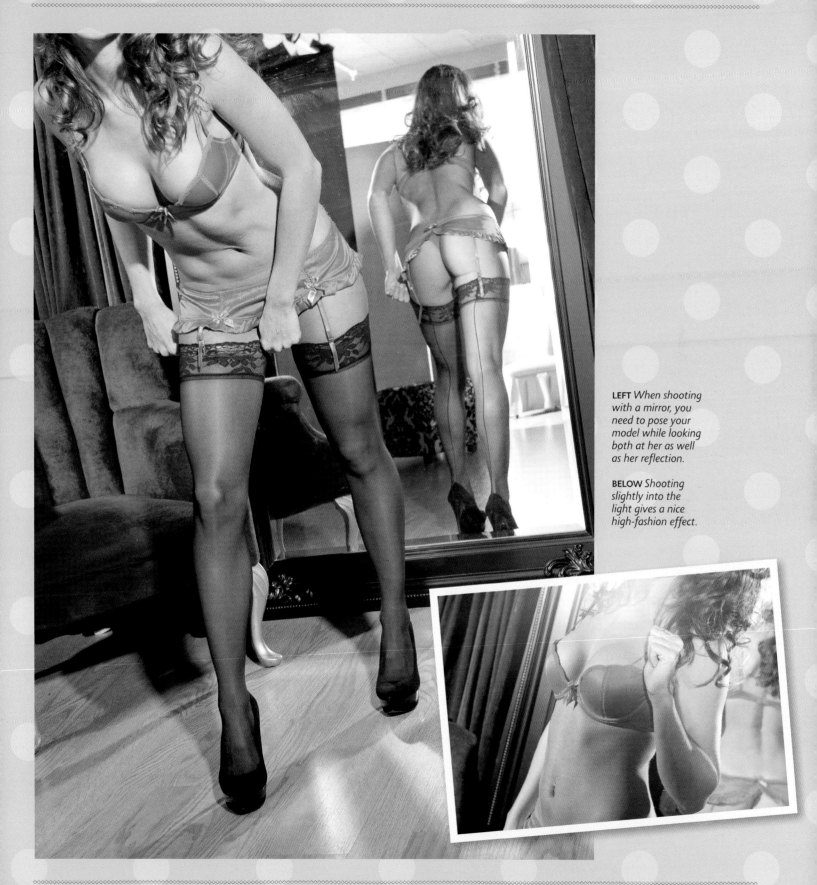

LEFT *When shooting with a mirror, you need to pose your model while looking both at her as well as her reflection.*

BELOW *Shooting slightly into the light gives a nice high-fashion effect.*

Dramatic black & white

I HAD A CLIENT COME INTO THE STUDIO who wanted a very dramatic black-and-white scene, that included her in a bedroom with a "classic Hollywood" feel to it. I took a look at the lingerie she brought with her and her outfit was perfect for this style of photo. She had all the vintage details; garters, stockings, and housecoat, so it looked like we had ourselves a Hollywood starlet!

As she changed into her outfit, I started getting things ready in the boudoir studio. I knew I wanted to photograph her on the bed, and standing next to it too, and that I wanted the photos to tell a story—perhaps she was waiting for her man to get home?

Once she was ready, I had her stand next to the window and started off shooting with just natural window lighting and a studio strobe as a fill light for the bedroom set. After I had taken a few window shots, we moved over to the bed, starting with a few simple standing poses before she hopped up onto the bed.

For the shots of her with the bed, she was a little too far away from the window for the natural light to light her well, so I used my parabolic reflector up high and angled it so that it was shining down onto the bed, creating a large, soft pool of light that filled in the whole scene.

As far as camera settings went, I shot this entire set with an aperture of $f/5.6$ to give me a modest depth of field, and I bumped my ISO up to 800 to give the shots a slightly "gritty" edge. The shutter speed bounced around from 1/60 sec to 1/250 sec depending on whether I was using flash or relying purely on the ambient window light. Rather than capture the images as black-and-white photos, I actually shot them in color, so I would have the option to use them in color if I wanted to. All of my black-and-white shots are made that way, with the conversion to monochrome coming in Adobe Lightroom during post-production.

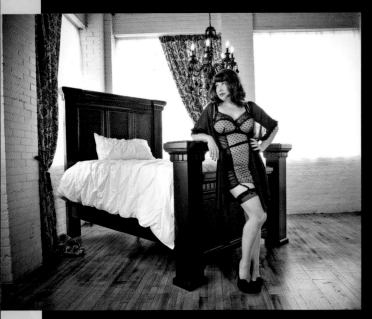

ABOVE *This style of black-and-white photography just screams old-style Hollywood.*

RIGHT *Dramatic facial expressions are a must for this style of shooting.*

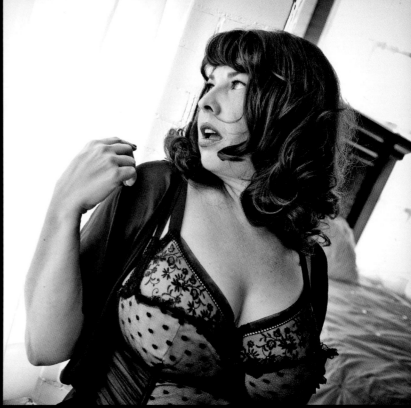

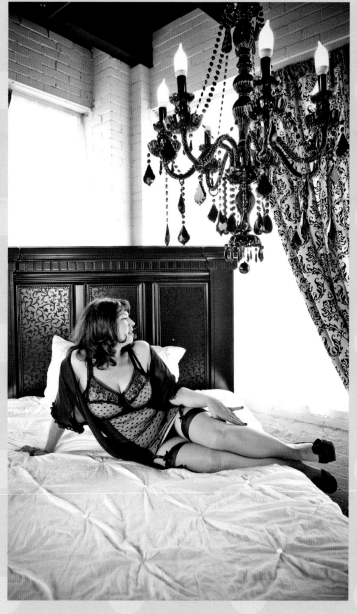

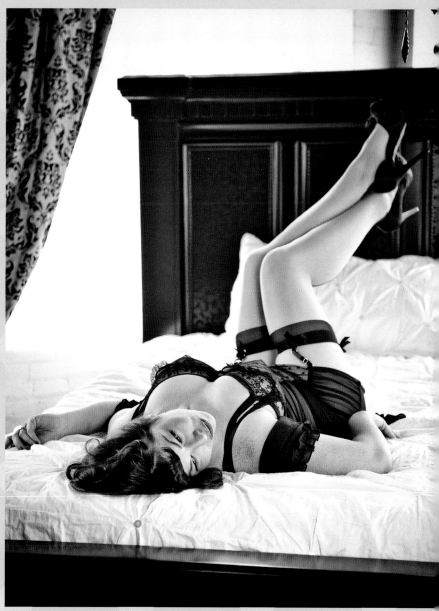

ABOVE *I almost always have the client looking off to the side for this type of shot.*

ABOVE RIGHT *Classic pinup poses work great, but a more serious facial expression is needed to pull it off.*

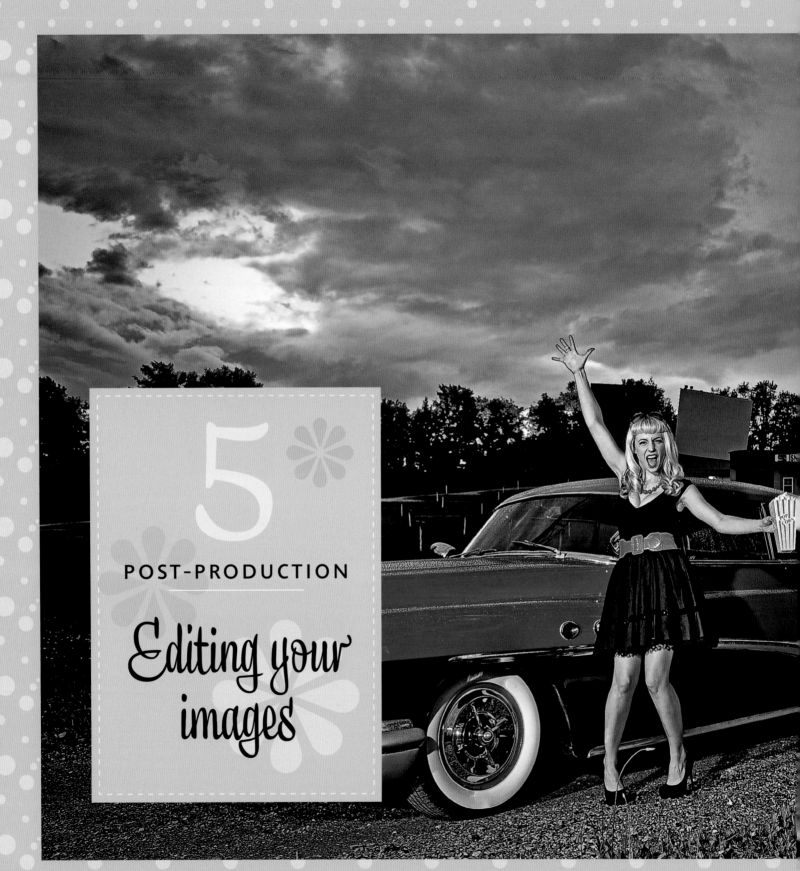

5

POST-PRODUCTION

Editing your images

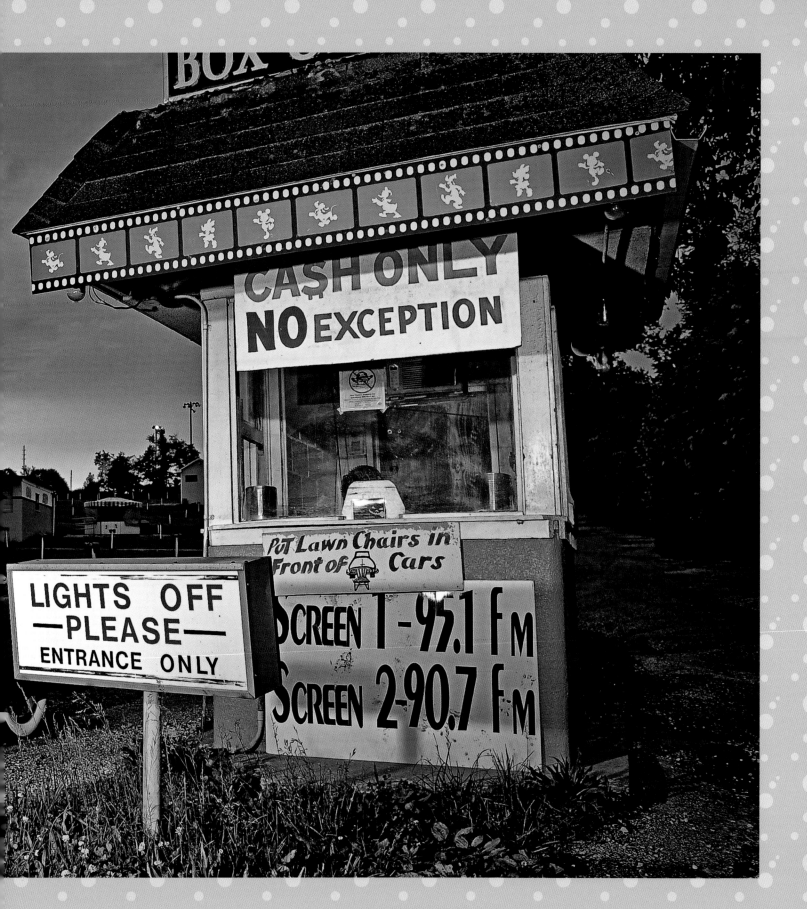

Workflow

STEP BY STEP

YOU CAN'T TALK ABOUT DIGITAL PHOTOGRAPHY without mentioning workflow. In the past, if you shot film you would take the exposed film out of your camera and drop it off to the lab for processing—that was workflow. Some brave people even developed their own film.

But with digital photography, actually taking photographs is only half of the process because a digital image needs to be optimized, or at the very least transferred from the camera's memory card. There are many different ways to go about this, and everybody has their own preference, but I will walk you through my workflow. I use Adobe Bridge to manage my photographs; it is bundled with Adobe Photoshop and integrates perfectly with the editing program. I also like using Bridge because of its easy user interface.

3 The next step is to select the images I want to edit and deliver to the client, as outlined on page 144. For this, I use another Adobe product; Lightroom. After launching Lightroom, I import the image folder from Bridge. I know this is an extra step, and you can load your pics right into Lightroom, but I just like using Bridge to start with.

1 The first step is to get your images onto your computer. I simply pop my memory card into a card reader and Bridge goes to work, adding my images to a new folder.

2 Once all of the files have been downloaded, I can quickly scroll though my photos from the shoot. I can also view the EXIF data, which lets me see what camera settings I used for a certain image.

4 Now that I have narrowed down my images, it's time to edit and retouch them. For retouching I use Adobe Photoshop, while all of my creative edits are done in Lightroom. I start off by going through the five-star rated images and if I see an image that needs retouching, I click on it and open it in Photoshop. Once in Photoshop, I will do my retouching and resave the image, as outlined on pages 145–147. The resaved image will appear in Lightroom and I will continue retouching the rest of the images that need it.

4

5

5 When I am satisfied that any and all major retouching has been done, I move onto the creative edits using Lightroom (see pages 148–151). Lightroom is a very fast way for me to make adjustments to my photos, as I have created my own "presets" that I can apply. Presets allow me to edit an image and save all of the changes as a single preset. I can then apply the preset to another image, so I don't have to spend a bunch of time making all the changes individually— just click the preset and it's all done.

6

6 Once all of my images are edited, I export them by clicking the Export button. From here, I can resize them, choose which folder to export them to, and so on. I always add my finished images to a folder titled "Edited" inside the original folder, and once they have been exported, they all end up back in Bridge.

Image selections

STEP BY STEP

WITH DIGITAL PHOTOGRAPHY, it is easy to find yourself over-shooting and ending up with hundreds of images, even though you only need one quarter of that amount. One of the hardest things to do is to cut down that folder of images from your shoot, but it is an essential step. Thankfully, Lightroom makes it a bit easier for you to figure out which shots are "keepers."

3 To help me identify five-star images, I use certain criteria when making my selections. If an image is even the slightest bit out of focus, it gets passed over and forgotten about; if the studio lights misfired, that frame is gone forever; and if the model moved when I snapped the photo, there is no way to edit that back into place, so those shots get discarded as well. All photos where the model has her eyes closed or appears to be making a weird face are gone as well, although I will often keep a few of the goofy pics to slip into her gallery to make sure she is paying attention!

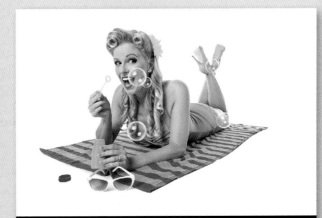

1 With your images in Lightroom, you can scroll through them quickly and view them almost full-screen. The area at the bottom of the Lightroom window displays all of your images in the order that you shot them in—you can use the arrow keys on your keyboard to zip through them.

2 To help me identify which images I want to use, I go through every shot from my session and use the rating system built into Lightroom. If I like an image, I will press the "5" key on my keyboard to assign the image a five-star rating.

4 When I finish rating my images I apply a filter so that I am only viewing the shots with a five-star rating. It is then time to retouch and edit them.

Retouching in Photoshop

STEP BY STEP

Photoshop is a very powerful image-editing tool that can enable you to change someone's entire appearance with just a few swipes of the mouse. One of the things that I try to avoid when retouching is making the model look like someone else—retouching should be used to help enhance a client's natural beauty, rather than hiding it or changing her features.

2 Although this model has a gorgeous eye color, I feel that the photo could be much more striking if one or two areas are touched up. With this particular pose it is common for a vein in the temple area to become more obvious, while the expression can make wrinkle and laughter lines more prominent. I want to correct both of these elements.

3 Before you start your retouching, duplicate your layer. This is a useful habit to get into, especially if you are new to Photoshop, as it will allow you to go back and check that your retouching hasn't gone too far.

1 Once you've opened your image in Photoshop, study it and ask yourself if anything stands out as a distraction? In this example, the thing that catches my attention straight away are the model's eyes.

2

3

Original Image

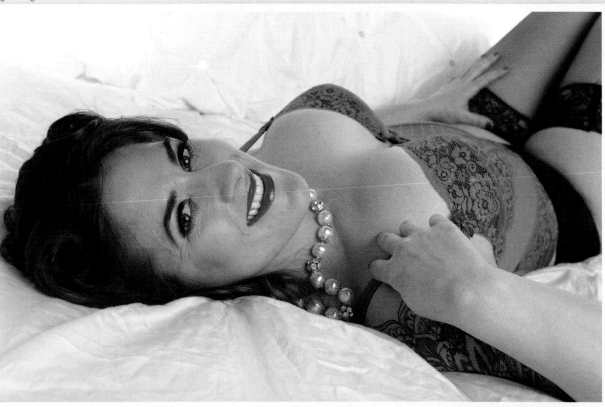

1

Retouching in Photoshop

STEP BY STEP

4 With this shot, I'm going to start my retouching around her right eye, so I'll zoom in close so I can see clearly what I'm working with. I'll start with the Clone Stamp tool, making sure that the opacity is set to a low value of 15–20. This is because you can make subtler adjustments if you go over an area more than once to "build up" the correction, rather than making a single pass at a higher opacity.

5 I will select an area of skin as my cloning "sample" that is very close to the area I want to retouch and use this to make the vein and wrinkles less noticeable. Once the skin tones are evened out, I will switch to the Healing tool to go over any slight discoloration until it's gone. Keep in mind that skin has texture, and you don't want to lose this in the area you're retouching. To avoid this, I work on one area at a time, and zoom in and out frequently to check my progress.

6 With the laughter lines and smaller wrinkles I use the same method; the Clone Stamp tool to make the blemishes less noticeable, followed by the Healing tool to tidy up the cloning. If you want the blemishes gone completely, use "Content Aware" healing in Photoshop CS5, or make sure you've selected Proximity Match in earlier versions of the program. I keep the brush size fairly small so that it doesn't affect the skin around the blemish. This is also useful if you want to remove any shine on the model's skin.

7 After I've finished with these areas, I zoom out, check my work, and see if there is anything else that needs to be touched up. I'm sure if I spent long enough staring at an image I could find a thousand things to do, and spend hours on a single frame, but you have to stop somewhere!

Of course, you could be lazy and blur the skin to remove all imperfections, but in doing so you will lose texture. Your client will know immediately that they've been Photoshopped and some may find that a little offensive, which is the last thing you want.

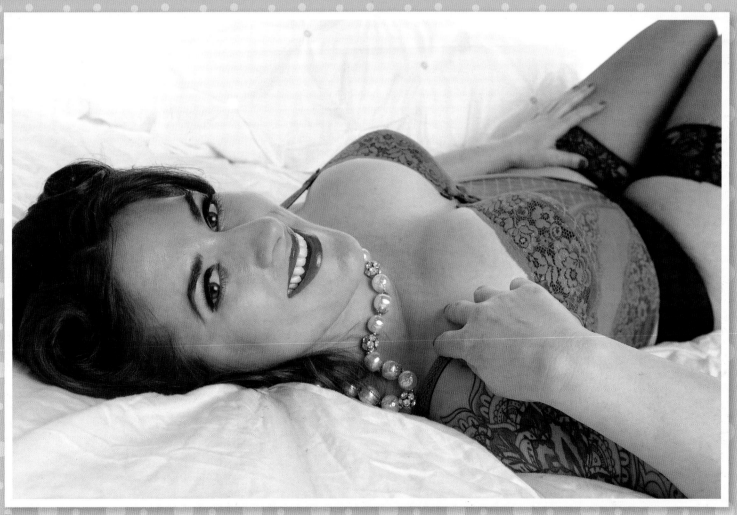

7 Final Image

Lightroom effects

Now that you have selected and retouched your favorite photos from your session, it's time to do your creative edits. I do this in Lightroom, as it has a very easy-to-use preset feature and the sliders to the right of the screen in the Develop module make it very easy to add subtle adjustments. My personal style is to keep my pinups in full color—the outfits and props have fun colors in them so I like to keep that in the photos. If you are not familiar with Lightroom and using presets, the following steps will help you cut your editing time in half compared to editing in Photoshop.

1 Images are selected from the "filmstrip" at the bottom of the Lightroom screen. When you have the image you want to work with on screen you need to enter the Develop module, which is where all of the editing tools are found. At the right of the screen are sliders for manually controlling your settings, while presets, snapshots, and history categories appear at the left of the screen.

2 When you expand the Presets category, you will see a list of default presets to choose from. Lightroom offers a unique feature that allows you to preview the preset before you select it; simply roll your cursor over a preset and the effect it will have is previewed in the small copy of your image in the Navigator. When you find a preset that you want to use, just click on it to apply the settings to your image.

3 As well as choosing a default preset, you can also create your own, although you first need to familiarize yourself with Lightroom's various editing options. In the column at the right of the Lightroom window, below the Histogram, are all of our favorite basic editing tools; the Cropping tool, Spot Removal, Red-eye Removal, Graduated Filter, and an Adjustment Brush. The only one of these that I use is the Cropping tool—any other retouching is done in Photoshop.

4 Below the "tool box" is a set of drop-down boxes that are categorized according to function. The first one listed is the Basic functions. This is where you will find the most commonly used features: white balance, lighting, and color/clarity settings. As you move the various sliders, you will see the effect they have on your photo immediately, which is great for quick editing.

6 Next is the HSL/Color/Grayscale option. This is a very powerful function as it allows you to make changes to specific colors by altering the Hue, Saturation, or Luminance, or a combination of two or three of these elements. Again, the image is updated in "real time," so you can see precisely what is happening to your photograph.

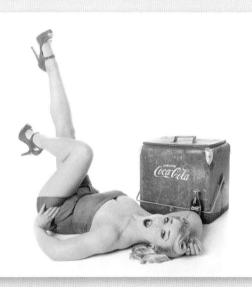

5 The next category on the drop-down boxes is Tone Curve, which can be used to control your Highlights/Lights, and Darks/Shadows. As before, move the sliders to see how the adjustments affect your image.

7 Split Toning is the fourth drop-down and used properly this tool will give you some really fun results. The sliders allow you to select the Hue and Saturation of your highlights and shadows, allowing you to introduce a different color into each area. However, be careful with this tool as it can give you some crazy, unnatural results!

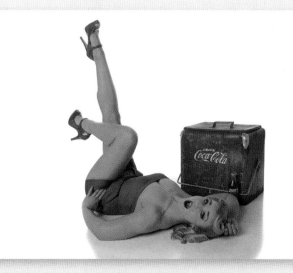

Lightroom effects

8 After Split Toning comes Detail. This is where you make adjustments to the sharpness of your photo, or apply noise reduction. This is great if you just need a small amount of added sharpness or noise reduction, but if your photo needs more serious attention, it may be better to use other, more specialist software.

9 The next useful tool you'll see is the Vignettes category. This provides you with a simple means of drawing attention to the center of an image by darkening the corners. The Lens Correction vignette is more subtle than the Post-Crop vignette, and is the one I use most often.

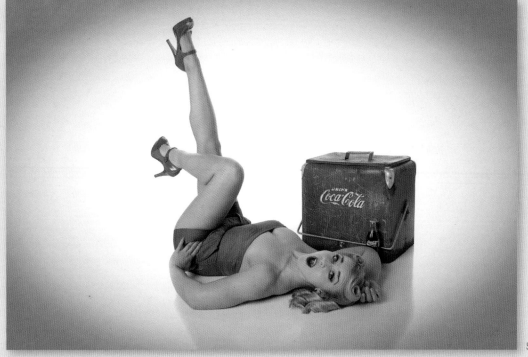

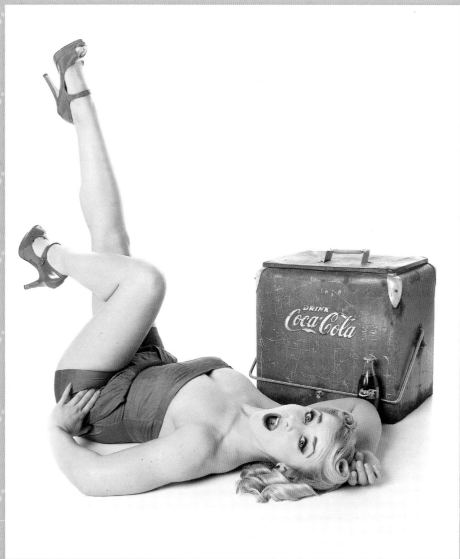

Final Image

10 Once you are familiar with Lightroom and all its creative tools, you can start to create presets that will help speed up your editing. To do this, edit an image using the tools outlined previously and, when the photo is to your liking, choose New Preset from the Develop menu at the top of the screen.

Your new preset will be added to the Preset list, allowing you to apply all of the settings again, using just one click of your mouse. Don't forget to give your preset a name that will describe what it does, so you can recognize it in the future!

Quick retro background

STEP BY STEP

IF YOU HAVE SPENT ANY TIME looking at classic pinup images, you will notice that some of them have funky, retro backgrounds in them. If you were to purchase all of these backgrounds, you would be broke in no time, so it is much cheaper to add them in post-production.

Original Image

1 First, I open up the image I want to add the retro background to in Photoshop. Then I open the image that I want to use for my background.

3

LAYERS | **CHANNELS**
✓ Normal
Dissolve

Darken
Multiply
Color Burn
Linear Burn
Darker Color

Lighten
Screen
Color Dodge
Linear Dodge (Add)
Lighter Color

Overlay
Soft Light
Hard Light
Vivid Light
Linear Light
Pin Light
Hard Mix

Difference
Exclusion
Subtract
Divide

Hue
Saturation
Color
Luminosity

2 With both images open, use the Move tool to drag your background image onto your pinup image. At this point, all you will see is your background image.

LAYERS | **CHANNELS** | **PATHS**

Normal | Opacity: 100%

Fill: 100%

Layer 1

Background

BACKGROUNDS

The internet is full of images to use as backgrounds, just be sure you have permission to do so. One of my favorite places to purchase background images is Etsy.com, which has lots of custom images that make great photo backgrounds.

3 To reveal the pinup photo under the background, you need to combine the images. In the lower right corner of Photoshop you will find the Layers palette. The default blending mode for any layer is Normal, but if you change your background texture's blending mode to Multiply your two images will be combined.

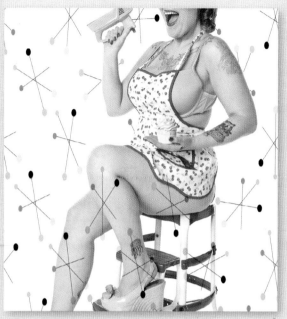

4

4 Although both images are combined, some of the background will be covering our pinup girl, so you need to get rid of it. The Eraser tool makes quick work of this—zoom in to make the erasing a bit easier.

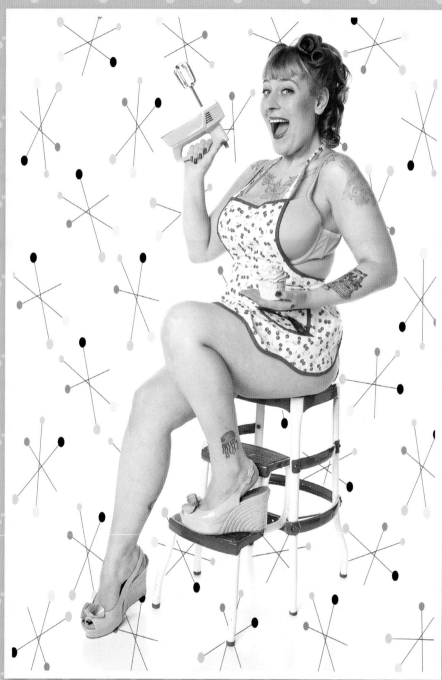

Final Image

ABOVE *The final image after the retro background has been added. With all of the background image removed from your model, you are left with a unique background to your pinup studio shot. This whole process took less than 45 seconds to do, but it was helped by careful background selection to start with; as the background image was white and I shot my model on white, it was very easy to combine the two elements.*

Quick retro coloring

STEP BY STEP

IF YOU WANT TO QUICKLY select an image and make it ready to show the world, a workflow-centric program such as Adobe Lightroom is fantastic (especially if you've got Adobe Photoshop on hand to make more detailed retouches). Since the emphasis here is on speed, I'll jump right into the steps.

1 I shot this pinup on a white background (with the background lit from both sides), so it will be a quick edit. First, I select the Paintbrush tool and choose white as my foreground color. Then I start to "paint out" any areas in the background of the shot that should be white.

2 Next, I select the Dodge tool and set the Range to Highlights and the Exposure to 50%. I go over everything that is white in the picture to make sure that it is pure white rather than a very light gray. As I am only affecting the highlights, this is a very quick thing to do.

3 Next, I remove the cord of the exercise machine. Just a simple swipe of the paint brush and it's gone!

4 I want to add a yellow background to this picture, so start by creating a new layer (Layer › New › Layer). This will add a new blank layer to the photo.

Layer		
New ▶	**Layer...**	⇧⌘N
Duplicate Layer...	Layer From Background...	
Delete ▶	Group...	
	Group from Layers...	
Group Properties...		

5 The next step is to select a color for your background. Do this by clicking on the "set foreground" color selector located toward the bottom of the tool bar. Once you have your color selected, choose the Gradient tool and pick a circular gradient from the tool options at the top of the screen. Set the Mode to Normal and the Opacity to 100%. Take your cursor and draw a line from the center of your image to the top—I always extend it slightly past the top of the photo.

Original Image

Range: Highlights Exposure: 50%

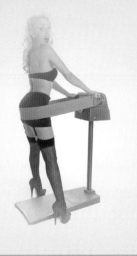

6 To make sure you can see the pinup girl, go to the Layers palette and change the gradient layer's blending mode from Normal to Multiple. Set the Opacity to 50%.

7 If the color is still covering parts of the model, select the Eraser tool and set its Hardness to 0%. Simply erase the color from the parts of the photo where you do not want it to show.

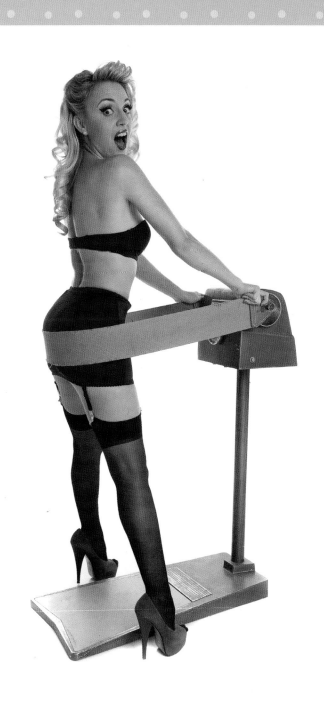

ABOVE *The final image with a touch of color, adding to the perfect vintage pinup girl look.*

Final Image

Dramatic lighting

STEP BY STEP

THERE ARE MANY TIMES when lighting doesn't work out in reality the way it does in your head. You will have an idea of what you want your final image to look like, but the sun will be in the wrong place, with no option to come back and shoot again. I always try to avoid shooting at certain hours of the day, but sometimes it is unavoidable due to the location, the model schedule, or for some other reason, so it's nice to have some tricks up your sleeve, both during shooting as well as when editing.

1 This shot was taken in Red Rock Canyon in the afternoon. I wanted the sun to light up the awesome red colored rocks in the background, but the problem was that it also pushed flat light on to my model, and the single Nikon SB800 flash I was using to light her just wasn't powerful enough. I wanted more drama in the final photo, so I decided to add a little punch in Lightroom.

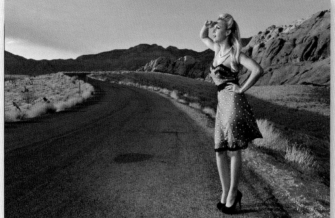

3 Returning to Lightroom, the next thing I wanted to do was to add a vignette to enhance the vintage feel and help pull the viewer into the center of the shot. To add the vignette I switched to Develop mode and opened the Vignettes drop-down adjustments at the right of the screen. I slid the Post-Crop amount to -58 to give a nice dark area around the photo and help make my model stand out—a little more drama, but still not enough.

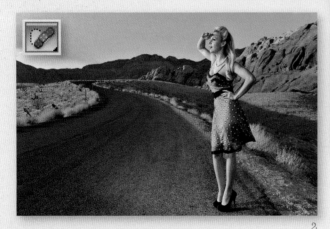

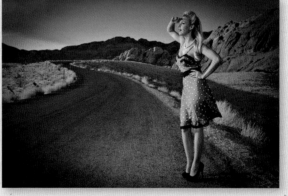

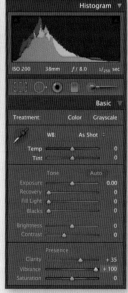

2 Before starting work on the lighting, I needed to get rid of a nasty oil spot on the road that I felt distracted from the pinup girl. Using Photoshop's Healing tool set to Content Aware quickly got rid of the spot.

4 To really make my shot pop, I decided to apply a "Dragan" effect, named after the Polish photographer, Andrzej Dragan, who is credited with inventing the process. This style of editing adds a lot of blacks to the image, as well as a huge bump in fill lighting, and while the two adjustments counteract each other they give a highly detailed look that is not dissimilar to HDR imaging.

First, I open the Basic drop-down and adjust the Clarity to 35 to give a little extra sharpness to the photo. Next, I take the Vibrance slider all the way to 100.

5 To balance out the wacky colors, I adjust the Saturation slider to -71.

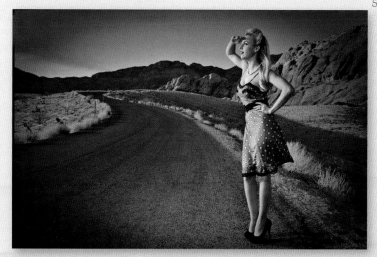

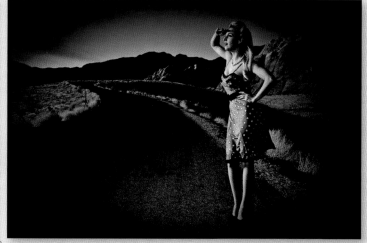

7 I need to counteract some of the added black by using the Fill Light slider, which I set to +100. The combination of high black levels and high fill light gives a very dramatic effect, but don't overdo it!

6 Next, I take the blacks way up to around +70—I know what you are thinking, this photo looks really bad now!

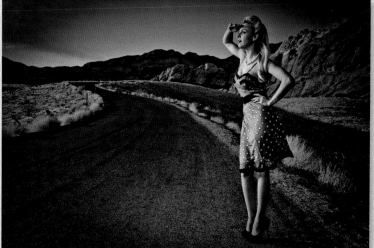

Dramatic lighting

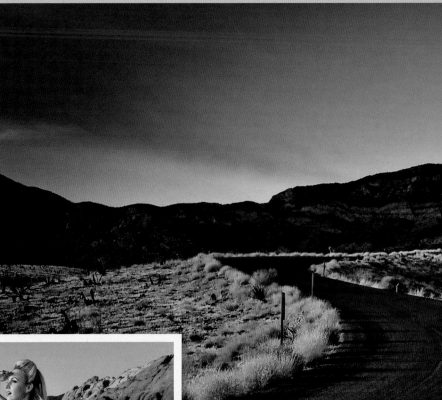

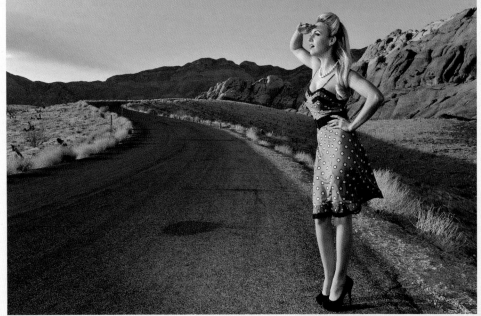

Original Image

ABOVE and RIGHT *By making a few basic adjustments in Lightroom I was able to add a lot of drama to this image in less than one minute. To make the process even quicker I could save the changes as a Preset.*

Final Image

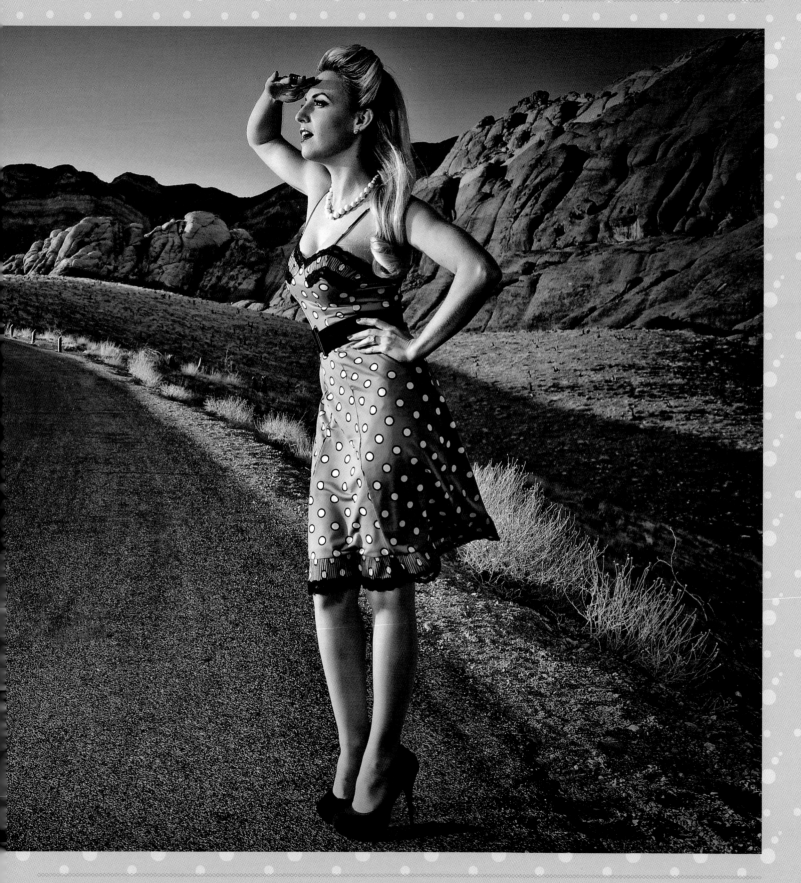

The drive-in

STEP BY STEP

THE DRIVE-IN SHOT is one of my favorite location pinups. It really shouldn't have turned out as well as it did considering I shot it in the middle of a thunderstorm, but because I concentrated on getting the key elements lit evenly, I knew I could rely on post-production to make everything pop. This is totally against what I normally do, but sometimes mother nature wins.

2 In the Basic drop-down I adjusted the Blacks slider to +20 to increase the amount of black in the image. This leaves me with a very dark image.

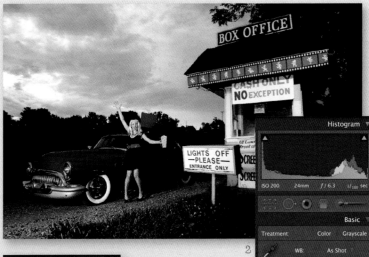

3 To bring the brightness back, I adjust the Fill Light to +65, although this makes the highlights way too bright.

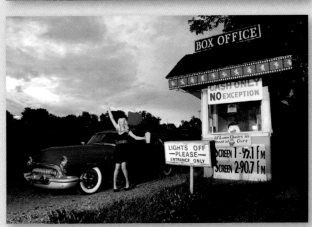

1 Because of the weather conditions the image was "flat" as shot, so the first thing I needed to do was to bump the contrast up to +100. The image seems to darken a bit, and the details in the photo appear to stand out more.

4 The highlights can be brought back using the Recovery slider. This is a great way to bring a little bit of detail back to an image that is washed out, but be careful—if you overuse the Recovery tool it can add a lot of noise to your image. For this image I set the Recovery slider to +81.

5 Now that I have the brightness and even lighting that I want, it's time to tone down those cartoony colors. I did this by pulling the Saturation down to -56 and increasing the Vibrance to +75. I also increased the Clarity to +50 to bring out the detail— when shooting on location there are always a lot of details in the photo, and I want them all to be tack sharp.

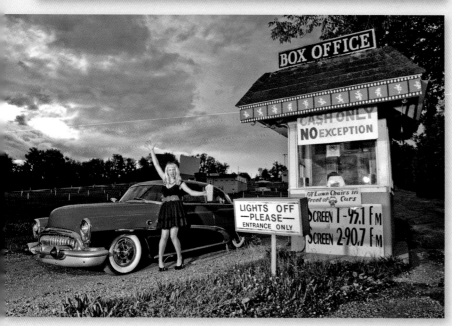

6 The next step is to fine tune some of the colors, which means clicking on the HSL/Color/ Grayscale drop-down. I wanted to change the color of the clouds so they were more blue than dull gray, so I tweaked the blue Hue.

I wasn't happy with the grass either—it seemed very vibrant, especially compared to the car, which should be a key element to the photo, but seemed dull. By cranking up the red Saturation, and decreasing the green Saturation, the emphasis was put back on the car.

The drive-in

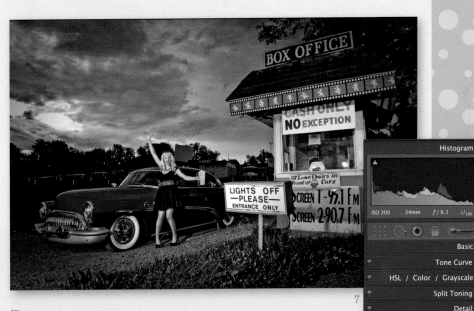

7 To enhance the vintage feel I added a simple vignette via the Vignettes drop-down, setting the Post-Crop Amount to -38.

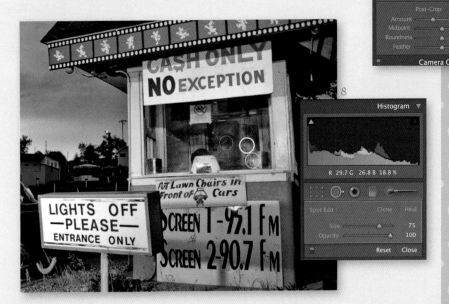

8 Finally, I noticed that at the lower right corner of the ticket booth window there was a reflection from one of my strobes that had to go. Using the Spot Removal tool, I selected a tool size that was slightly larger than the reflection and clicked on the reflection to remove it.

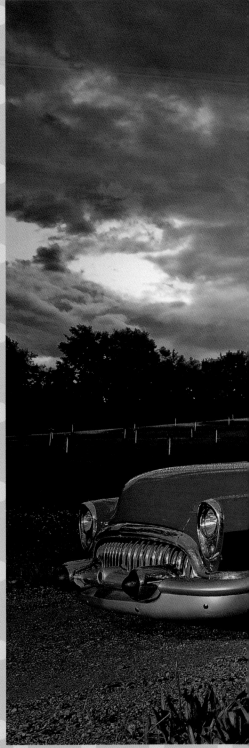

Final Image

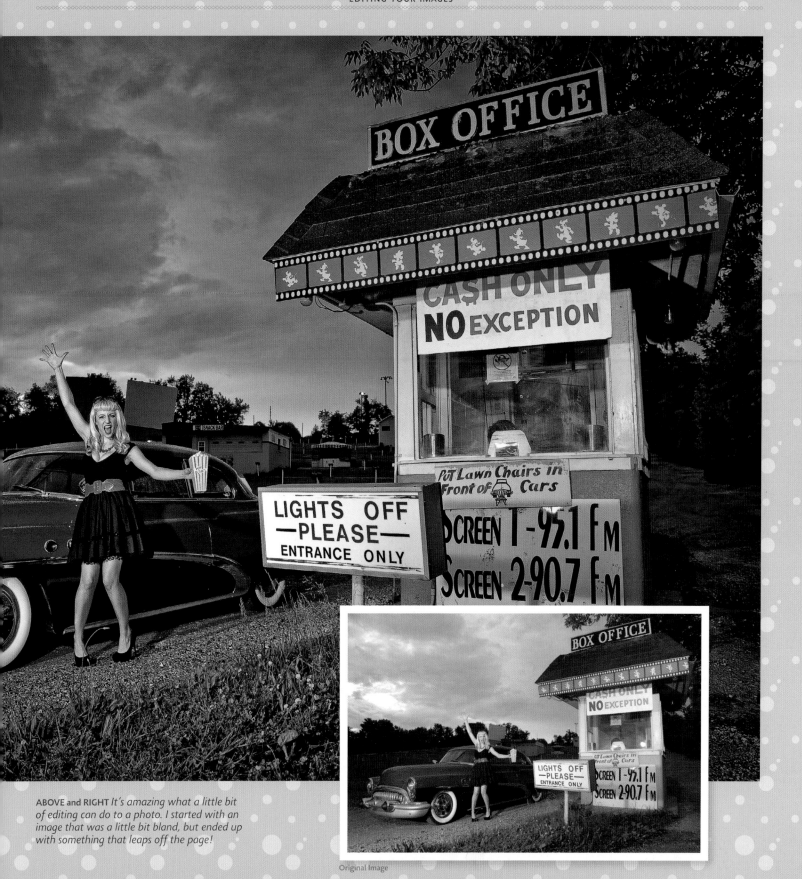

ABOVE and RIGHT *It's amazing what a little bit of editing can do to a photo. I started with an image that was a little bit bland, but ended up with something that leaps off the page!*

Original Image

Tilt-a-whirl

STEP BY STEP

SINCE ITS INVENTION IN 1926, the Tilt-a-whirl has been a staple at fairs and midways. The ride featured here dates from the 1950s, making it the perfect setting for a period pinup girl photo shoot. However, it took a few Lightroom tweaks to give the shots a little extra something.

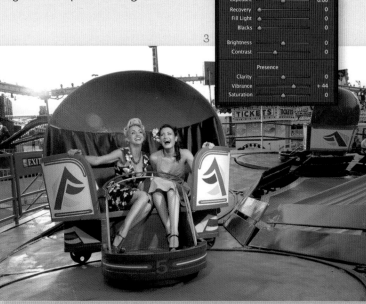

1 After looking at the photo, I decided that I wanted the colors to be stronger. The predominate colors in this scene are blue and red, and while the reds looked pretty good, the blues were less exciting. Also, since this was shot directly into the sun, I felt the color balance was a bit too warm—cooling the whole image down would fix this, and help make the blues stand out as well.

2 My first adjustment was to the Temp slider in the Basic drop-down palette, which I reduced to -19. I also increased the Tint slider to +4. This immediately made the blues stand out a bit more, and also cooled down the skin tones in the process.

3 The next step was to add a bit more color overall, which I did by setting the Vibrance slider to +44. As you can see, the colors throughout the image are now quite a bit brighter.

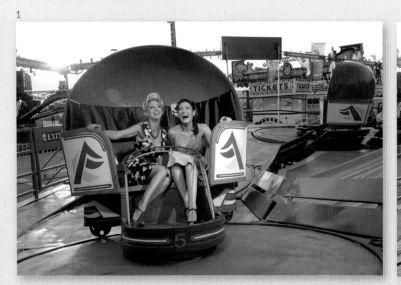

4 With my colors altered, I looked at the image again and realized that I wanted to make the skin tones a little more realistic. To do this, I used the Split Toning options, setting the Hue to +71 and the Saturation to +27 for the Highlights. This seemed to mellow out the skin tones.

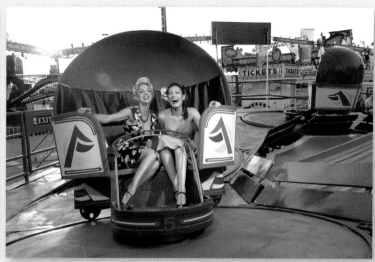

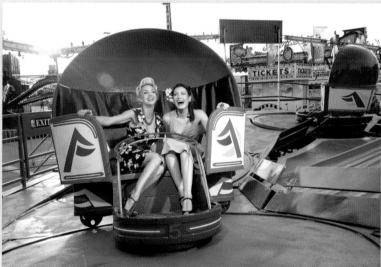

5 The various color adjustments had meant that I had lost a little bit of the brightness overall, so I returned to the Basic settings and adjusted the Brightness to +13 and the Contrast to +27. Immediately, the image had a similar brightness level to that which I had started with.

6 Finally, I added a vignette to draw the viewer in. This was done through the Vignettes panel, setting Lens Correction to -100 and Post-Crop to -23.

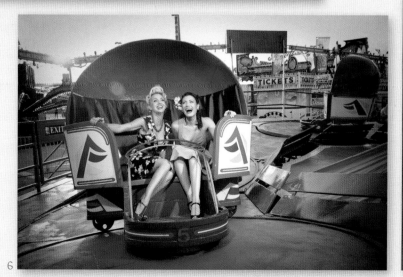

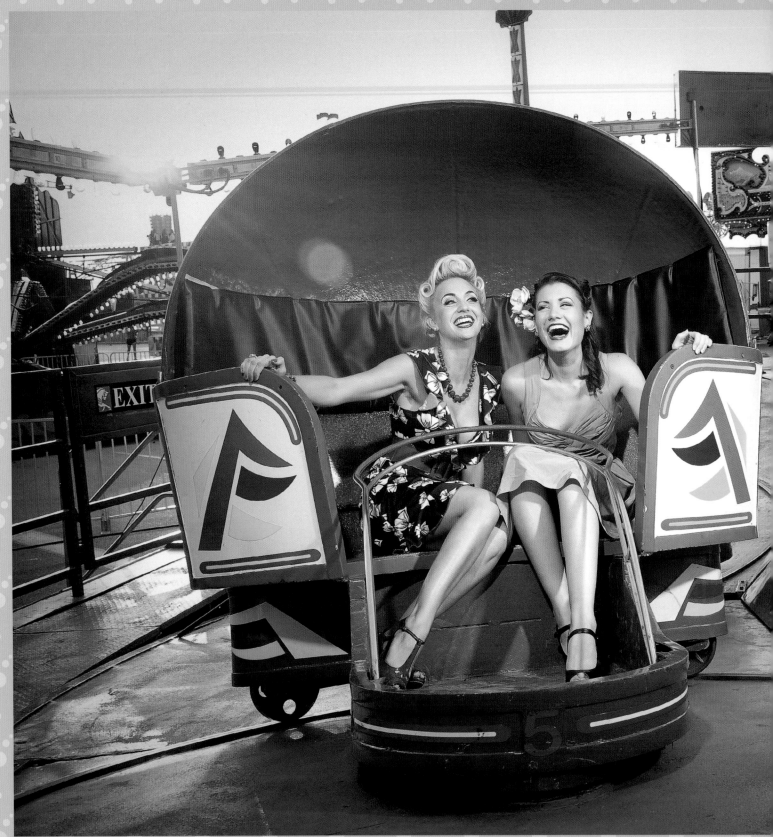

Final Image

LEFT and BELOW *As you can see, not a lot of editing was done to this photo. I added a very subtle color wash and played with the colors a bit. Nothing too major.*

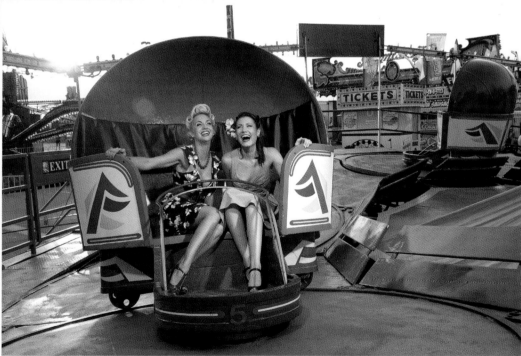

Original Image

Split toning

STEP BY STEP

SPLIT TONING IS A GREAT WAY to add a very quick retro look to your images. By simply adding color to the highlights and shadows of your image you can make your photo look like it was taken in the 1950s, 1960s, or 1970s!

1 Vintage photographs always seem to have a bit more yellow in them, so I opened the Split Toning panel and adjusted the Hue slider to +64 to add yellow to the highlights. I also bumped the Saturation slightly, increasing it to +14.

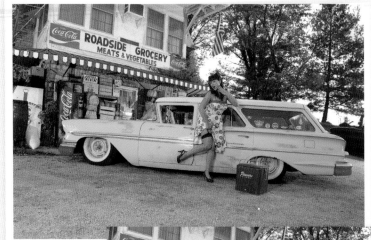

Original Image

2 With the highlights adjusted, I moved on to the shadows. I always like adding a little purple to my shadows, because I feel it gives a nice vintage color to an image. I selected my purple (259 on the Hue) slider, and set the shadows Saturation to +20. You don't want to add a bunch of color here, just a subtle amount so the photograph still appears natural.

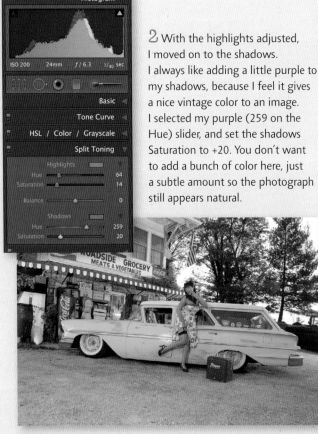

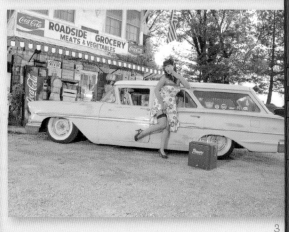

3 Whenever you start modifying the colors in an image, you take away the brightness, so I went to the Basic adjustment panel and bumped the Expose to +33, Recovery to +18, and the Fill Light to +25 to compensate.

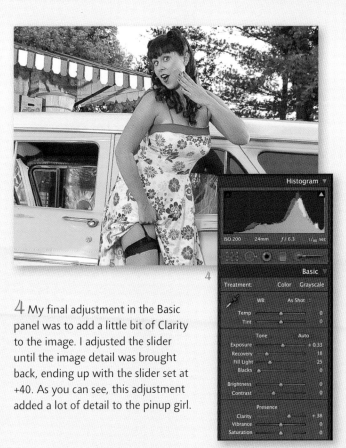

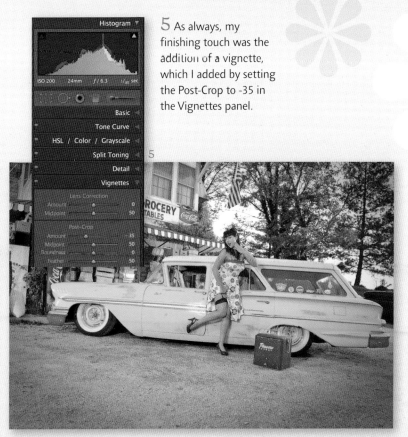

5 As always, my finishing touch was the addition of a vignette, which I added by setting the Post-Crop to -35 in the Vignettes panel.

4 My final adjustment in the Basic panel was to add a little bit of Clarity to the image. I adjusted the slider until the image detail was brought back, ending up with the slider set at +40. As you can see, this adjustment added a lot of detail to the pinup girl.

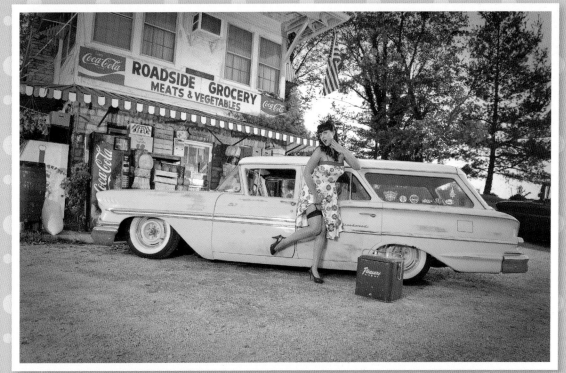

RIGHT *Very minimal editing was needed on this image. I did decide to split tone the photo as well as add a vignette to give it a more retro look.*

Final Image

Film noir

STEP BY STEP

REMEMBER THOSE OLD CRIME DRAMA movies from the 1940s and 1950s that had that dark, gritty look to them? Well, "film noir" is the cinematic term associated with the low-key, black-and-white look, which literally translates as "black film." This style of editing has a very dark and moody feel to it, but it is also very sexy, so let's learn how to give your images the classic film noir look.

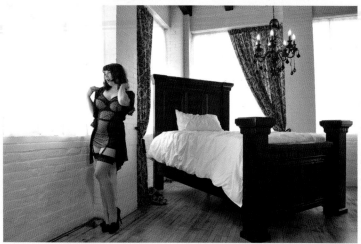

Original Image

1 As always, I opened my image in Lightroom and started with the Basic adjustment panel. First, I wanted to adjust my Blacks, which I set to +44 to give my photograph a very dark appearance. Then I made adjustments to the Contrast slider, bumping this to +11.

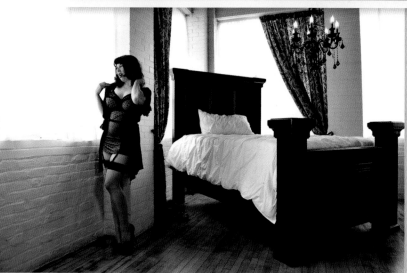

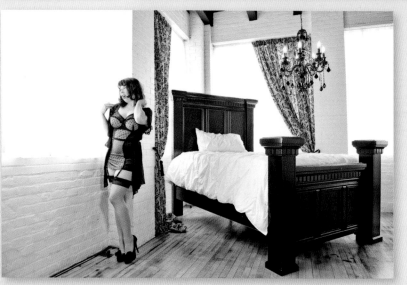

2 There is always a balancing act between the black levels and the image brightness and exposure, so as the image was too dark, I needed to add some brightness. I started doing that by sliding the Brightness control to +3, but the biggest adjustment to the image brightness was made using the Fill Light control. I made adjustments until I was in the ballpark—I ended up with the slider set at +60— which brightened up the image by quite a bit.

3 I also wanted to bump the exposure a bit, so adjusted the Exposure slider to +50.

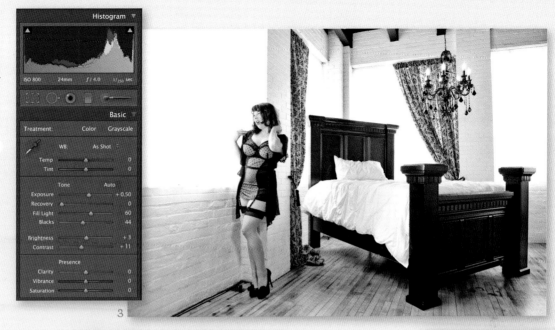

4 With a nice bright image, it was time to add a little bit of crispness to it. For this, I adjusted the Clarity to +29.

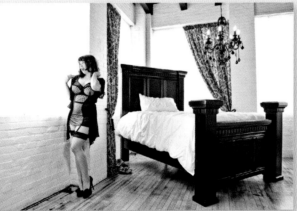

5 With the basic adjustments out of the way, it was time to transform this photo into a black-and-white image. Most people would go for the saturation slider and remove all of the color from the image, but a better option is to use the Grayscale adjustment panel. By adjusting the sliders you can control each color in the monochrome conversion separately. You wouldn't think that adjusting a color would make a difference when editing a black-and-white image, but it does. I normally use the preset Lightroom values, then use these sliders to fine tune everything. The red channel always makes for a drastic adjustment.

Film noir

6 Next up is the tone curve. After clicking on the Tone Curve, I decided to adjust the lights as well as the darks. I set the Lights to -6 and the Darks to -15. This is a very subtle adjustment, but one that will come into play in the final image.

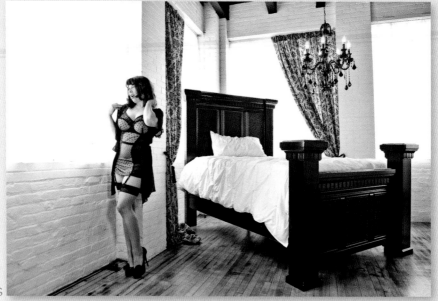

8 To add a little more drama to the image, I added a vignette to the photo, via the Vignettes panel. For this image I set Lens Correction to -100 and the Midpoint to 25. This is a pretty heavy vignette, but it adds to the film noir look, which is now finished.

7 Classic film noir imagery is often very sharp and gritty, so it's time to open the Detail panel, where you can sharpen your image. I started by setting the Amount to +44 to add extra crisp detail to the whole photo.

9 Although my editing is finished, I really like the outcome, so I want to save it in the form of a preset that I can use on photos at a later date. I mentioned this earlier in the book, but here I'll show it in a "real world" situation.

The first thing you want to do, is to go to the top menu bar and select Develop > New Preset. This will bring up a dialog box where you name your preset—the obvious choice would be "Film Noir."

After saving the preset, it will show up in the Presets list to the left of the screen.

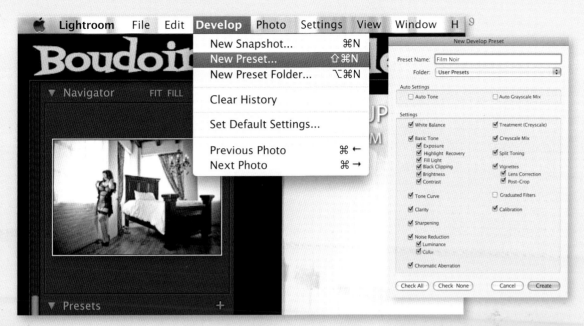

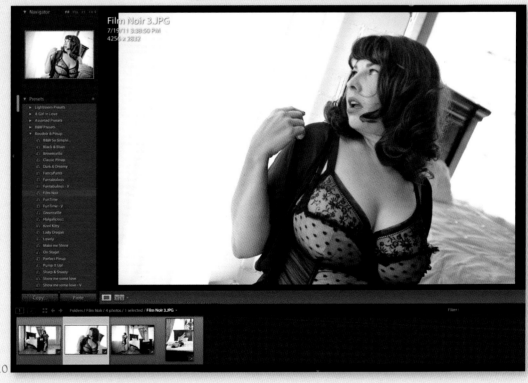

10 If you have other photographs that you want to have the film noir look, select the photo that you want to apply it to from the bottom of the page.

11 With the photo selected, go to the Preset area and find your film noir preset. When you hover over it, you will be shown a preview of this action. Since I know I want to use it for my shots, I just click on it and all of the editing is done. Continue doing this for any other photographs that you want to apply this preset to.

Film noir

12 If you have several photographs that you want to apply the same preset to, then you can save even more time by applying the preset to them as a batch. Start by selecting all of the photos you want to apply the film noir preset to from the bottom timeline.

13 Now, right click on one of the images to bring up a menu. Select Develop Settings and find your film noir preset out of the list. Click on it and all of your selected images will be transformed at once.

Final Image

BELOW As you can see, the final photo is more dramatic when converted to black and white. Since the film noir look is all about drama, it is only fitting that we add a little moodiness to the photo.

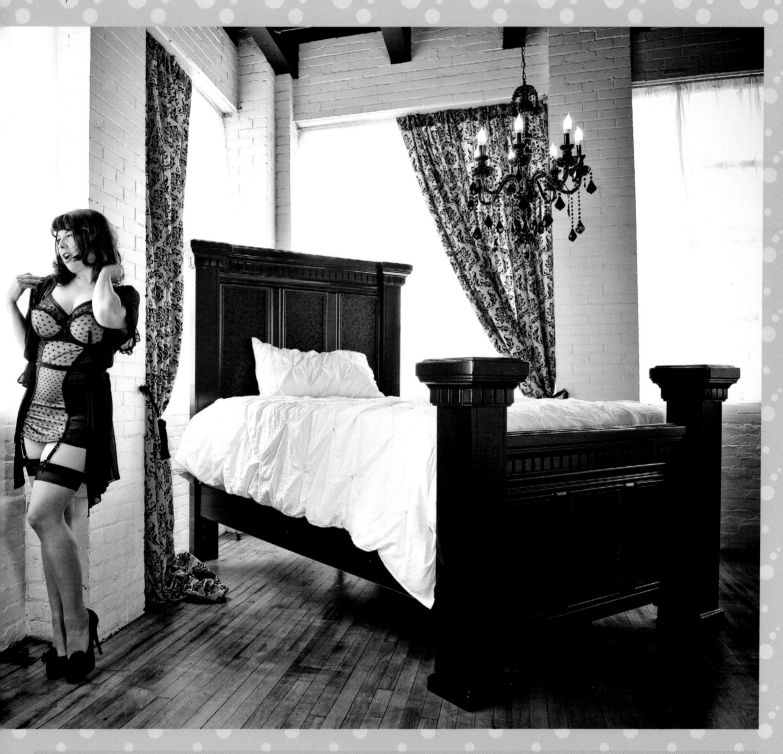

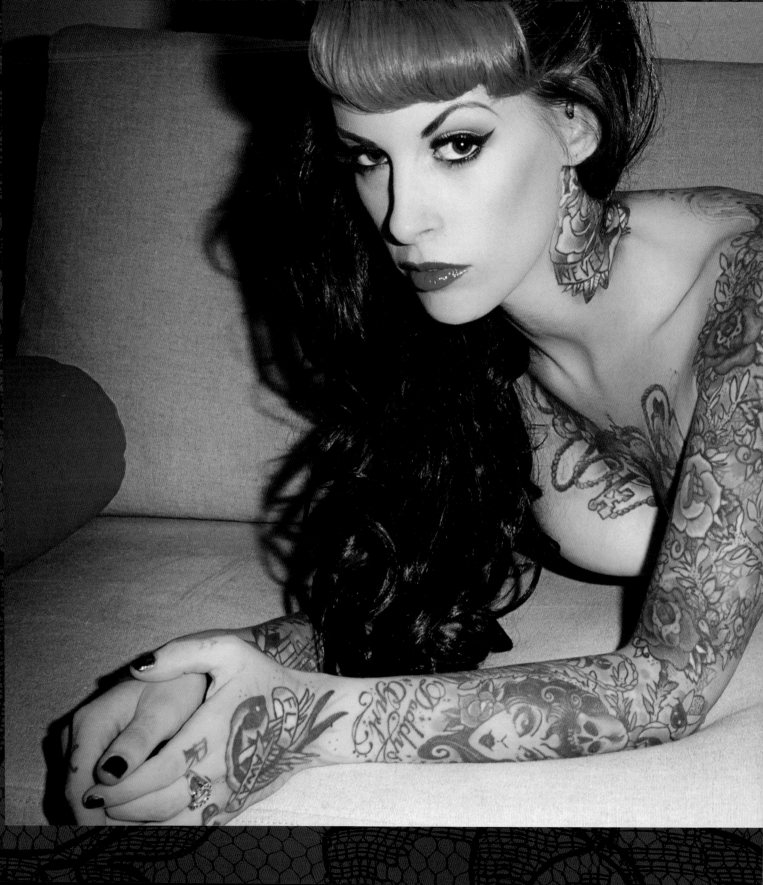

6

PHOTOGRAPHER'S

Gallery

Celeste Giuliano

CELESTE WAS INTRODUCED to pinup illustrations by her grandfather, who was a clothing designer in Philadelphia. He used to collect pinups and had old calendars featuring the work of Gil Elvgren, Earl Moran, and Alberto Vargas hanging on the walls of both his bedroom and work room. While in college, Celeste rediscovered his collection of pinups, and they inspired her classic style of pinup photography.

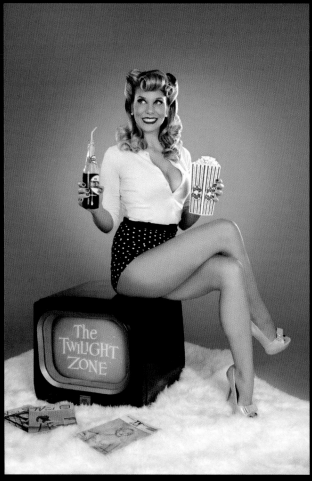

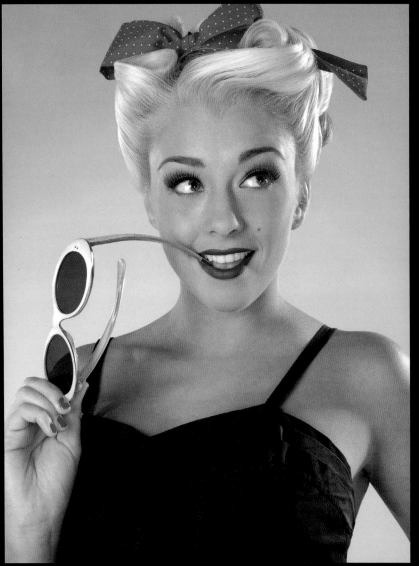

As a child I spent many a moment drawing in my grandfather's workshop while staring at torn-out pages of vintage pinup illustrations that he had tacked on the wall. Now, just like those iconic artists of the 1940s and 1950s, I am creating and sharing beautiful pinups of my own. And who knows, maybe somewhere out there, a few of my images will wind up tacked on a wall or two.

Celeste Giuliano

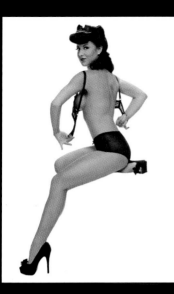

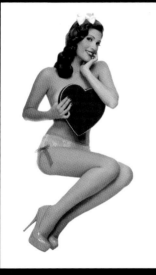

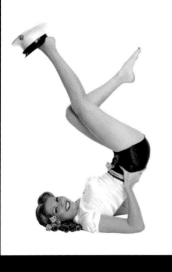

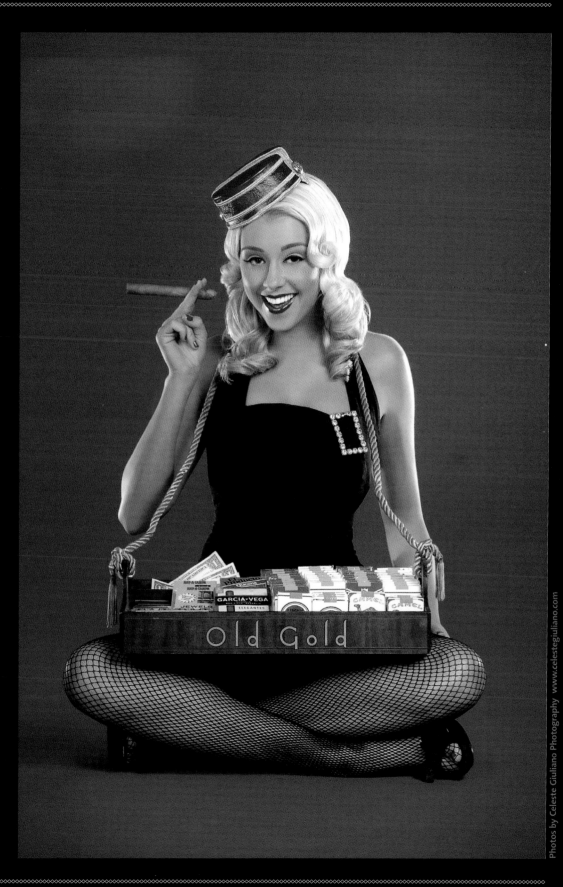

Melanie Benson

Melanie Benson of Va Va Voom Pinups has been a professional photographer since leaving high school. Her mother is an avid retro collector and interior designer specializing in the atomic era, and it is this that has helped form Melanie's passion for the 1950s and '60s. Melanie describes her style as eclectic, as she tries not to stick to one specific genre of pinup photography, and she often tries to mix humor and sensuality in her work.

> *I often find inspiration for my shoots in the vintage decor and wardrobe that I find. I adore pinups because they are sensual and always leave me wanting to see more.*
>
> Melanie Benson

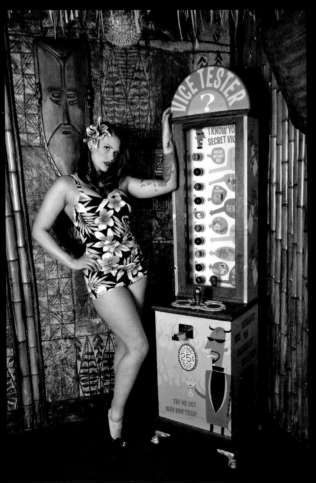
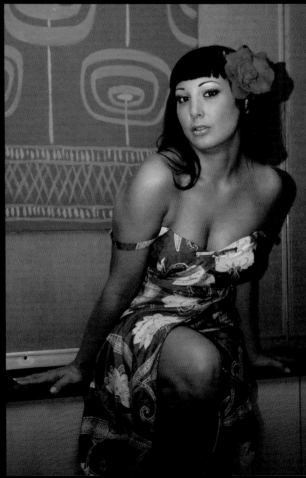

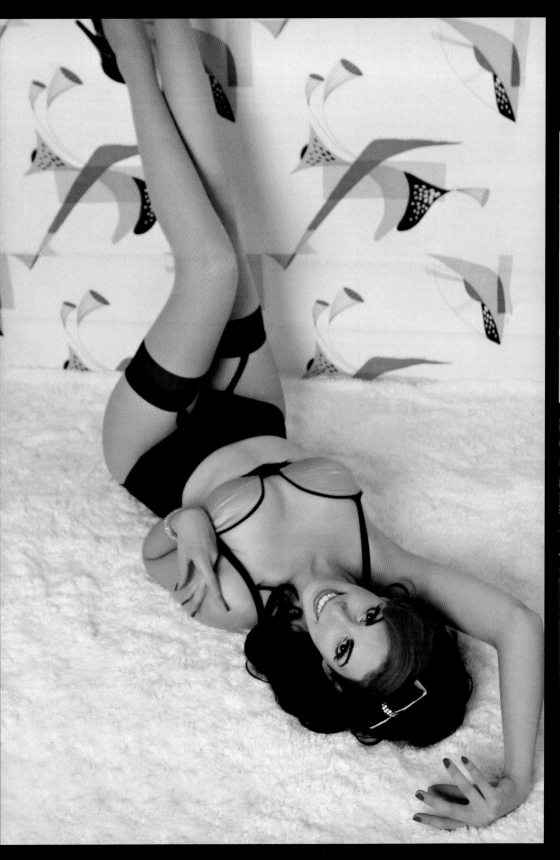

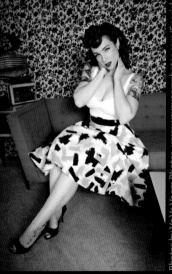

Holly West

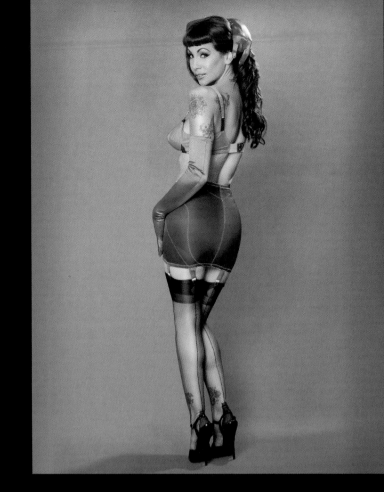

HOLLY WEST HAS BEEN INTO PHOTOGRAPHY since she was a kid, and has been shooting professionally for nearly twenty years. She describes her style as "classic pinup and retro glamour with a modern edge." Her biggest inspiration—and the reason why Holly loves retro style imagery—is her grandmother who raised her. Holly's grandmother was a drummer in several women's quartet bands in San Francisco during the 1930s and '40s, and loved music and fashion from all eras, as well as pinups and classic Hollywood glamour—all of which was passed on to Holly.

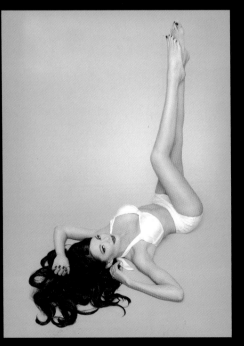

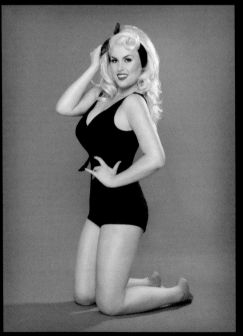

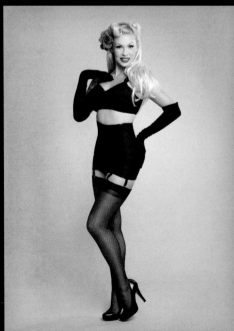

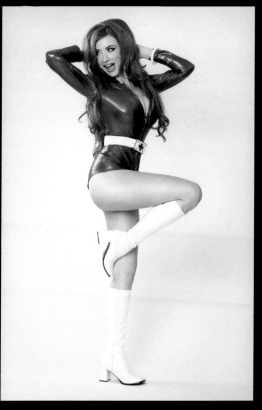

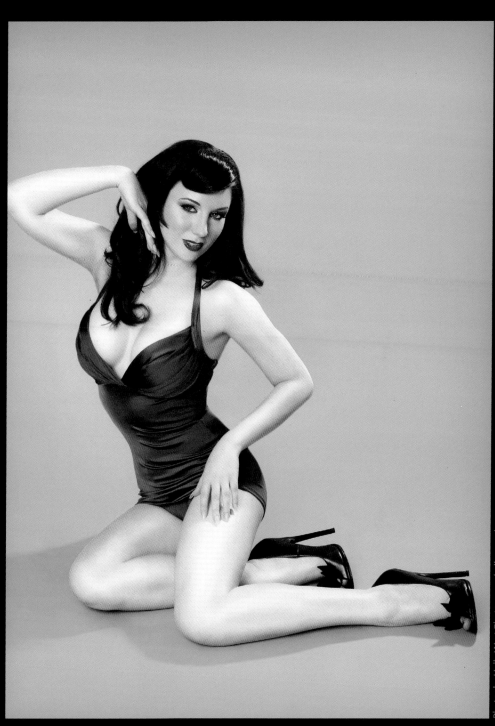

I credit several sources as inspiration for incorporating retro-style imagery into my photography, the main one being my Grandmother Jessie and the moment I discovered George Hurrell. My Grandmother was a drummer in several women's quartet bands in the 1930s and 1940s, and was an avid collector of traditional American pinup art and vintage couture. I was fortunate enough to have those influences in my life from an early age in addition to an appreciation for old movies and music from the big-band/

Edson Carlos

EDSON CARLOS HAS CREATED HIS STYLE by combining the look and feel of film with the modern pinup: a raw, gritty, and sexy combination that makes you wonder if you've stumbled onto a stash of photographs that you weren't supposed to see. Harsh shadows and a "lo-fi" look give Edson's pictures a spontaneous "snapshot" feel, which is enhanced by the lack of fancy lighting setups or a frame full of staged props. Edson captures energy and personality in a photograph: where there is fun, there is a snapshot.

" *My favorite images of that era were unrefined, unposed, and imperfect—a snapshot. My aim is to capture that filmy soul in a fun, loose atmosphere.* "

Edson Carlos

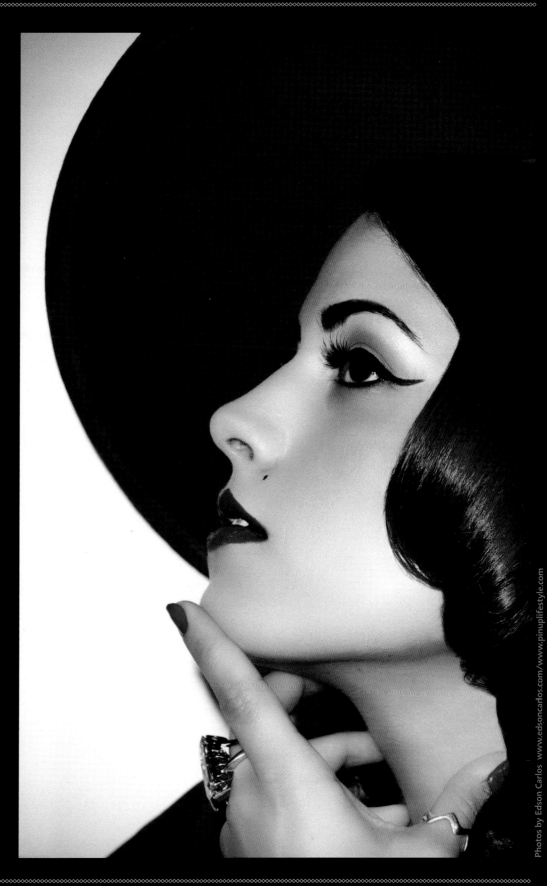

Michael Bann

A PHOTOGRAPHER AND "HEAD HONCHO" at *Retro Lovely* magazine, Michael gets his inspiration from artists working outside of the pinup community, such as Helmut Newton, Bob Carlos Clarke, and the surrealists from Paris in the 1920s and 1930s. Michael is a slave to locations when shooting, and has actually never shot a pinup image in a studio—he would much rather find an awesome location and rely upon his dramatic lighting skills.

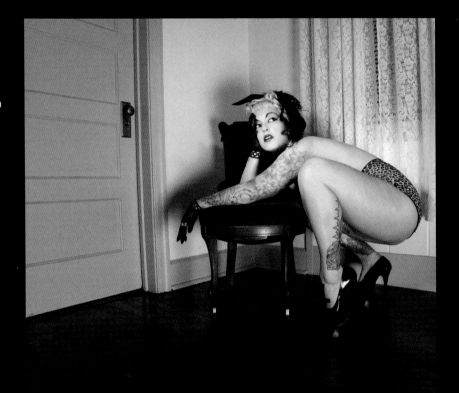

"

Pinup for me took root at an early age. My father had a lawn ornament business. Flamingos, jockeys... Elves. He painted them using an airbrush, a Devilbiss model actually. In his shop were dozens of books on airbrushing and most had examples of the work of Varga... I was fascinated by it all. Later I was influenced by the likes of Helmut Newton, which put a decidedly darker, more naughty aspect to what I shoot for myself. What I like about pinup is how wide a range of looks and styles it can encompass, and how very varied 'beauty' can be within those parameters. After all this time I still see things that I've never seen before in this art. "

Michael Bann

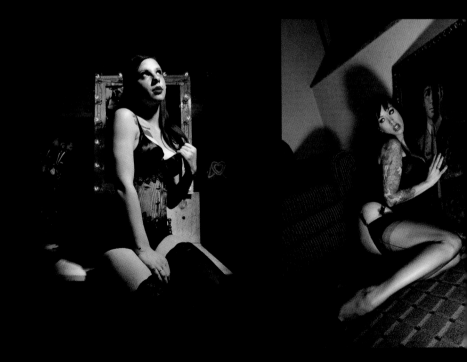

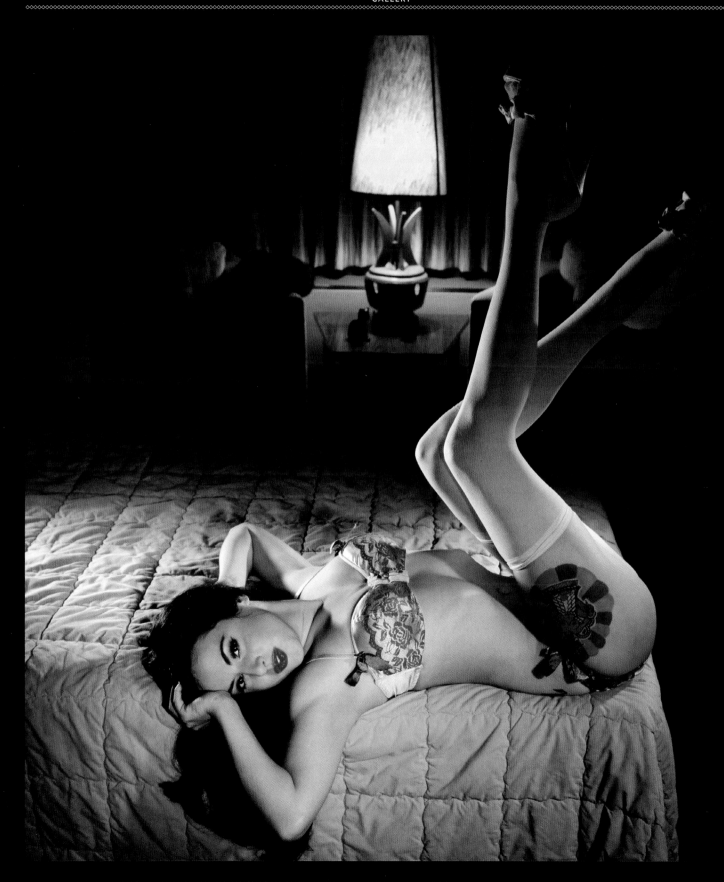

Angela Morales

H AVING ALWAYS BEEN A FAN of the pinup art of the 1940s and '50s, Angela Morales decided to produce her own take on the genre in 2009. Initially, she did a lot of classic, studio-based pinup work, with some artistic editing to put her own spin on it. She went on to shoot on location and after just two short years (and being completely self taught) she has been published internationally. Now, her ultimate goal is to have her own book.

I would describe my style as modern pinup with a vintage twist. I started shooting pinup because I wanted to make girls feel confident and see how beautiful they really are. I love the reactions I get from clients who come to us looking for a little pick-me up and end up doing it again and again because we have so much fun being girls and playing dressing up!

Angela Morales

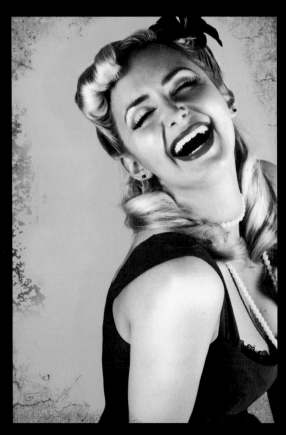

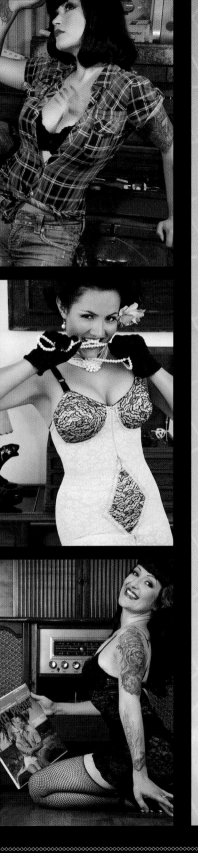

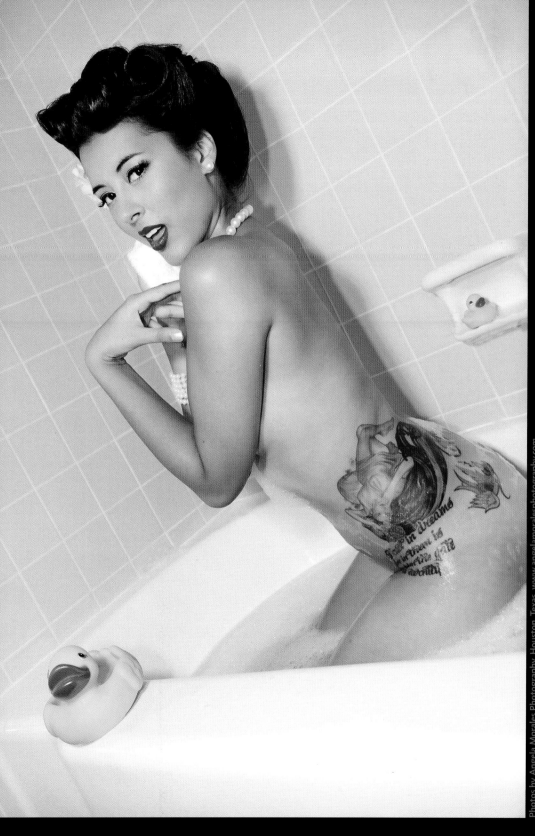

Index

Acknowledgments

Author's thanks

TO THE VERY BEST assistant and friend in the world, a huge "thank you" to Britt—I could not have done all of this without you. A big thanks to all of the Boudoir Louisville crew as well—it's easy to do great work when you have great people helping you. I would also like to thank all of the girls that trusted us to shoot them wearing next to nothing!

Publisher's thanks

The publisher would like to thank the following for their kind permission to use their images:

- Celeste Giuliano
- Melanie Benson
- Holly West
- Edson Carlos
- Michael Bann
- Angela Morales

AUTHOR'S Special thanks

SPECIAL THANKS to Adam and Cathy— your support and friendship is very much appreciated. Lastly, I would like to thank my very understanding wife, Jenny. Thanks for being there for me and also for allowing me to photograph woman in their underwear!